Roy Lichtenstein

Roy Lichtenstein

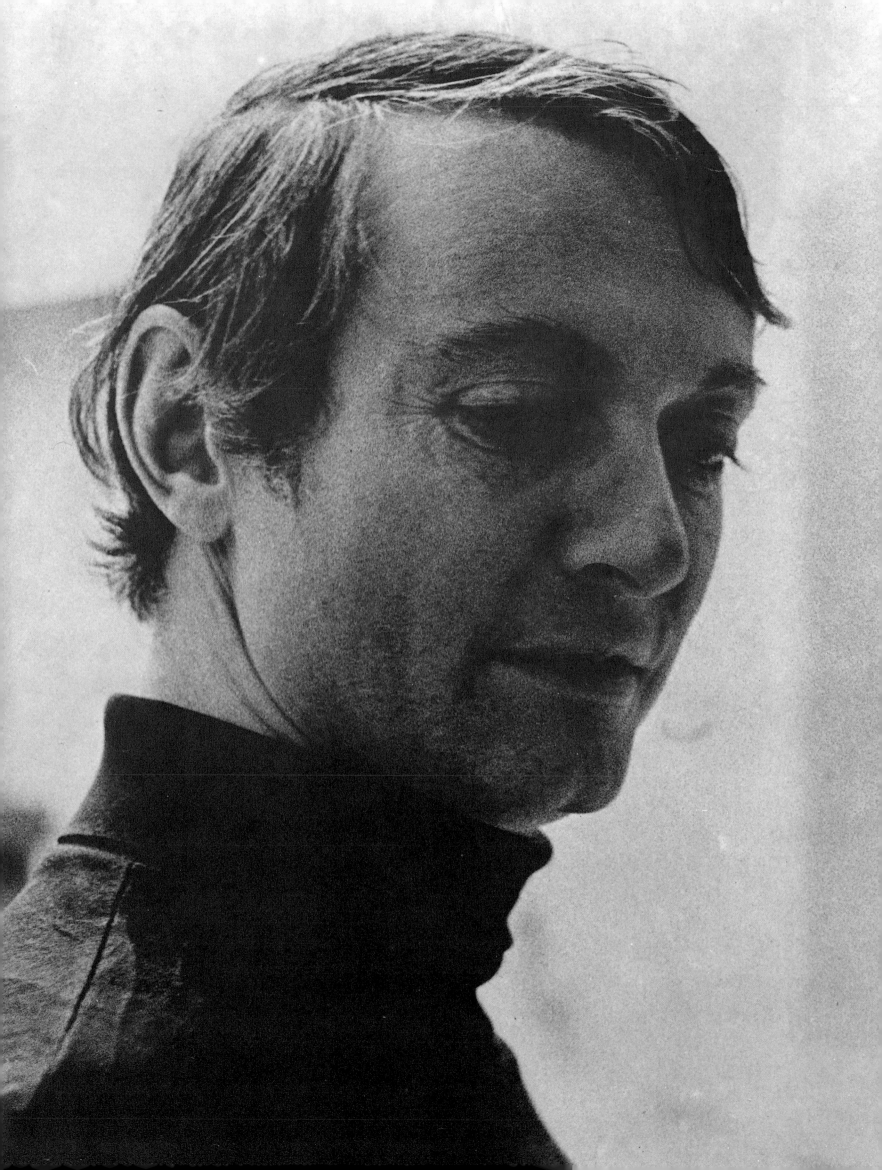

Roy Lichtenstein

Drawings and Prints

With an Introduction by Diane Waldman

Contents

This is the second in a series of books on contemporary American artists.

This book includes drawings, prints and studies. The *Catalogue of Drawings* includes every drawing and the *Catalogue of Prints* every lithograph, etching, silk screen and limited poster edition from 1961 to 1970. The chapter, *Studies*, is not complete; many studies have been lost or given away without record.*

Drawings and studies are identified both by year and by number: prints by number only. Works exhibited under several titles are listed by the title selected by Roy Lichtenstein. Dates enclosed in parentheses do not appear on the works themselves. The dimensions listed in the caption are sight dimensions, except where noted. Where no provenance is listed the work was obtained directly from Roy Lichtenstein.

The following exhibitions are abbreviated:

Cleveland Museum of Art, 1966
Roy Lichtenstein, Cleveland Museum of Art, Cleveland, 1955

Guggenheim, 1969:
Roy Lichtenstein, The Solomon R. Guggenheim Museum, New York, 1969

Hannover, 1968:
Roy Lichtenstein, Kestner Gesellschaft, Hannover, 1968

Kunsthalle, Bern, 1968:
Roy Lichtenstein, Kunsthalle, Bern, 1968

Pasadena/Minneapolis, 1967:
Roy Lichtenstein, Pasadena Art Museum, Pasadena, 1967
and the Walker Art Center, Minneapolis, 1967

Stedelijk, 1967:
Roy Lichtenstein, Stedelijk Museum, Amsterdam, 1967

Tate, 1968:
Roy Lichtenstein, The Tate Gallery, London, 1968

All color reproductions of the studies were made directly from the originals and, in most cases, the reproductions are the same size as the originals.

I would like to thank for their cooperation: Roy Lichtenstein, Leo Castelli, Richard Dimmler, Sidney Felsen, Matthew Foley, Ivan Karp, Dorothy Lichtenstein, Ileana Sonnabend, Phyllis Tuchman, and Barbara Wool.

Paul Bianchini

* It would be greatly appreciated if anyone owning a work not included here would send the details to me at 14 East 77th Street, New York, 10021, to be included in future editions.

Introduction

In the notorious marriage of a wholly radical subject matter with the methods of fine art, Roy Lichtenstein brought documentation of the American life style to a new level of awareness and brilliantly proclaimed the comic strip as a fitting theme for the new American painting of the 1960's. He forced us to confront images of a new "reality" that challenged our accepted values and ways of seeing art. The incorporation of common household items as objects of pictorial concern proved anathema to many, critics and laymen alike, who could, nonetheless, grudgingly admit to an intellectual accommodation within the long tradition of genre painting. But Lichtenstein's use of a cartoon imagery, and the brutality of its presentation, seemed too great a hurdle to leap; the cries of anguish and dismay are just beginning to fade. A misunderstanding of the importance of subject matter in relation to form was responsible for much of the hostility. This confusion was compounded by the application of a common denominator, Pop art, to describe a phenomenon that occurred in 1961 which appeared at the time to be a total rejection of Abstract Expressionism. One need only recall the multitude of artists assigned to Pop art at its inception to recognize that the term served to obscure rather than clarify the situation. As a convenient label it did substantiate the mutual interest of an otherwise independent group of artists in the banal as subject and in the mass media. It had, indeed, some validity in terms of the most easily apprehended features of many artists' work. Like all such labels—like Abstract Expressionism and Action Painting, for example—it failed to distinguish between major artists and the second or third-rate practitioners of a style. But it also failed as an accurate evaluation of the contribution of the major artist to his time.

That subject matter plays a crucial role in the formation of a style is undeniable; Lichtenstein's subjects are a case in point. Familiar by now, his images are still thoroughly provocative, capable of arousing anger, laughter, annoyance, a considerable range of human emotions. But the dynamic vitality of his subjects has in effect acted as a clever decoy, obscuring the very formidable originality of his pictorial statement. It may be an open question whether it is ever possible to sustain a subject matter of such heroic amplitude without an equally rigorous formal structure, but the historical evidence is against it. For Lichtenstein, as with any major artist for whom representation has provided the vehicle for innovation, subject matter functions as the bridge by which the artist accomplishes the transition from idea to art.

Lichtenstein's subjects range from cartoons to cathedrals, landscapes to the Thirties, brushstrokes to pyramids, hot dogs to haystacks. The need for such a protean subject matter is the stimulation that it offers the artist to extend the potential of his ideas; the syntax, however, remains entirely consistent. To assume, therefore, that the power and originality of Lichtenstein's work depends primarily

upon its subjects is to misconstrue his intent. Such an assumption implies that a sensational subject matter must be followed by an ever more outrageous one, when in fact the opposite is true. Lichtenstein's successive images are consistent in their indication of another objective, the exploration of form.

Lichtenstein's drawings of 1961-1969 form a cogent, if selective, documentation of the development of his style. Although his drawings are similar in conception to his paintings, and in some cases identical in subject, they are not intended as preparation for the paintings but as a fresh investigation of the material. The restrictions of the medium not only dovetail with his innate graphic sensibility but are consistent with his formal requirements. The boundaries of a drawing afford the inward-directed pressure that Lichtenstein needs to organize his images. His drawings, therefore, form a homogeneous entity with his paintings in that they are conceived with an uncommon singleness of purpose.

Granted this fundamental similarity, there are some striking differences between his drawings and paintings, most notably in the complete elimination of color. Lichtenstein chose to suppress color for a variety of reasons: besides the apparent wish to make a statement clearly distinct from his paintings, he obviously relished the possibility of making a specific reference to "drawing" as a unique concept within the larger context of art. (The closest parallel to this systematic appraisal of drawing occurs in the drawings of Jasper Johns. Renowned for his elaboration of the multiple meanings and uses of gray, Johns is as consistent as Lichtenstein in his approach to drawing.) Another reason for Lichtenstein's decision to work in black and white can be most easily explained with his often quoted statement: "I want my painting to look as if it had been programed. I want to hide the record of my hand."[1] One could say, therefore, that black and white offered the equivalent resistance to his drawings that his use of red, yellow, and blue established in his paintings, a facsimile of mass-produced, "commercial" color and line. That Lichtenstein succeeded in overcoming this resistance to make paintings and drawings of great versatility is a tribute to his formal inventiveness.

The elimination of color is not, of course, the only difference between Lichtenstein's approaches to drawing and to painting: he has occasionally produced a painting in black and white. A striking comparison exists between the painting and drawing of the same subject, *Ball of Twine*, 1963. In the drawing, the Ben Day area around the figure is noticeably larger than in the painting: this causes the object to float, in decided contrast to its weightiness in the painting. By capitalizing on the size of the twine in the painting, dramatically increasing the use of heavy black accents on the white skein, and emphasizing the irritating tension between

the bottom edge of the subject and the space around it, Lichtenstein imparts a gravitational force of enormous potential to the painting. In the painting also, Lichtenstein recognizes the inherent properties of the object, addressing himself to the suggestion of mass to call into question the reality of the object.
For the very reason that an object brings with it an implication of reality, it forces a confrontation with the issue of illusion. We know, for example, that a ball of twine is three-dimensional in actuality. We bring to the image our knowledge of the ball of twine as an object that occupies a particular and concrete shape and space. By presenting the object with only some of the data of its existence, Lichtenstein can pose a challenge to the reality of his subjects and resolve the potential conflict in favor of the illusion. It is in Lichtenstein's use of artifice, and our awareness of the fiction involved in the presentation of the subject, that we can appreciate the full potential of the image.

The "objectness" of Pop is the direct outcome of the influence of Rauschenberg and Johns. Both artists placed maximum stress on the actual physical attributes of an object. Johns' great contribution was to make a flag or a target both a literal object and a statement about the rectangle. In focusing directly on the equivocal status of a flag or a target as object illusion, rather than relegating it to a marginal role, Johns became crucial to the development of many object-oriented artists working in the early sixties. Several of them, most notably Kaprow and Oldenburg, were experimenting with Happenings and the use of objects as important props for their performances. Alone among the so-called Pop artists, Lichtenstein dematerialized the object and effected a new reconciliation with the picture plane. This is a significant departure: it both allows the object its original identity and confers a new one upon it. For the transformation of the object to be successful, it was necessary to maintain an exact equilibrium between the original subject and the translation of that subject. Lichtenstein obtains this duality by the conjoining of a "real" image with an abstract form.

One of the most remarkable achievements of his work is this ability to hold reality and illusion in tandem. To arbitrate between the demands of the subject and form, Lichtenstein broke out of the usual one-to-one relationship between artist and his subject matter by referring to an interim stage, the mass media. By maintaining this one-step remove from his subjects, he became free to manipulate them and make any number of references without disturbing the validity of the image. It is precisely for this reason that the concept of transformation was so crucial because it argued for the recognition of perceptual data that were literal in point of origin but not in depicted fact. What the "representation of a representation", as Donald Judd has accurately phrased it, provided the means of reconciling actuality with form, an accommodation that for the artist could only be successful if it were accomplished on the picture plane. [2]

It is evident that for Lichtenstein the choice of subject was particularly crucial; deliberately iconoclastic, the single objects and the cartoons are his most extreme and disturbing statements. In order to transcend his subjects, he needed an imagery so potent that it would offer tremendous resistance. Only in this way could he retain both the object-oriented and ground-directed impulses of his work. In keeping with his subjects, Lichtenstein has used the most obvious clichés of the mass media to provoke instant recall of both the subject and the situation to which the subject refers—an abstraction of life. Using a few ruthlessly selected clues, totally avoiding "documenting" an image by such conventional means as the use of perspective, modeling, or context, Lichtenstein has proposed a concept of representation more radical than any advanced during the Sixties. Advertising, its myths and methods, offered certain readymade choices which the artist could exploit for their maximum impact.

In the earliest drawings of 1961, Lichtenstein culled not only the subjects but the stylistic mannerisms from newspaper ads. Such drawings as *Couch* and *Piano* are faithful to the particular brand of advertising that Lichtenstein found useful at this time. The promotional schemes of the Yellow Pages, for example, held more potential interest for the artist than the award-winning ads of Madison Avenue. Having deliberately picked subjects seemingly unfit for "high" art, he resolutely pushed them to their optimum limit, particularly in the beginning stages of his career. We find, therefore, that his subjects evoke not the most sophisticated, but the most low-brow, products put on the market for the average consumer. By replicating the simplistic drawing, the patent vacuousness, and the "hard sell" of this type of promotion, Lichtenstein could mount a particularly strong challenge to the very premises of art. Not only did he introduce a subject matter of all-pervading rudeness but he completely rejected the conventional approach to drawing as well. Lichtenstein suppressed not only color but nuance, substituting for the familiar flourishes of the draftsman directness and a mass-produced look. Although he had worked as an Abstract Expressionist from 1957 to 1960, it became apparent to him that the style was rapidly deteriorating into mannerism. It was precisely this mannerism as well as anything remotely like it that he disavowed so forcefully and ironically in his paintings and drawings of 1961.

If the absorption with the immediate outside world that Lichtenstein and the other Pop artists shared was in part a reaction against Abstract Expressionism, it was also an acknowledgement of the self-aggrandizing quality of contemporary American life. The blatant proliferation of products was the natural target for an art that looked out at the world, and advertising neatly summed up the scope and quality of that life. The shorthand symbols used in advertising for maximum impact in promoting a product have been shrewdly adapted by the artist in the cursory

indication of volume, the restriction of color, and the use of Ben Day dots. Nevertheless, what is fundamental to the Lichtenstein style is the relentless structure of his work, of a quality that is completely absent in advertising. Without the thorough preparation and grounding in both Cubism and Abstract Expressionism evident in his work from the late 1940's to 1960, it is unlikely that Lichtenstein would have arrived at the rigorous formal order that his work possesses from the very beginning of his Pop paintings and drawings. His idea, if not its full potential, was thus fully formed by 1961; it is in the juxtaposition of the seemingly antithetic strictures of advertising and art that Lichtenstein forged a new and unique style.

Lichtenstein has experimented with a number of techniques: the drawings of 1961, for example, are in ink; those of 1962 in ink and tempera, ink, or pencil and frottage; those of 1963 in pencil and stick touche, a type of lithograph crayon. Lichtenstein found that he could simulate the brittle newspaper texture with touche even more successfully than with ink or tempera. At first small in size and uneven in application, the Ben Day dots were gradually enlarged and regularized in a manner that suggested the commercial printing process. The uneven application of dots found in works like *Mail Order Foot*, 1961, is entirely superseded by the mechanically perfected pattern of *Shock-Proof*, 1963, *Reckon Not Sir*, 1964, and *Tablet*, 1966. The Ben Day dot which is required by the printing process has become one of Lichtenstein's outstanding formal tools. In both the early paintings and drawings, the dots served as a means of separating one form from another and as the method by which Lichtenstein observed the continuity of the entire image. The allover effect of the Ben Day dots is not unlike the covered surface of a Johns drawing; Lichtenstein, however, prefers to regularize his pattern and reveal less of the hand. Where gesture is vital to Johns in making a statement about Abstract Expressionism, it is ironically just as logical for Lichtenstein to comment on gesture by introducing its opposite. The Ben Day dots serve several functions: not only do they imply a generalized reaction against Abstract Expressionism, but in providing for the white space between them, they force an explicit recognition of the surface. At this point, Lichtenstein is free to manipulate his dots, in some instances using double screens to suggest illusion, without giving free rein to illusionism. By methodically suppressing many of the descriptive characteristics of his subjects, he conveys an impression of implacable flatness entirely in keeping with the two-dimensional nature of drawing as a medium. Alternating with the all-over pattern of *Bratatat*, 1962, or *I Know How You Must Feel, Brad*, of 1963, is the sole use of a black line as a mark which both divides the space and delineates an object. The use of a recognizable subject puts a burden on the artist in a way that is precluded with non-representational subject matter and form. The use of line alone, in such drawings as *Couch, Zipper*, or *Cup of Coffee*, allows the object and the background to remain on one

plane. In *Couch*, the weight of the black silhouette is more than compensated by the interior space that it encloses and the generous expanse of space that surrounds the subject. That Lichtenstein preferred a seemingly mechanical line is evident in a comparison of any of these black and white drawings with the studies for his paintings and sculpture. This procedure allowed him to neutralize the edge of a form and prevent the image from lifting away from the background. Even a more active silhouette like *Piano*, 1961, is uninflected, closed and static in feeling, quite similar in effect to the simple shape of *Ball of Twine*. Although the outlines are simplified, they were initially different in weight; both *Piano* and the accusatory *Finger Pointing* are substantially more emphatic than the *Girl with Accordion* or *Mail Order Foot*.

By 1962, however, Lichtenstein began to arrive at a more defined and cohesive technique. At the same time, his subjects, for the most part, appeared to be portrayed in an act which is not completed—a zipper not quite closed, a conversation still in progress, a fabric torn and mended. His figures appeared to be fraught with anxiety, ranging from the fierce unsmiling cowboy in *Reckon Not Sir* to the tender *Him*, the unhappy *Crying Girl*, the Hollywood passion of *Kiss II*, etc. *Couch* and *Piano*, like most of the single object drawings of 1961-1962, have a dead-pan, head-on, blatantly aggressive stance that Lichtenstein adapted with alacrity from newspaper ads.

In his presentation of the common object, Lichtenstein offers us images that are both perversely ironical and whimsically self-effacing, a combination that is, to say the least, provocative. To say that the artist is both moved and amused by his subjects may in turn account for the mixed reactions that they elicit from the spectator. Part of this heightened emotional response to Lichtenstein's subjects arises from the nature of the subjects themselves. As fragments of life situations with which we are all familiar, they arouse, in us, to some degree, the same type of responses we would have to the actual situations were we to experience them. In *Baked Potato* or *Cup of Coffee*, both of 1962, the pungent aromatic flavor of the subject is skillfully suggested with just a few lines. Lichtenstein, in other words, uses a Pavlovian gestalt to force a reaction to a two-dimensional image as if the actual, mouthwatering foodstuff were set in front of us. As a result, the isolated single object or a fragment of an event, as Lichtenstein shapes it, becomes more potent than any near reality or fuller elaboration would have it.

The raw energy that is apparent in all of Lichtenstein's imagery is, of course, carefully cultivated, partly by incorporating the title or legend into the body of a work. Rather than using the title as appendage or accessory to the visual, as a label clue or as a play on illusion, Lichtenstein forces a direct confrontation between

the verbal and the visual. Both the verbal and visual statements are forced into visual co-existence, so that the image forms a totally integrated unit. But the spectator response to the set of visual phenomena is quite separate from the reaction to the verbal phenomena. We are encouraged to read, hum, sing, and in fact talk back to the drawings. Certain early drawings, like *Bratatat*, 1962, convey the impression of a TV camera zooming in for the climatic moment and, figuratively speaking, draw the spectator into the space of the drawing. This almost physical response is in marked contrast to the coolness of the technique.

The drawings are in many ways more revealing of the artist's sensibility than his paintings. The delicate adjustment of subject to form, of curve to rectangle, of a firm black line to the uninflected Ben Day dot, of the modulations created by the weight of the dots played against line, shape, or text, are but a few of the means by which he maneuvers his themes. These arrangements are as much a part of the paintings as of the drawings, but the drawings achieve a sense of starkness in the absence of color and scale that permits other equally important facets of his art to be revealed. Unlike his sketches, which are casual in execution, Lichtenstein's finished drawings are as coherently organized as his paintings. Contrasting with the near-classical perfection of *Foot Medication*, 1962, *Temple of Apollo*, 1964, or *Diana*, 1965, are works like *Bratatat*, 1962, or *Brushstrokes*, 1966-68; their complex visual organization is indicative of the way in which Lichtenstein likes to shift between a simple figure-ground relationship and the intricate coordination of multiple units. The figure-ground relationship occurs again in such works as *Brushstroke*, 1965, with one substantial change—a literally two-dimensional image replaces the earlier preoccupation with subjects whose actuality is in the round. The artist obviously enjoys the manipulation of the two- and three-dimensional, for he returns to it repeatedly. *Temple of Apollo*, 1964, is one example in which a solid mass is translated into its equivalent, a purely pictorial two-dimensional image.

From around 1963 certain pictorial devices which had appeared occasionally began to occur with increasing frequency. These include a kind of curved and at times almost baroque line which could designate anything from clouds to a woman's hair; the sharp zig-zag of the comic strip reappeared in the spiraling cloud formations of a landscape and again in the zooming diagonals of the Modern paintings; the dots created out of the surface a taut and rigid screen. An outstanding feature of both the drawings and the paintings is the frequent use of a cropped image to suggest its continuation beyond the perimeters of the paper and to identify the image with the rectangle.

The drawings have a sense of ebullience and humor, notwithstanding the restriction to black and white, which derives in part from the flagrant disregard that

the artist has for his subjects, an attitude closely related to Duchamp's. Humor, an essential component of Lichtenstein's work, is indispensible to his transformation of the object. The type of humor that the artist favors is new. Not only is it different from the whimsey of Klee, the scatological wit of Miro, or the blowsy eroticism of Oldenburg, it is also different from the type of humor that we are familiar with in the comic strips. It is closer, in fact, to the "situation" humor of the movies.

The Lichtenstein combination of humor and drama heightens the implication of "reality" which the artist simultaneously denies by formal means. In the Lichtenstein iconography of violence, the gun appears in two versions in the drawings, replaced in the paintings by the fuller blown format of the war cartoons. Two drawings of the same subject, *Hand Loading Gun*, both of 1961, appear well in advance of the notorious banner *Pistol*, 1964, and the even more recent cover for *Time* magazine. The awkwardness of the image is as engaging now as it was irritating in 1961. It is deliberately cultivated to evoke a Dick Tracy type of violence rather than to simulate a real situation. The idea of threat, as Lichtenstein envisions it, is a way of arguing against the academic strictures of representation which have survived to this day.

Lichtenstein's imagery is unyielding in its visual impact. Although it seethes with cross references, they are in every way subordinated to the primary function of his work, the embodiment of a purely pictorial imagery. There is little in the way of an overt social message in Lichtenstein's work, unlike that of Oldenburg, in which we recognize an explicit social commentary. Lichtenstein's references are not the powerful indictment of life that we find in Oldenburg but are paraphrases of events, public and private, ultimately turned toward art. Such a position has been responsible for his ability to push his subjects into the realm of "high" art and may explain not only his separation from most of the other Pop artists but clarify the formal affinities that he obviously shares with Noland and Stella.

If the number of drawings that Lichtenstein has produced is relatively limited, we must look to the sketches for the full complement of his achievement in painting, sculpture, enamels, prints, and other projects. For all of their inherent lack of scale and their subordination to the finished work, they are remarkably fresh and engaging. Most of them are no larger than a few inches in dimension, but they are unusually complete. Unlike the larger finished drawings which parallel the paintings, these sketches are the basis upon which Lichtenstein structures another work. Lichtenstein's working method is one that he arrived at after some trial and error. He selects motifs from illustrations or other second-hand sources and recomposes these images, small in scale, into equally small sketches, by means of an opaque projector. Once the sketch is enlarged to the scale of the canvas and

transferred, it is subject to a series of changes—of drawing, shape, and color sequences. When he arrives at a satisfying image on the canvas, the Ben Day dots are filled in by his assistants, but Lichtenstein does everything else himself. The preliminary sketch, therefore, plays a crucial role and a comparison with a finished work will indicate how extraordinarily close the relationship is. What the sketches offer is a fascinating glimpse of Lichtenstein's working method and an opportunity to study the completely logical development of his approach. All of the Lichtenstein repertory is revealed in these sketches; the stern frowning men, the anxious tearful women, the Mondrians and the Picassos, the picture-postcard landscapes, art moderne. The sketches document the consistency of Lichtenstein's style and the subordinate, if vital, role that his subjects play in their continuous challenge to form. What we witness, then, in the studies, is evidence of an imagery that is subject to the pressures of multiple discourses and an impressive formal originality, but one that manages nevertheless to survive with its humor intact.

1. " Roy Lichtenstein : An Interview ", *Roy Lichtenstein,* Pasadena Art Museum, April 18-May 28, 1967. Interview by John Coplans, p. 12.
2. Donald Judd, *Arts,* New York, November 1963, v. 38, no. 2, p. 33.

Catalogue of Drawings 1961-1969

In a few of the earliest drawings Lichtenstein applied his dots by rubbing a dog grooming brush over a grid of holes that he had drilled into an aluminum sheet. To achieve a more successful indication of mechanical perfection the artist developed a frottage technique in 1962. By placing a sheet of paper over a window screen, and rubbing the paper with a pencil, the raised portions of the screen emerged as a pattern with tiny dots, as in Keds *(62-1) and* Conversation *(62-4). In* George Washington *(62-14), Lichtenstein used another type of screen, one containing round perforations which, with frottage, appeared as negative forms, while the screen itself became the dominant pattern. In 1963 Lichtenstein placed the perforated screen on top of the paper and rubbed stick touche, a type of lithograph crayon, over the surface. He then pushed the touche through the perforations on to the surface of the paper. This method of application produced the uniform machine-look that the artist was after. From 1963 on both the size and the regularity of the dots increased consistently. In* Reckon Not Sir *(64-1),* Temple of Apollo *(64-6), and* Landscape *(64-8) Lichtenstein introduced a double screen in some areas achieving a dense pattern of dots to contrast with those sections containing only a single layer of dots.*

Lichtenstein brings to all of his drawings the meticulous treatment that is apparent in all of his work. In addition to reflecting a proclivity on his part for this type of finish, it undoubtedly expresses the artist's wish to simulate not only the mechanical perfection but the anonymity of the mass media.

61–1
AIRPLANE *(1961)*

Ink, 19¾ × 21⅝ in.
Provenance: Leo Castelli Gallery, New York
Collection Mr. and Mrs. Michael Sonnabend, Paris

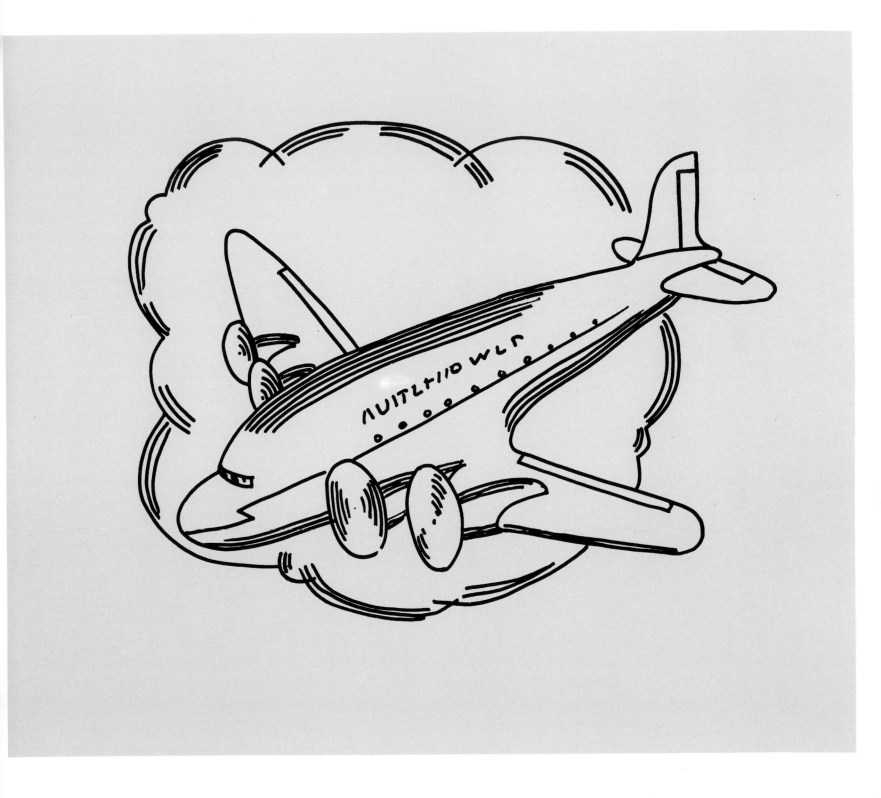

61–2
KNOCK, KNOCK *(1961)*

Ink, 20¼×19¾ in.
Provenance: Leo Castelli Gallery, New York
Collection Mr. and Mrs. Michael Sonnabend, Paris

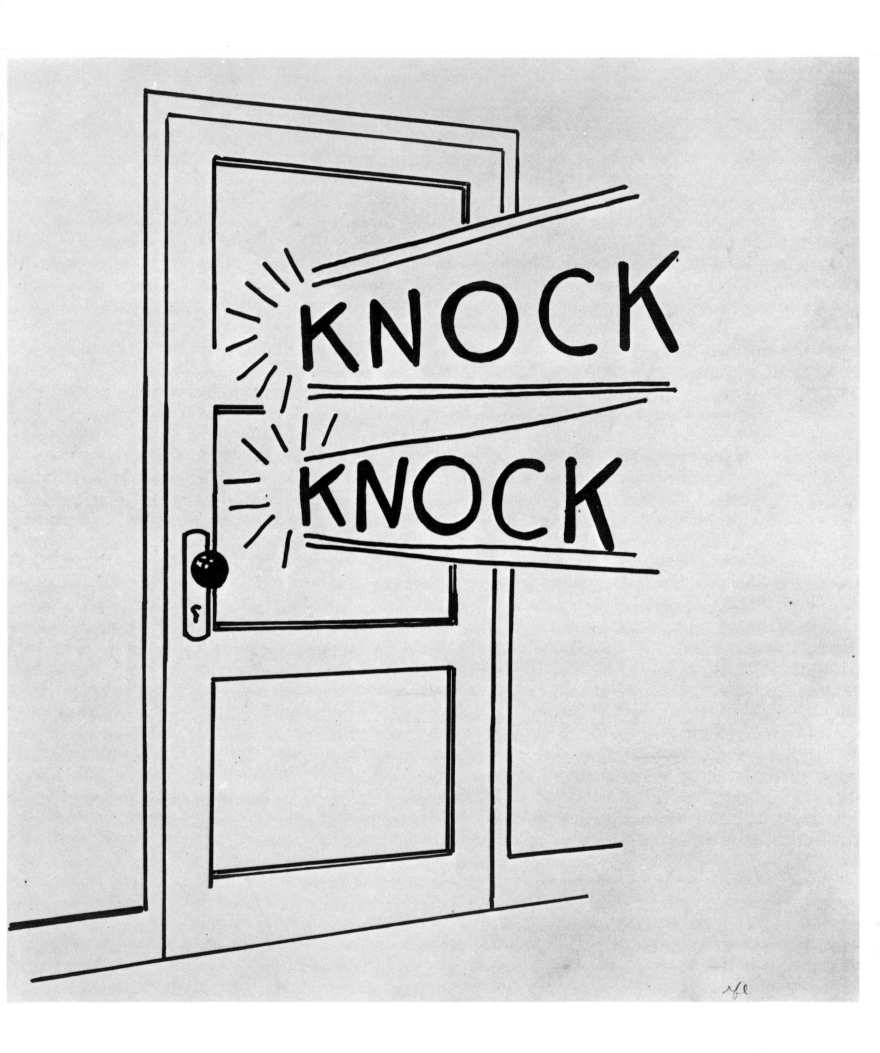

61–3
COUCH *(1961)*

Ink, 19¾×23¼ in.
Provenance: Leo Castelli Gallery, New York
Collection Mr. and Mrs. Michael Sonnabend, Paris

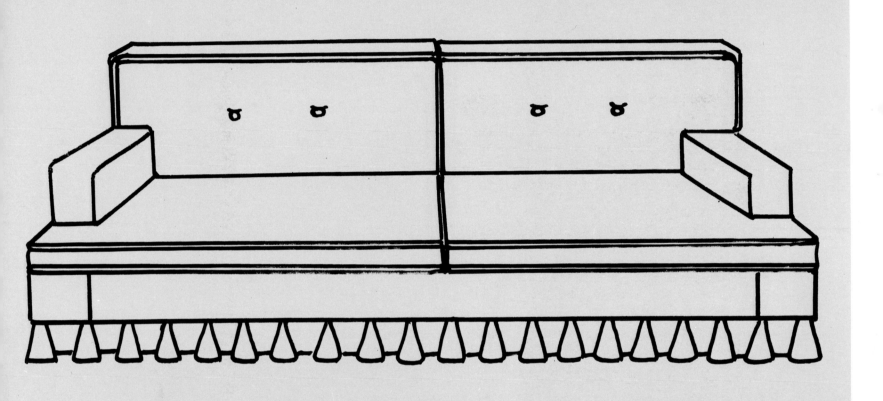

61–4
PIANO *(1961)*

Ink, 14⅞×15¾ in.
Private collection, New York

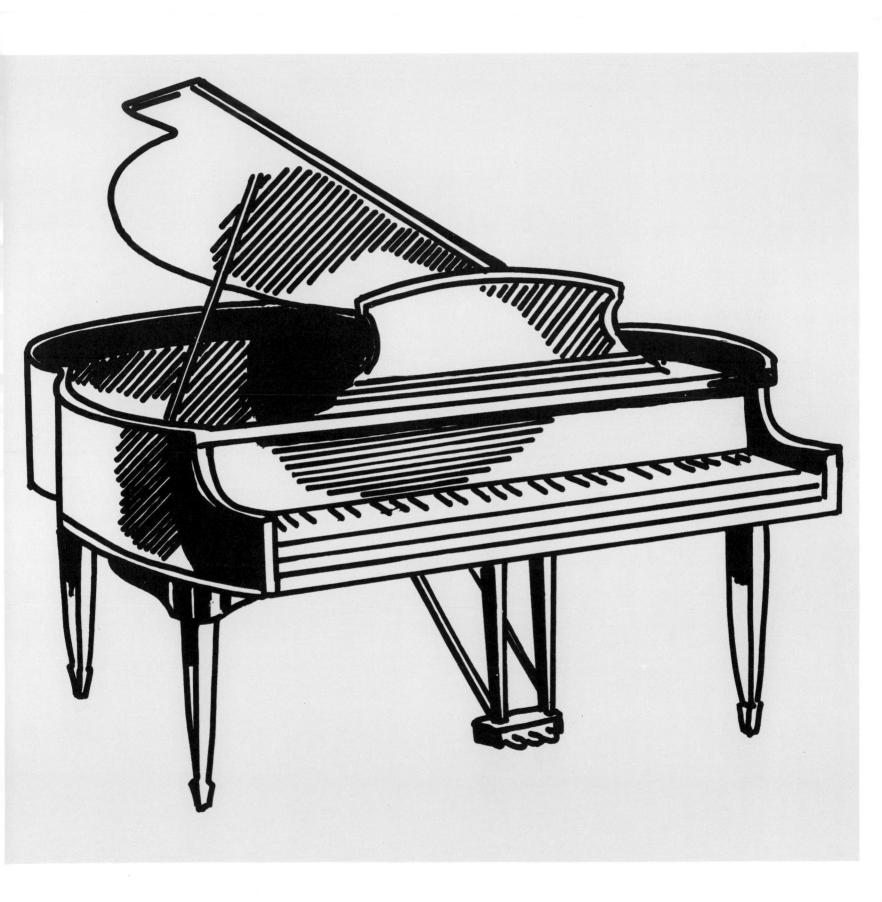

61–5
GIRL WITH ACCORDIAN *(1961)*

Ink, 20½×18⅞ in.
Provenance: Leo Castelli Gallery, New York
Collection Mr. and Mrs. Michael Sonnabend, Paris

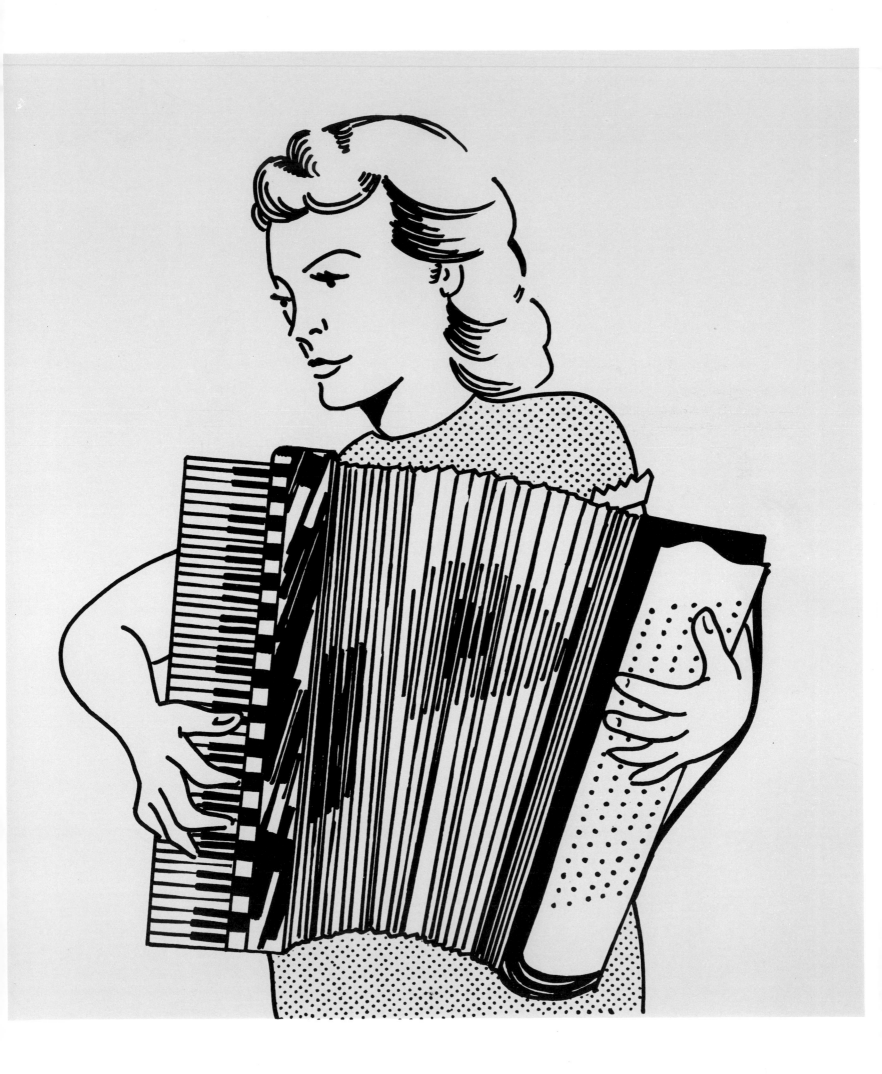

61–6
MAN WITH COAT *(1961)*

Ink, 20½×19¾ in.
Provenance: Leo Castelli Gallery, New York
Collection Mr. and Mrs. Michael Sonnabend, Paris

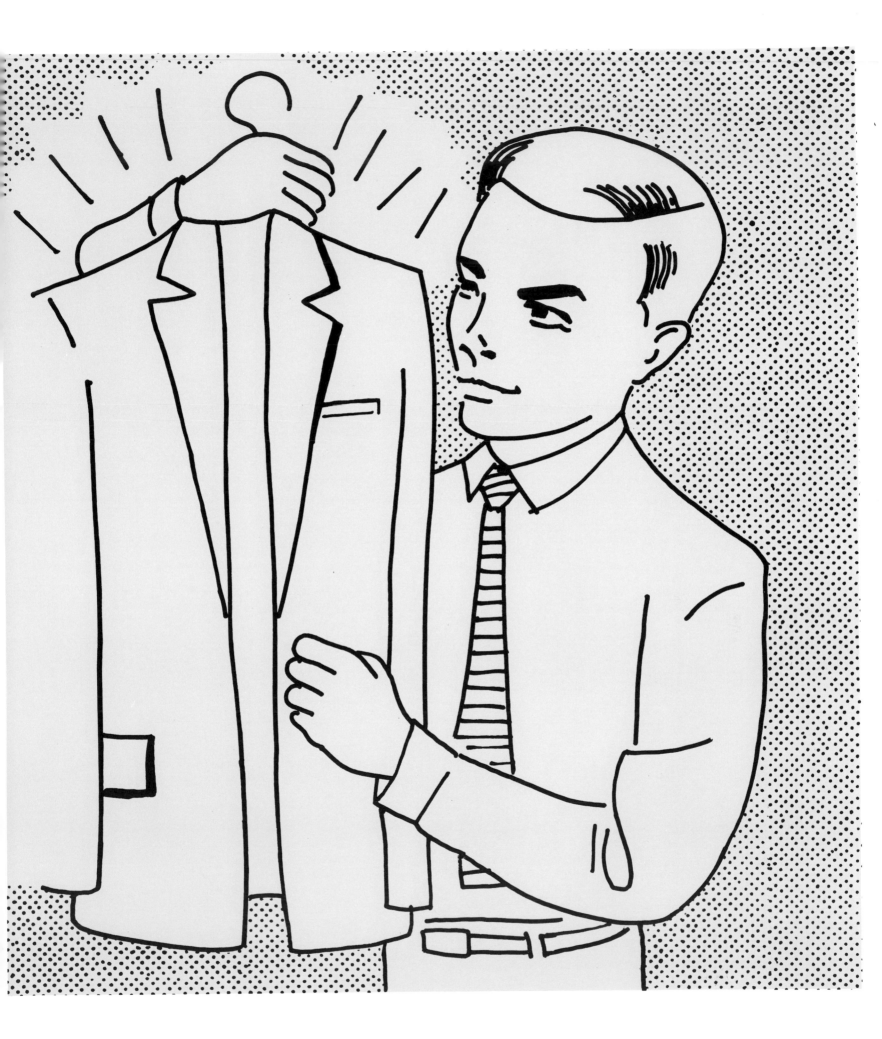

61–7
STEP ON CAN WITH LEG (Closed) *(1961)*

Ink, 23¼×19⅞ in.
Provenance: Leo Castelli Gallery, New York
Collection Mr. and Mrs. Michael Sonnabend, Paris

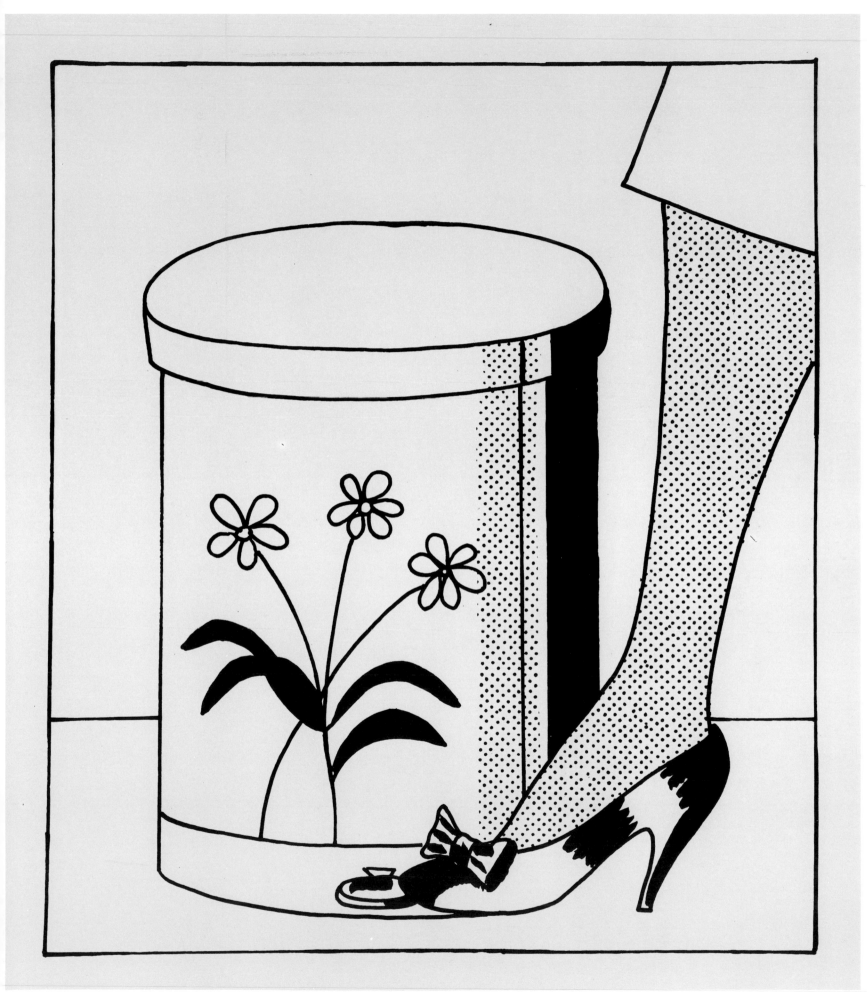

61–8
STEP ON CAN WITH LEG (Open) *(1961)*

Ink, 23¼×19⅞ in.
Provenance: Leo Castelli Gallery, New York
Collection Mr. and Mrs. Michael Sonnabend, Paris

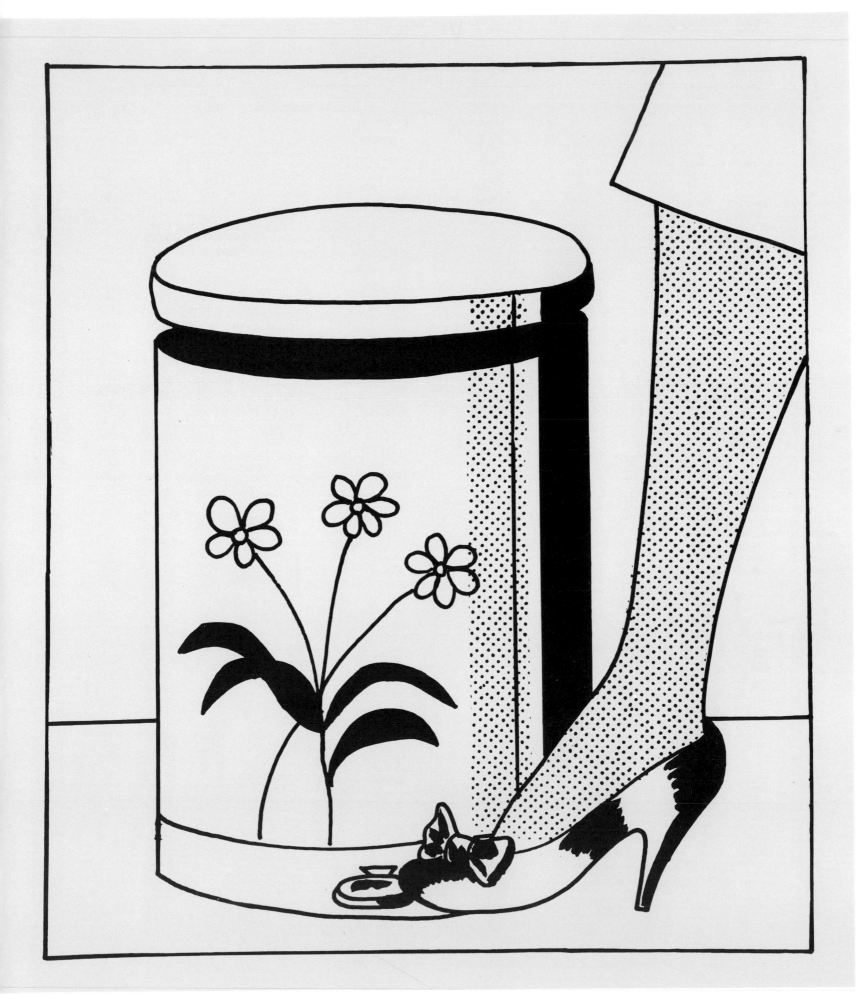

61–9

HAND LOADING GUN *(1961)*

Ink, 22½×30 in. sheet
Collection Stanley Landsman, New York

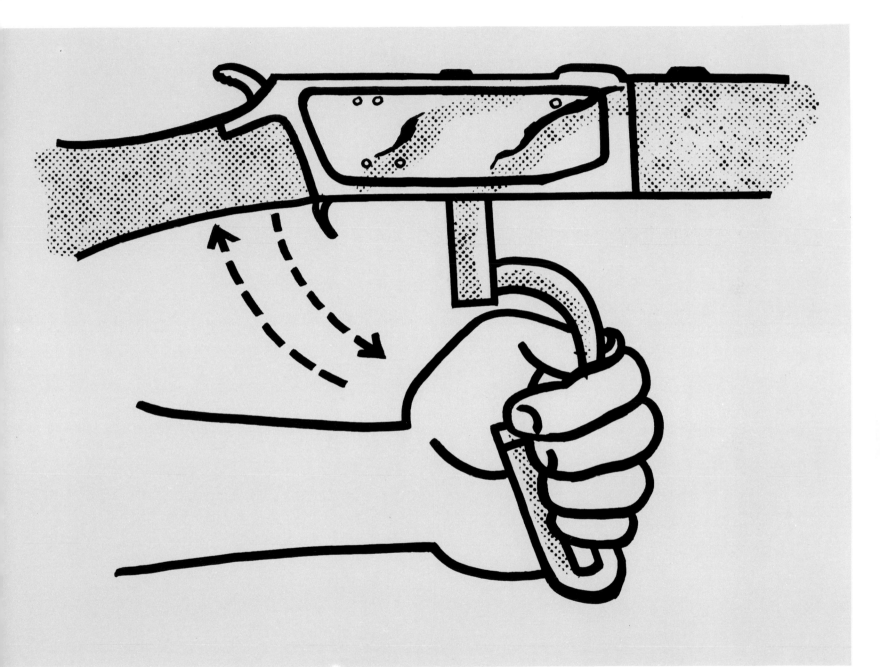

61–10
HAND LOADING GUN *(1961)*

Ink, 25½×40 in.
Collection Jesse Nevada Karp, New York

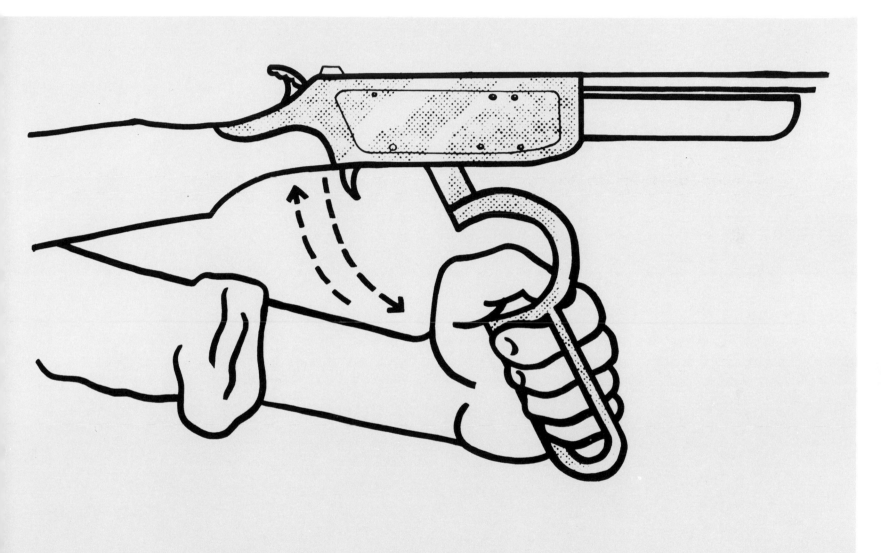

61–11
FINGER POINTING *(1961)*

Ink, 30×22½ in.
Collection Kiki Kogelnick, New York

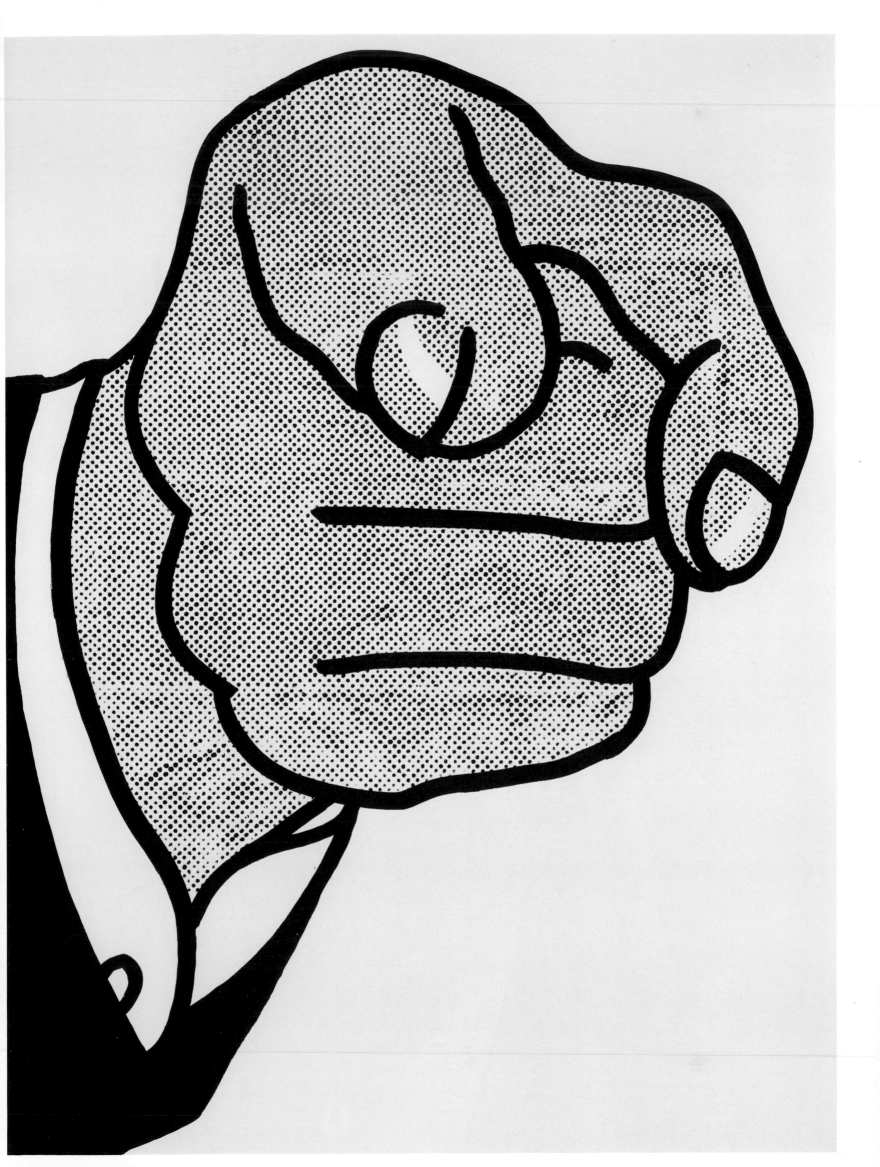

61–12
MAIL ORDER FOOT *(1961)*

Ink, 17⅞×27⅛ in.
Provenance: Leo Castelli Gallery, New York
Collection Mr. and Mrs. Michael Sonnabend, Paris
Exhibited: Stedelijk, 1967, No. 66, illus.
 Tate, 1968, No. 65, illus.
 Kunsthalle Bern, 1968, No. 59, illus.
 Hannover, 1968, No. 59, illus.

62–1
KEDS *(1962)*

Pencil and frottage, 22½×16½ in.
Provenance: Leo Castelli Gallery, New York
Collection Arthur C. Carr, New York
Exhibited: The Solomon R. Guggenheim Museum, New York,
 Contemporary American Drawings, 1964

62–2
FOOT MEDICATION *(1962)*

Pencil and frottage, 18½×18¾ in.
Provenance: Leo Castelli Gallery, New York
Collection Dr. James Holderbaum, Northhampton, Massachusetts
Exhibited: Leo Castelli Gallery, New York, *Drawings*, 1963
 Rose Art Museum, Brandeis University, Waltham, Massachusetts,
 Recent American Drawings, 1964
 Wadsworth Atheneum, Hartford, *Black, White and Grey*, 1964
 Guggenheim, 1969, No. 12

62–3
NO-NOX *(1962)*

Pencil, 25½×19 in.
Provenance: Leo Castelli Gallery, New York
Collection Gene Swenson, New York
Exhibited: Rose Art Museum, Brandeis University, Waltham, Massachusetts,
 Recent American Drawings, 1964

62–4
CONVERSATION *(1962)*

Pencil and frottage, 12½×10½ in.
Provenance: Leo Castelli Gallery, New York; Noah Goldowsky, James Holderbaum
Collection Mr. and Mrs. George L. Sturman, Chicago
Exhibited: Charlotte Crosby Kemper Gallery, Kansas City Art Institute, 1965
 Art Gallery, University of Notre Dame, Notre Dame, Indiana, 1966

62–5
ZIPPER *(1962)*

Pencil, 22½×19¾ in. sheet
Collection Mr. and Mrs. Leo Castelli, New York
Exhibited: Leo Castelli Gallery, New York, *Drawings*, 1963
 Cleveland Museum of Art, 1966
 Pasadena/Minneapolis, 1967, No. 56
 Stedelijk, 1967, No. 64
 Tate, 1968, No. 63
 Kunsthalle Bern, 1968, No. 57
 Hannover, 1968, No. 57
 Guggenheim, 1969, No. 74

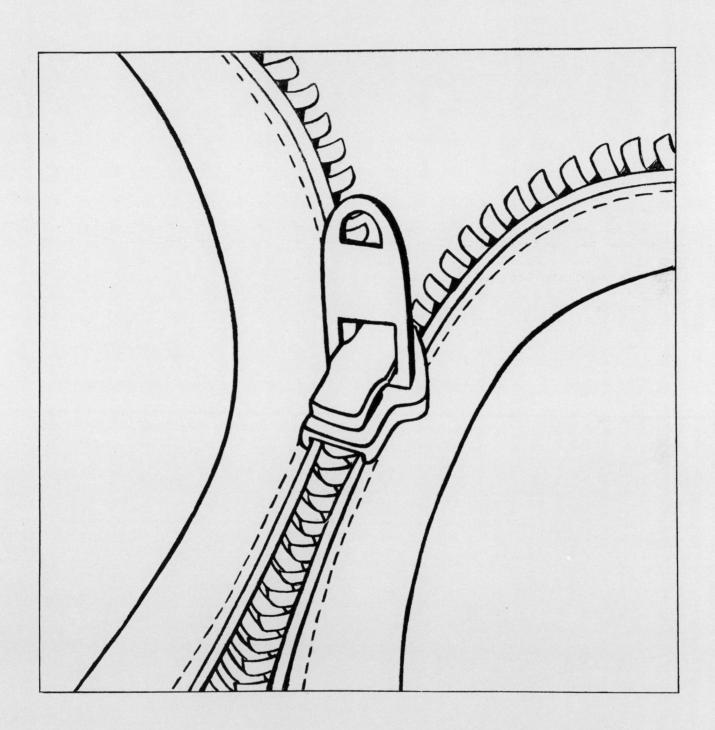

62–6
LIKE NEW *(1962)*

Pencil, 16½×22½ in.
Provenance: Leo Castelli Gallery, New York
Collection Cy Twombly, Rome

62–7
10 ₵ *(1962)*

Ink, 22½×30 in.
Provenance: Leo Castelli Gallery, New York
Collection Cy Twombly, Rome

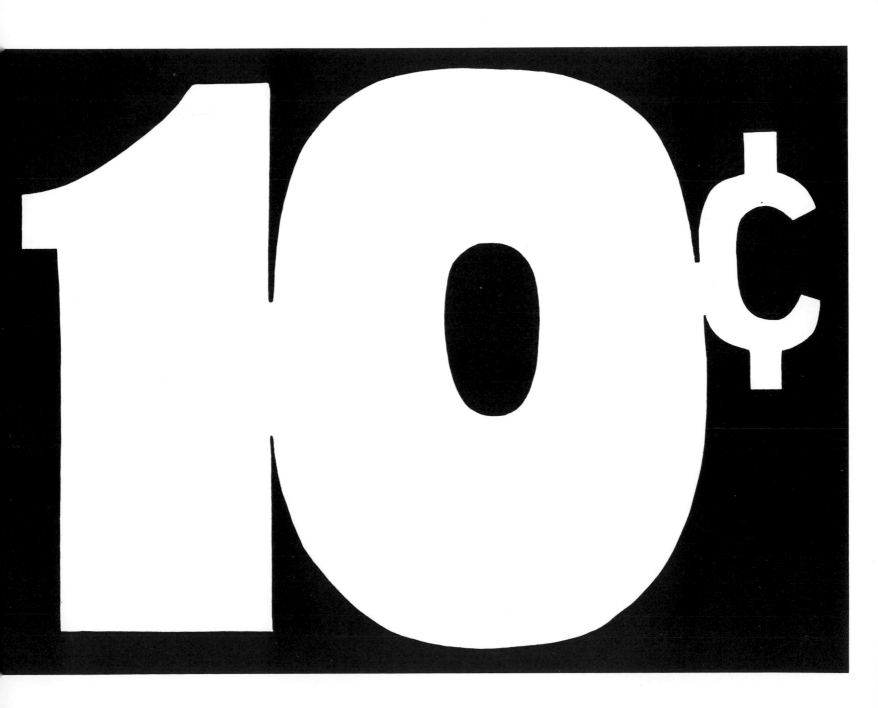

62–8
TURKEY *(1962)*

Pencil and frottage, 12½×22½ in.

Provenance: Leo Castelli Gallery, New York; Dwan Gallery, Los Angeles; Ben Birillo, New York

Collection unknown

Exhibited: Leo Castelli Gallery, New York, *Drawings*, 1962

Dayton Art Institute, Dayton, Ohio, *International Selection*, 1963

Contemporary Art Center, Fort Worth, Texas, 1965,

Master Drawings from Degas to Lichtenstein, No. 11, illus.

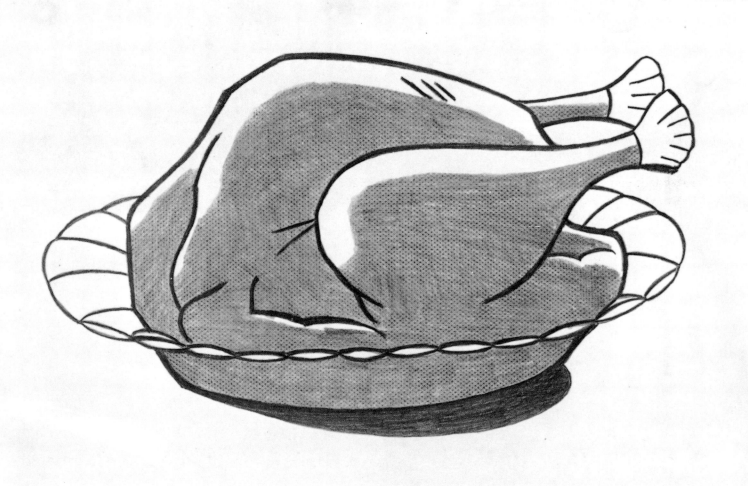

62–9
BAKED POTATO *(1962)*

Ink and tempera, 22½×30 in.
Provenance: Leo Castelli Gallery, New York
Collection Dayton Art Institute, Dayton, Ohio
Exhibited: University of Dayton, Dayton, Ohio, 1964,
 Grand Rapids Art Museum, Grand Rapids, Michigan, *20th Century American
 Paintings,* 1967

62–10 Not reproduced
BAKED POTATO *(1962)*

Ink and tempera, 21½×30 in.
Provenance: Leo Castelli Gallery, New York
Collection Karl Ströher, Darmstadt, West Germany

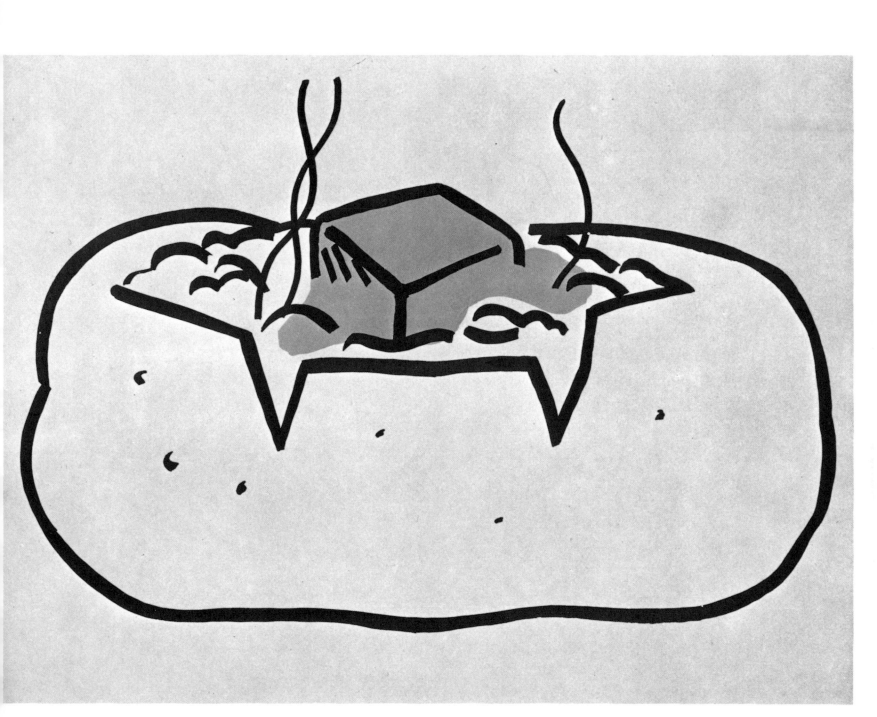

62–11
CUP OF COFFEE *(1962)*

Pencil, 22½×17½ in.
Collection Mr. and Mrs. Leo Castelli, New York
Exhibited: Hathorn Gallery, Skidmore College, Saratoga Springs, New York,
 Contemporary American Drawings, 1962
 University of Colorado, Boulder, Colorado, 1967,
 Radcliffe College, Cambridge, Massachusetts, 1968
 Guggenheim, 1969, No. 70

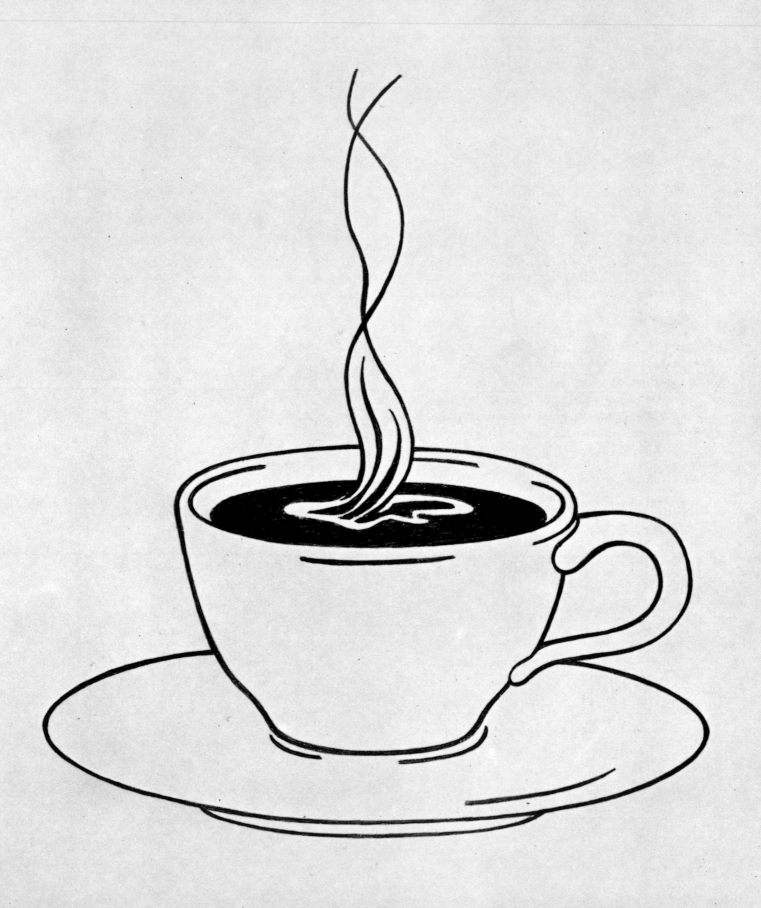

62–12
JET PILOT *(1962)*

Pencil and frottage, 22×23⅛ in. sheet
Provenance: Leo Castelli Gallery, New York
Collection Richard Brown Baker, New York
Exhibited: University of Rhode Island, Kingston, Rhode Island, *Watercolors, Drawings and Collages from the Collection of Richard Brown Baker,* 1964, No. 68
 The Aldrich Museum of Contemporary Art, Ridgefield, Connecticut, *Art of the 50's and 60's: Selections from the Richard Brown Baker Collection,* 1965, No. 61
 University of South Florida, Tampa, Florida, *Mid-Twentieth Century Drawings and Collages: A Selection from the Collection of Richard Brown Baker,* 1967, No. 51
 Guggenheim, 1969, No. 73, illus.

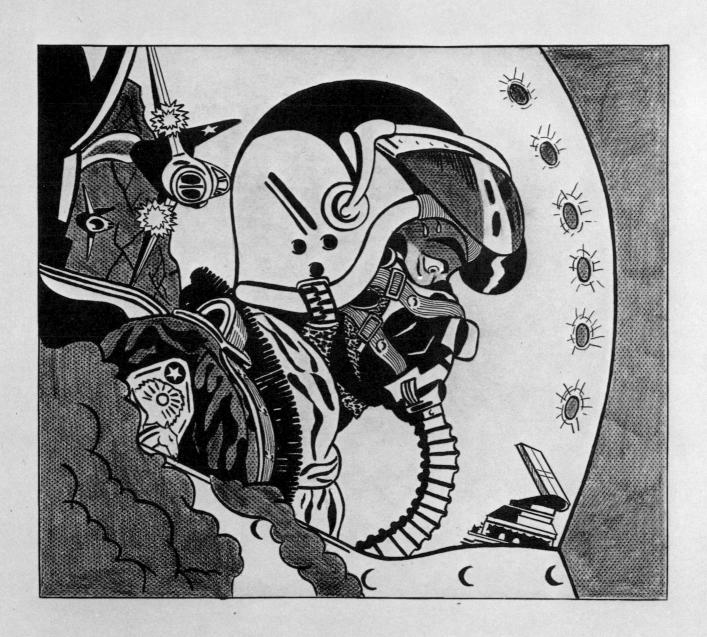

62–13
BRATATAT *(1962)*

Pencil and frottage, 20½×16¼ in. sheet
Provenance: Leo Castelli Gallery, New York
Collection Minneapolis Institute of Art, Ethel Morrison Van Derlio Fund, 64.75
Exhibited: American Federation of the Arts traveling exhibition *Wit and Whimsey,*
 1962–1963 Iowa State University, Ames, Iowa, 1964
 Cleveland Museum of Art, 1966
 Guggenheim, 1969, No. 67

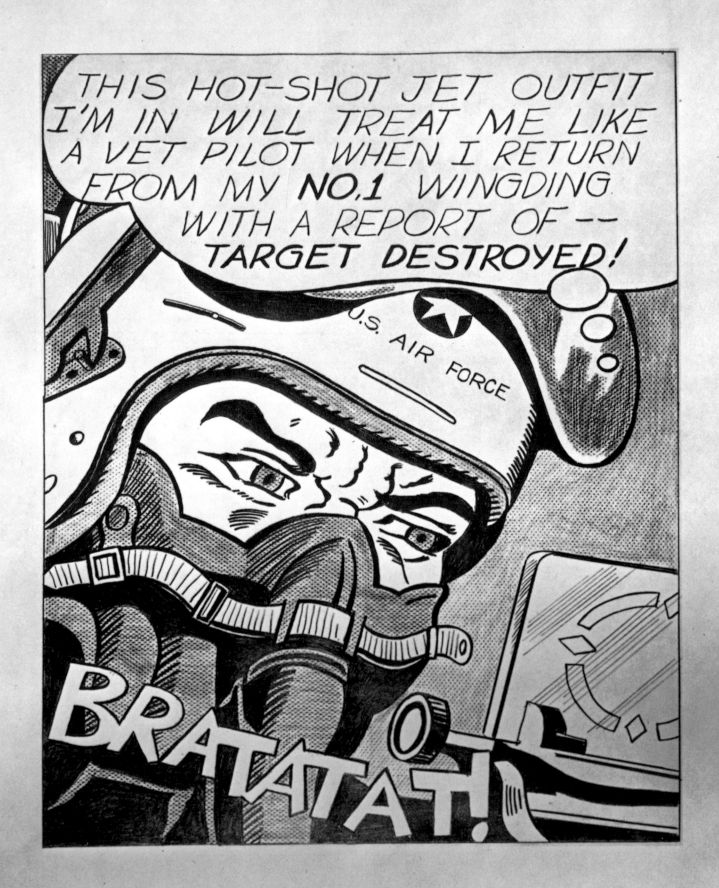

62–14
GEORGE WASHINGTON *(1962)*

Pencil and frottage, 18¾×14½ in.
Provenance: Leo Castelli Gallery, New York; Mi Chou Gallery, New York
Collection Mr. and Mrs. Ned Owyang, New York
Exhibited: Leo Castelli Gallery, New York, *Drawings,* 1963
 Mi Chou Gallery, New York, *Art of Two Ages,* 1962
 Cleveland Museum of Art, 1966
 Pasadena/Minneapolis, 1967, No. 55
 Stedelijk, 1967, No. 65
 Tate, 1968, No. 64
 Kunsthalle Bern, 1968, No. 58
 Hannover, 1968, No. 58
 Guggenheim, 1969, No. 72

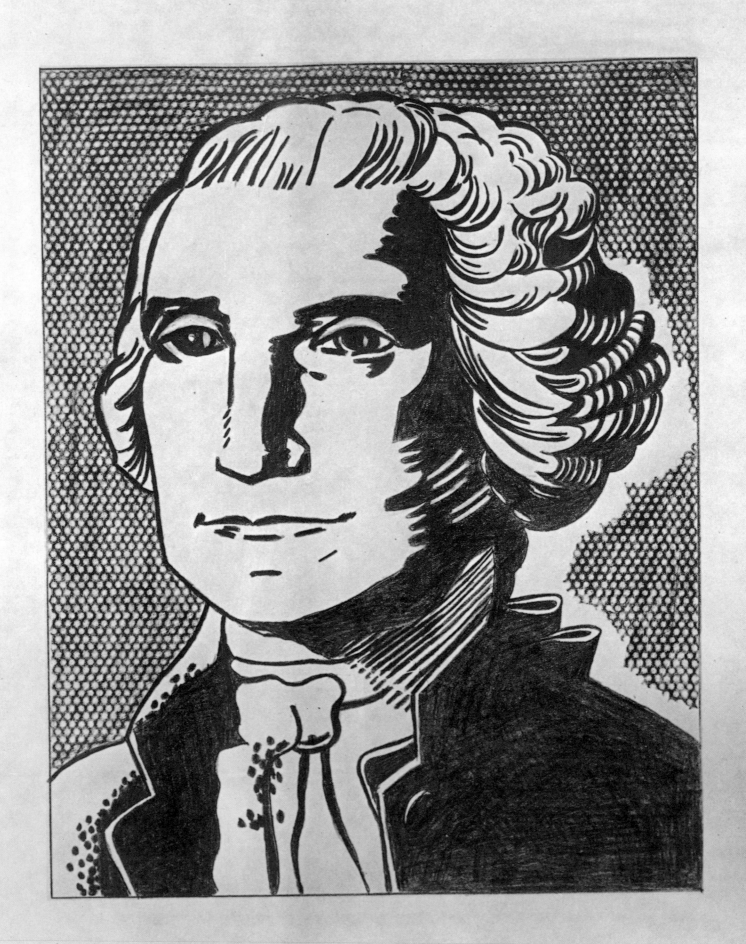

63–1
WOMAN IN BATH *(1963)*

Pencil and touche, 22½ × 22½ in.
Provenance: Leo Castelli Gallery, New York; Mr. and Mrs. A. Berliner
Collection John W. Weber, New York
Exhibited: Leo Castelli Gallery, New York, *Drawings,* 1963
 Guggenheim, 1969, No. 79

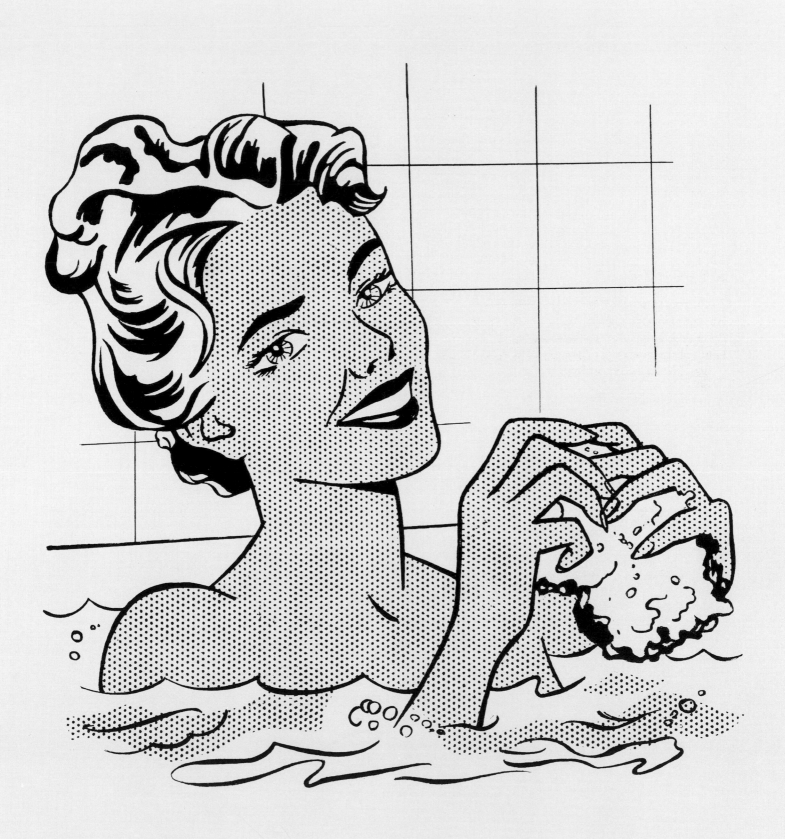

63–2
THE COLLARS *(1963)*

Pencil and touche, 30×17½ in.
Provenance: Leo Castelli Gallery, New York; Waddington Galleries, London
Collection Victoria and Albert Museum, London
Exhibited: University of Michigan, Ann Arbor, Michigan, 1963,
 Victoria and Albert Museum Traveling Exhibition, *Pop Graphics,* 1966

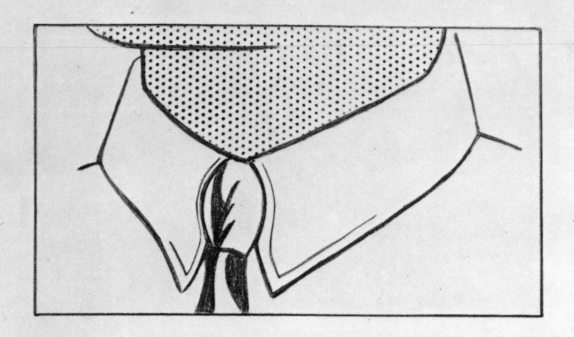

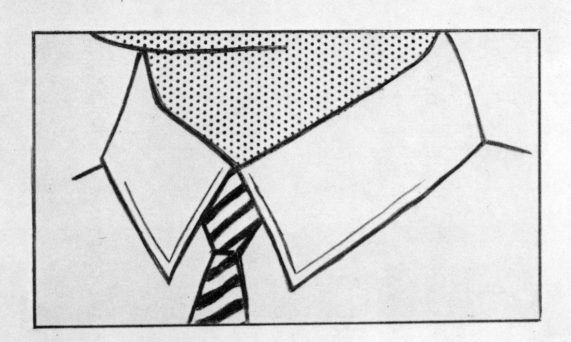

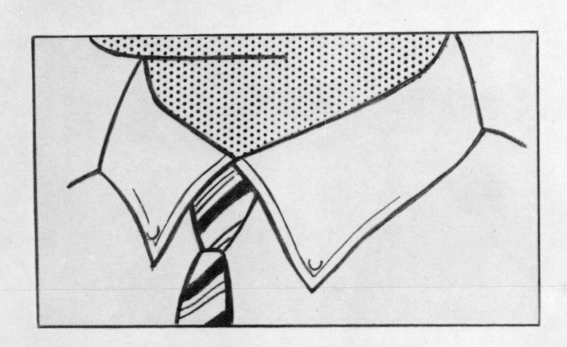

63–3
BREAD AND JAM *(1963)*

Pencil and touche, 18⅝×22⅞ in.
Provenance: Leo Castelli Gallery, New York
Collection Mr. and Mrs. Michael Sonnabend, Paris
Exhibited: Stedelijk, 1967, No. 67, illus.
 Tate, 1968, No. 66
 Kunsthalle Bern, 1968, No. 60, illus.
 Hannover, No. 60, illus.

63–4 *Not reproduced*
CHOP *(1963)*

Pencil and touche, 24×16 in.
Provenance: Leo Castelli Gallery, New York; Ileana Sonnabend, Paris; Robert Fraser, London
Private collection, Germany

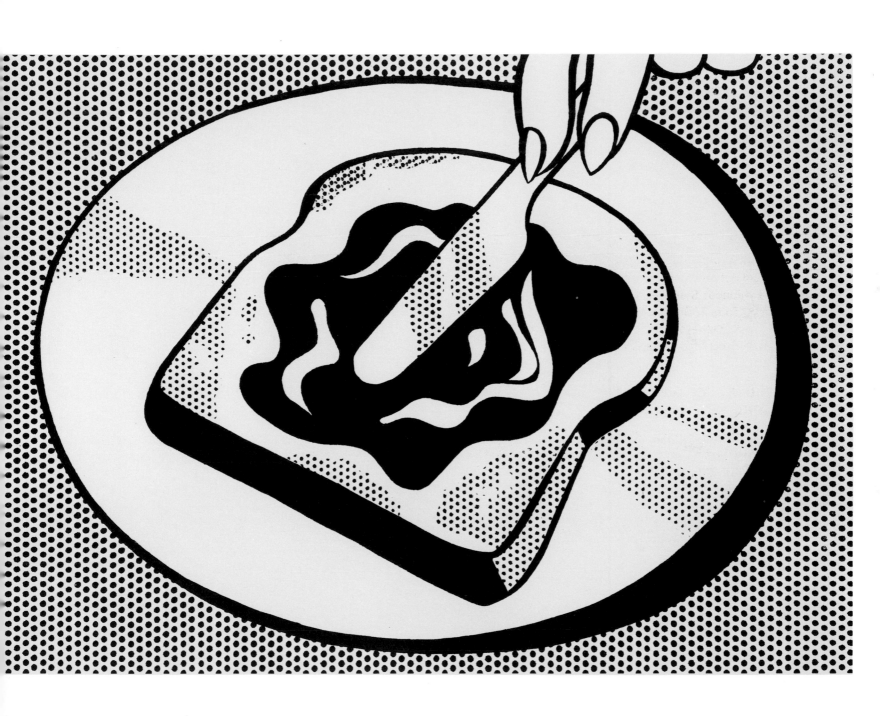

63–5
I KNOW HOW YOU MUST FEEL, BRAD! *(1963)*

Pencil and touche, 30×22½ in.
Provenance: Leo Castelli Gallery, New York
Collection Mrs. Vera List, New York
Exhibited: Leo Castelli Gallery, New York, *Drawings,* 1963
 Pasadena/Minneapolis, 1967, No. 60
 Stedelijk, 1967, No. 68
 Tate, 1968, No. 67
 Kunsthalle Bern, 1968, No. 61
 Hannover, 1968, No. 61
 Guggenheim:, 1969, No. 76, illus.

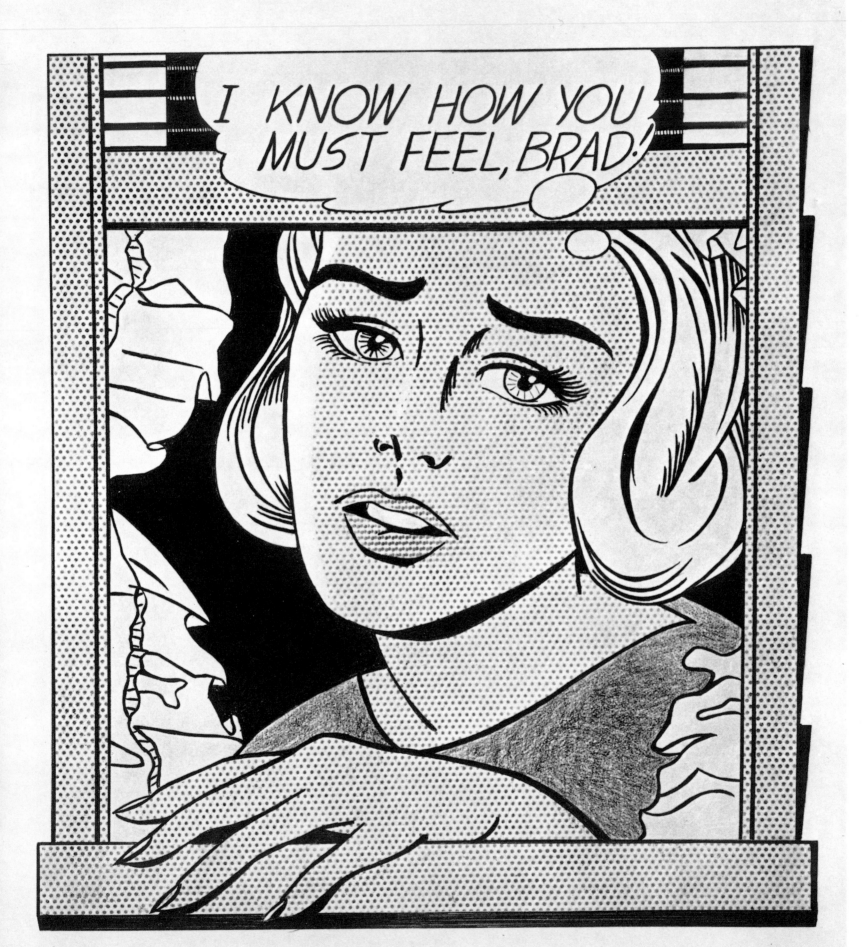

63–6
CRYING GIRL (Design for lithograph) *(1963)*

Ink, 19½×25½ in.
Collection Mr. and Mrs. Marcus Ratliff, New York

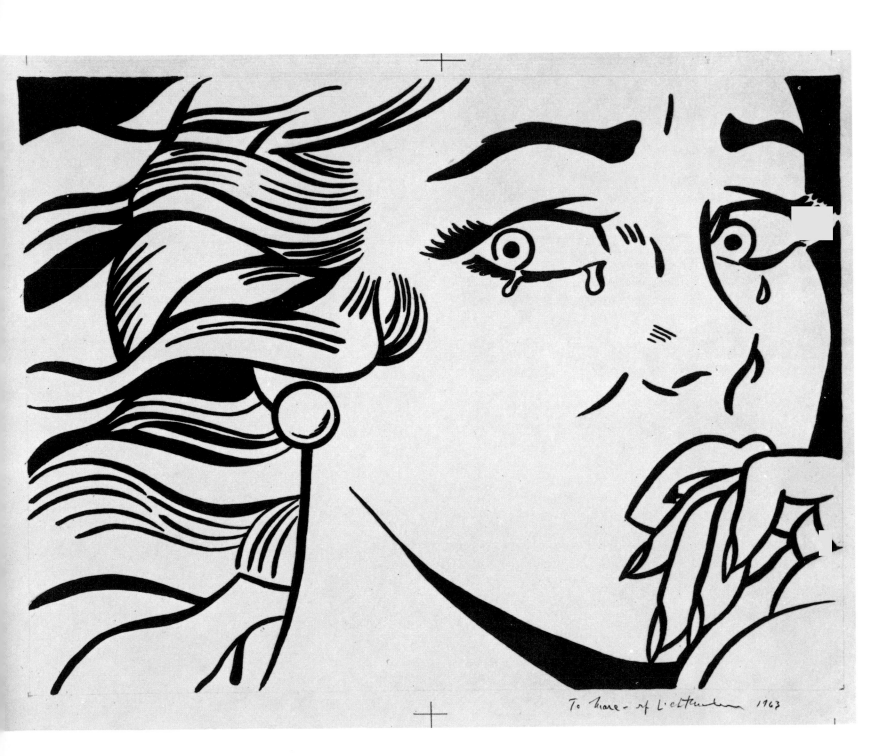

To Marc — rf Lichtenstein 1963

63–7
KISS II *(1963)*

Pencil and touche, 18½×20 in.
Provenance: Leo Castelli Gallery, New York
Collection Mr. and Mrs. Michael Sonnabend, Paris
Exhibited: Stedelijk, 1967, No .72
 Tate, 1968, No. 71
 Kunsthalle Bern, 1968, No. 65
 Hannover, 1968, No. 65

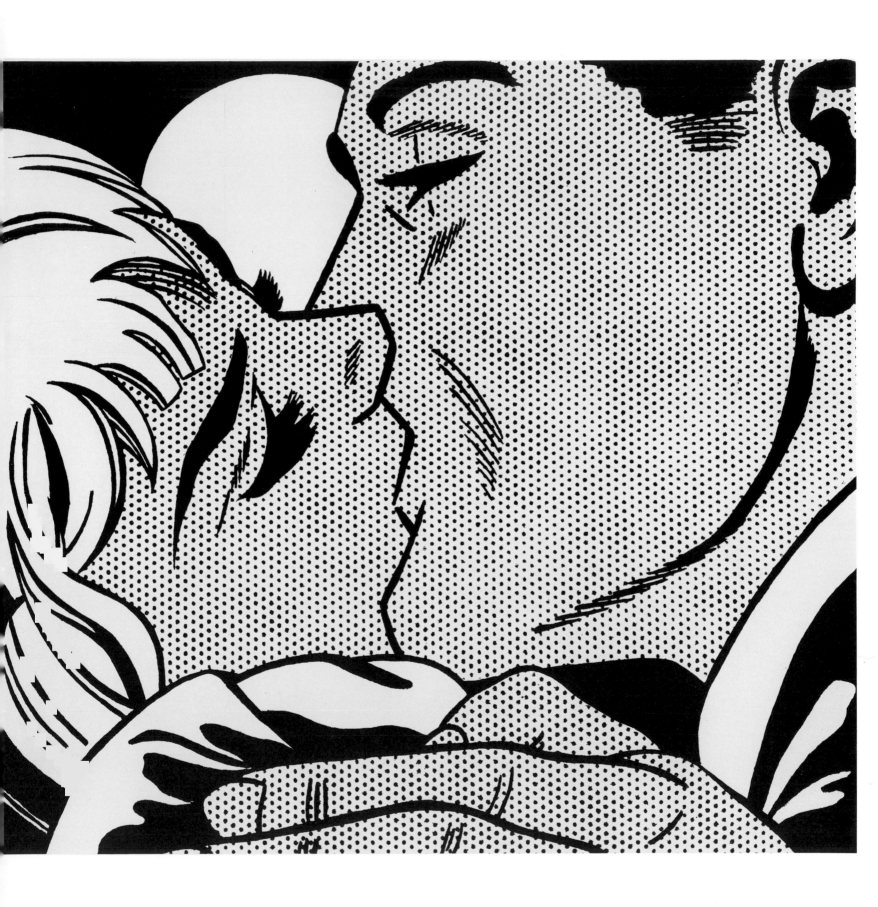

63–8
SHOCK-PROOF *(1963)*

Pencil and touche, 30×22½ in.
Collection Mr. and Mrs. Leo Castelli, New York
Exhibited: Leo Castelli Gallery, New York, *Drawings,* 1963
 Washington Gallery of Modern Art, Washington D.C., 1963
 Wadsworth Atheneum, Hartford, Connecticut, *Black, White and Grey,* 1964
 The Solomon R. Guggenheim Museum, New York, *Contemporary American Drawings,* 1964
 Akron Art Institute, Akron, Ohio, 1966
 New York University, New York City, 1966
 Pasadena/Minneapolis, 1967, No. 57
 Stedelijk, 1967, No. 69
 Tate, 1968, No. 68
 Kunsthalle Bern, 1968, No. 62
 Hannover, 1968, No. 62
 Guggenheim, 1969, No. 77

63–9
BALL OF TWINE *(1963)*

Pencil and touche, 15×12½ in.
Collection Mr. and Mrs. Leo Castelli, New York
Exhibited: Philadelphia Museum, 1965
 Pasadena/Minneapolis, 1967, No. 58
 Stedelijk, 1968, No. 71, illus.
 Tate, 1968, No. 70, illus.
 Kunsthalle Bern, 1968, No. 64, illus.
 Hannover, 1968, No. 64, illus.
 Guggenheim, 1969, No. 75

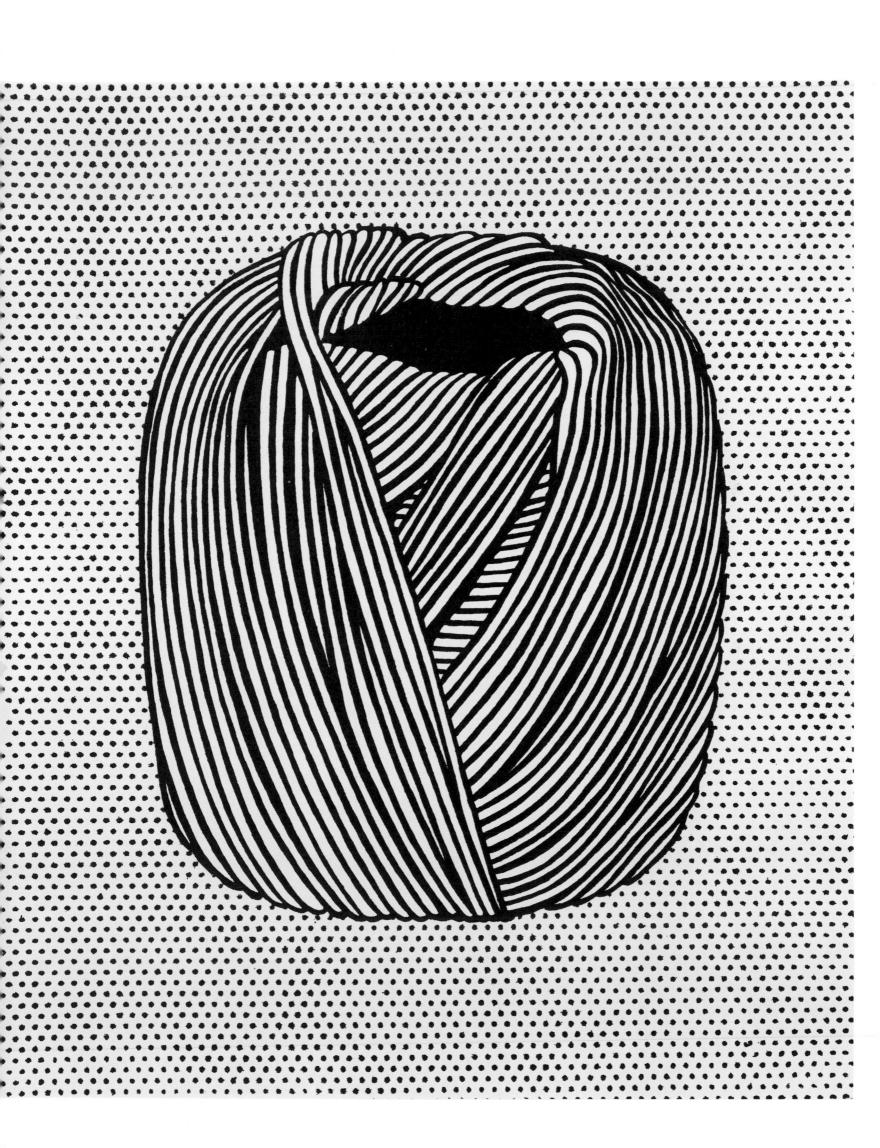

63–10
THREE BIRDS *(1963)*

Pencil and touche, 13¼ × 20 in.
Collection Jean Christophe Castelli, New York
Exhibited: Philadelphia Museum, 1965
 Pasadena/Minneapolis, 1967, No. 59
 Stedelijk, 1967, No. 70, illus.
 Tate, 1968, No. 69, illus.
 Kunsthalle Bern, 1968, No. 63, illus.
 Hannover, 1968, No. 63, illus.
 Guggenheim, 1969, No. 78, illus.

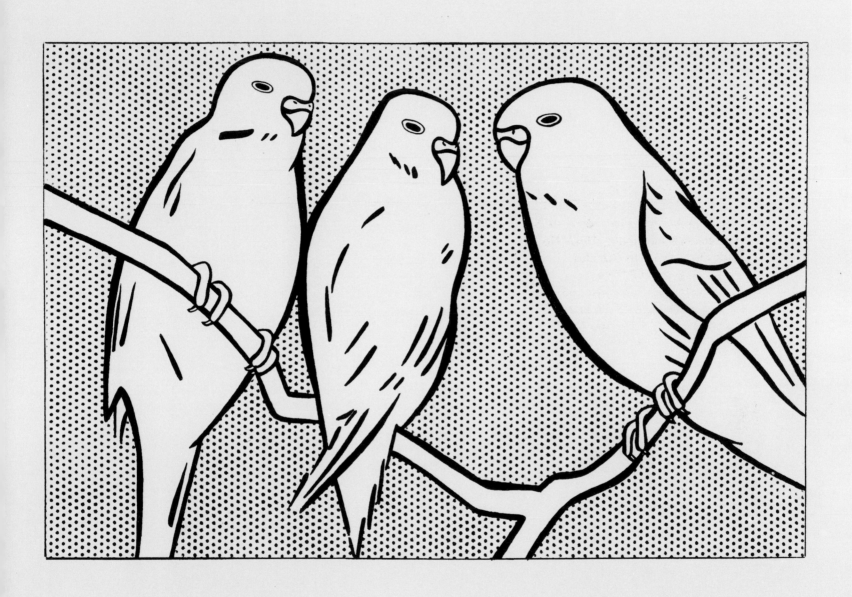

64–1
RECKON NOT SIR! *(1964)*

Pencil and touche, 27½×19¼ in.
Provenance: Leo Castelli Gallery, New York; Museum of Modern Art- Art Lending Service
Collection John Paul Jones, Beverly Hills, California
Exhibited: Cleveland Museum of Art, 1966
 Guggenheim, 1969, No. 80

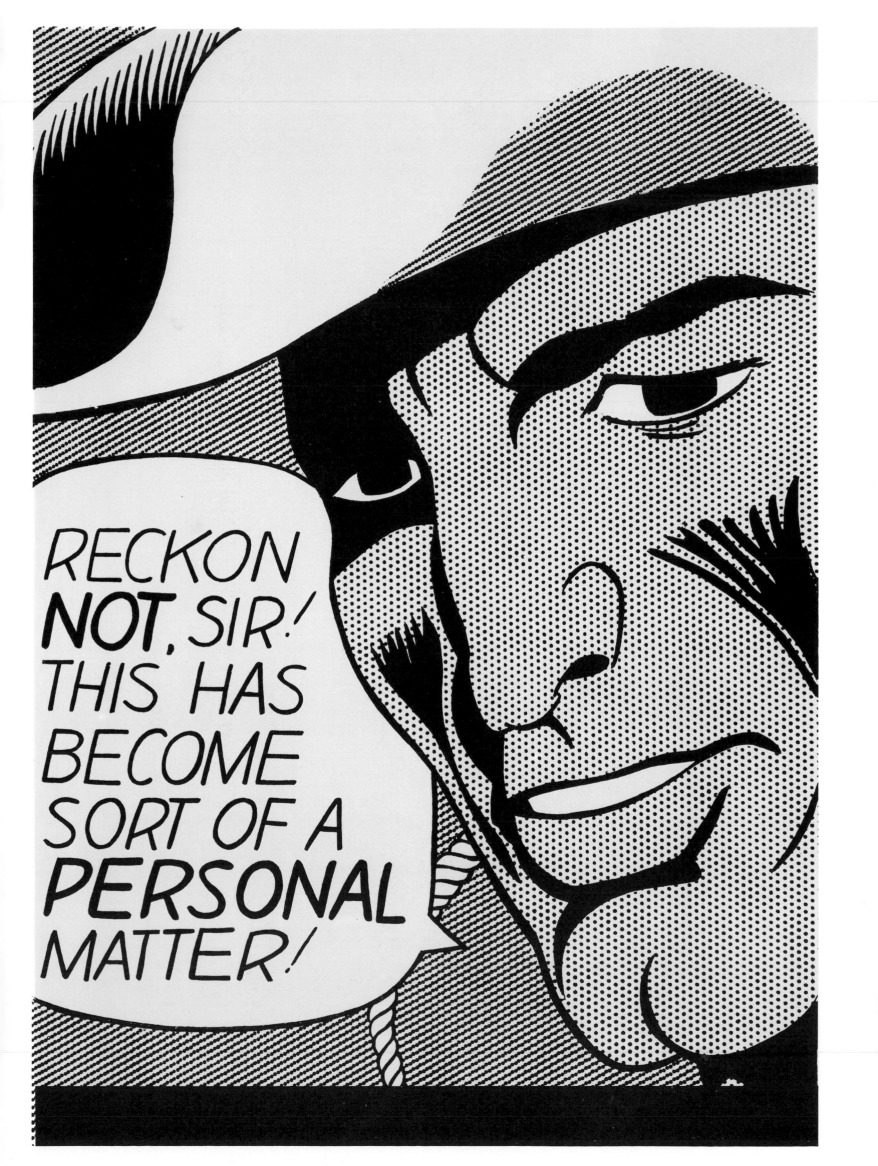

64–2
HIM *(1964)*

Pencil and touche, 22½×17 in.
Provenance: Leo Castelli Gallery, New York; Byron Gallery, New York
Collection Mr. and Mrs. Michael B. Magloff, Los Angeles
Exhibited: Byron Gallery, New York, *100 American Drawings,* 1964

64–3
SANDWICH AND SODA (Design for silkscreen) *(1964)*

Ink, 24×27½ in. sheet
Private collection, New York

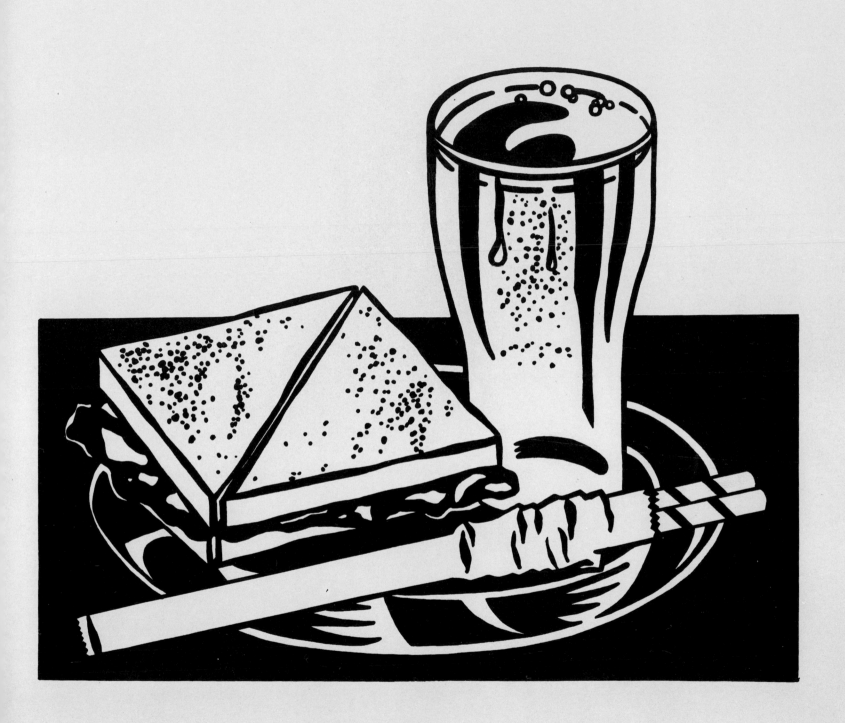

64–4
HOT DOG (Design for enamel) *(1964)*

Ink, 13¾ × 24¼ in. sheet
Private collection, New York

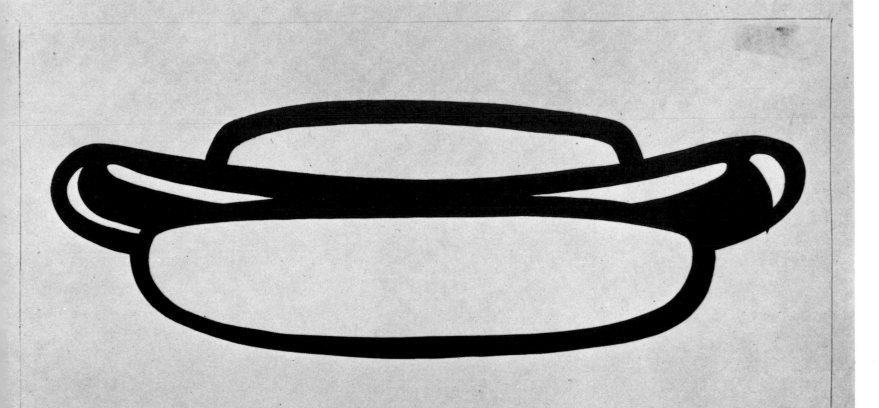

model for enamel R. Lichtenstein 1964

64–5
PISTOL (Design for banner) *(1964)*

Ink, 17⅛×9⅜ in. sheet
Private collection, New York

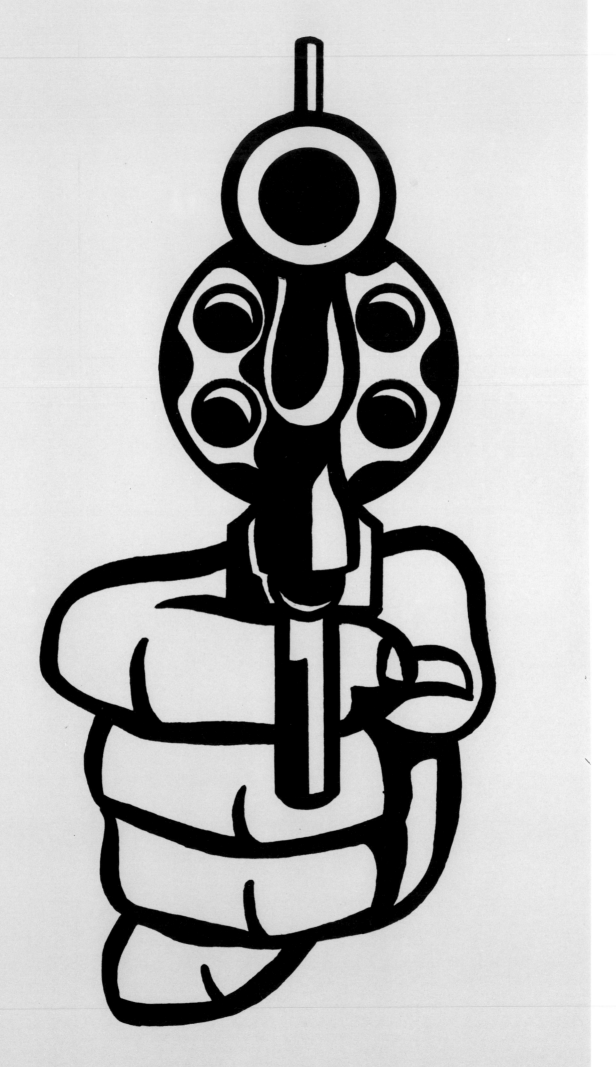

sketch for banner Roy Lichtenstein 1964

64–6
TEMPLE OF APOLLO *(1964)*

Pencil and touche, 22¼×30 in.
Provenance: Leo Castelli Gallery, New York
Collection Jean Yves Mock, London
Exhibited: Tate, 1968, No. 73

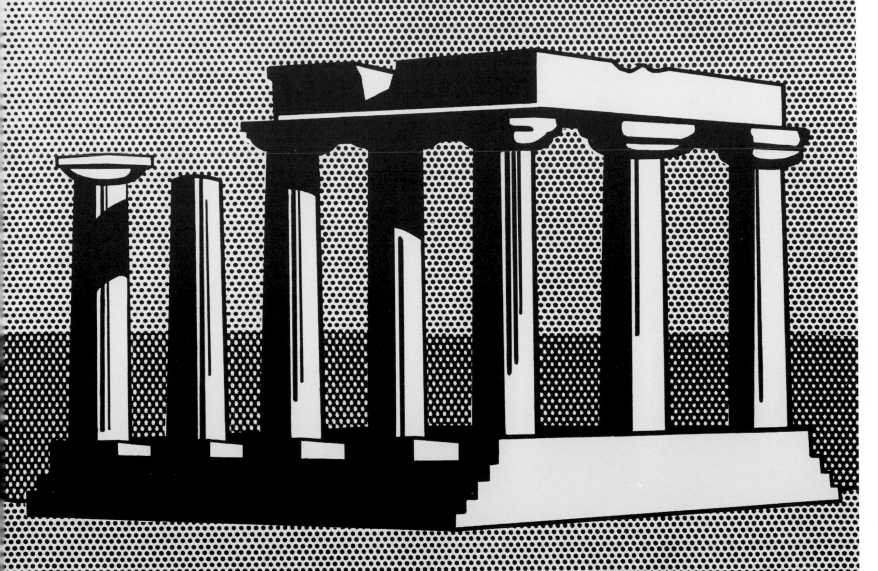

64–7
TEMPLE (Design for lithograph) *(1964)*

Ink, 24×18 in. sheet
Private collection, New York

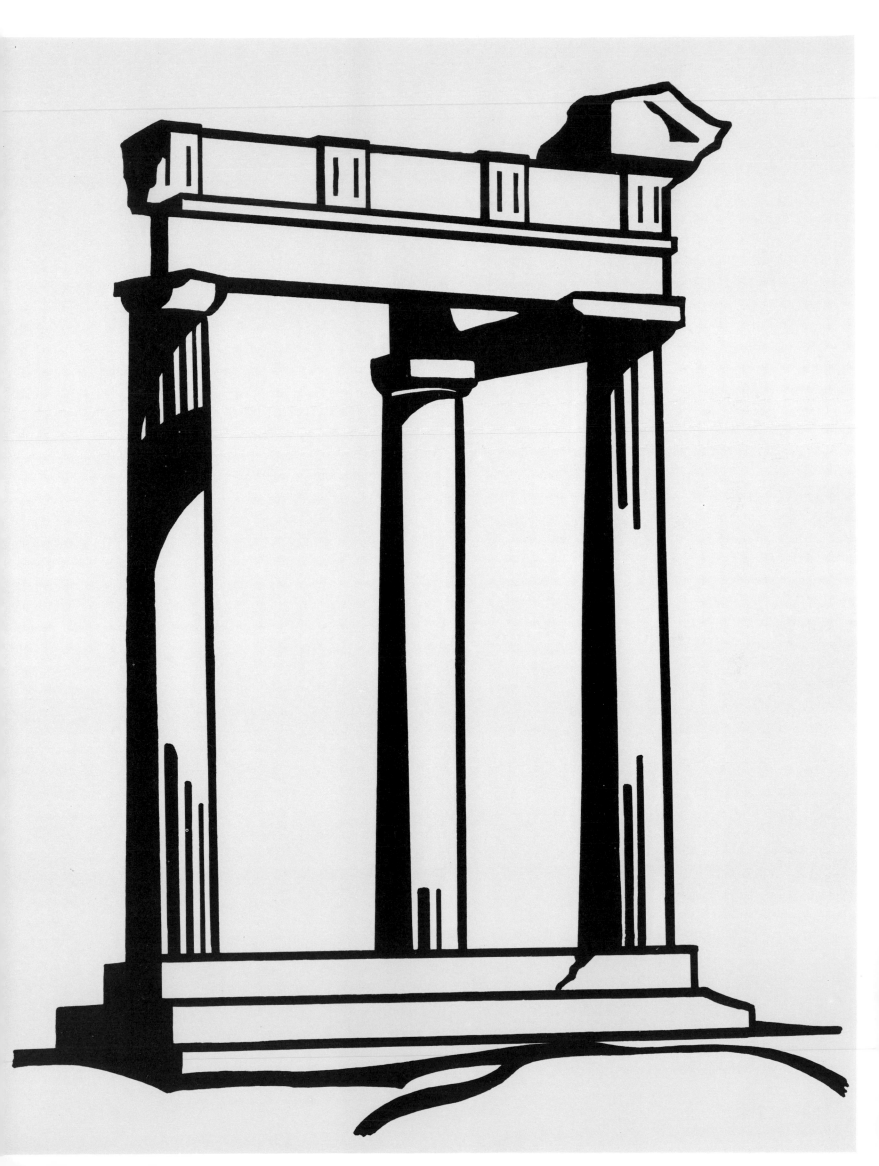

64–8
LANDSCAPE *(1964)*

Pencil and touche, 18×22 in.
Collection Lettie Lou Eisenhauer, New York

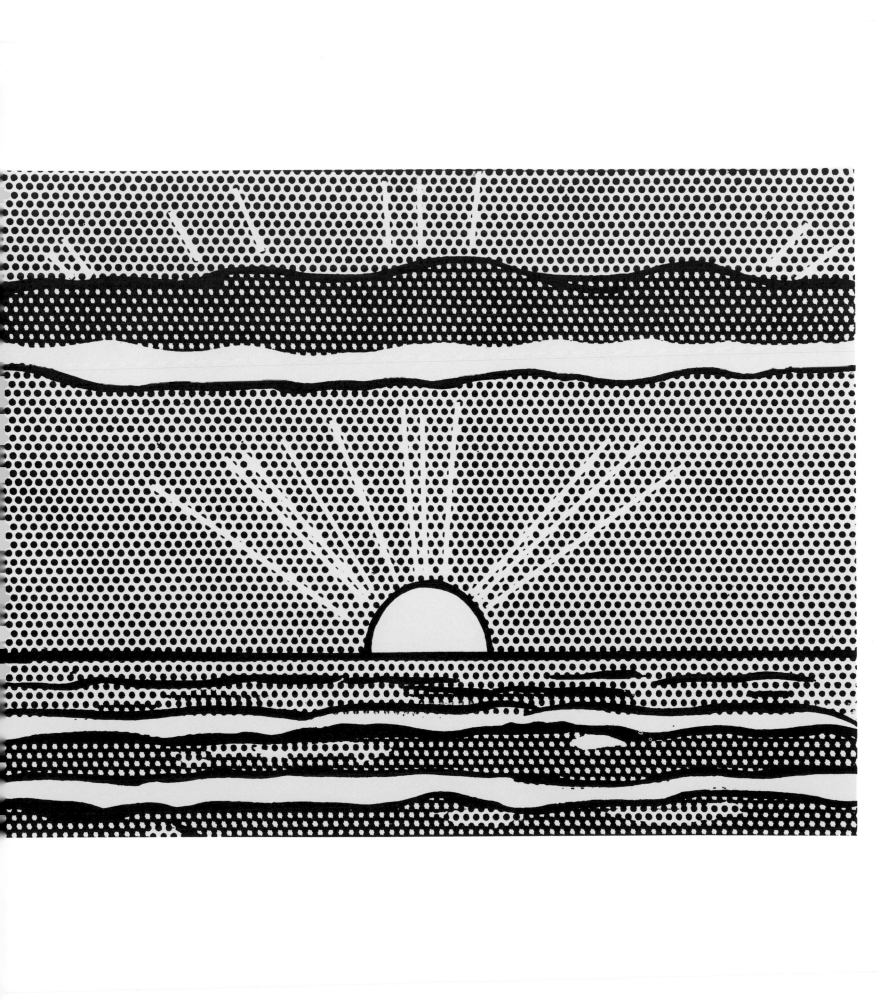

65–1
DIANA *(1965)*

Pencil and touche, 29¾×22¼ in.
Collection Mr. and Mrs. Leo Castelli, New York
Exhibited: Cleveland Museum of Art, 1966
 Pasadena/Minneapolis, 1967, No. 62
 Stedelijk, No. 74, illus.
 Tate, 1968, No. 74, illus.
 Kunsthalle Bern, 1968, No. 67, illus.
 Hannover, 1968, No. 67, illus.
 Guggenheim, 1969, No 82, illus.

65–2 Not reproduced
SWEET DREAMS BABY (Design for silkscreen) *(1965)*

Ink, pencil and pasted paper, 36⅝×26⅜ in.
Provenance: Unknown; Zwirner Gallery, Cologne
Collection Suermondt Museum, Aachen. Loan of Dr. Peter Ludwig

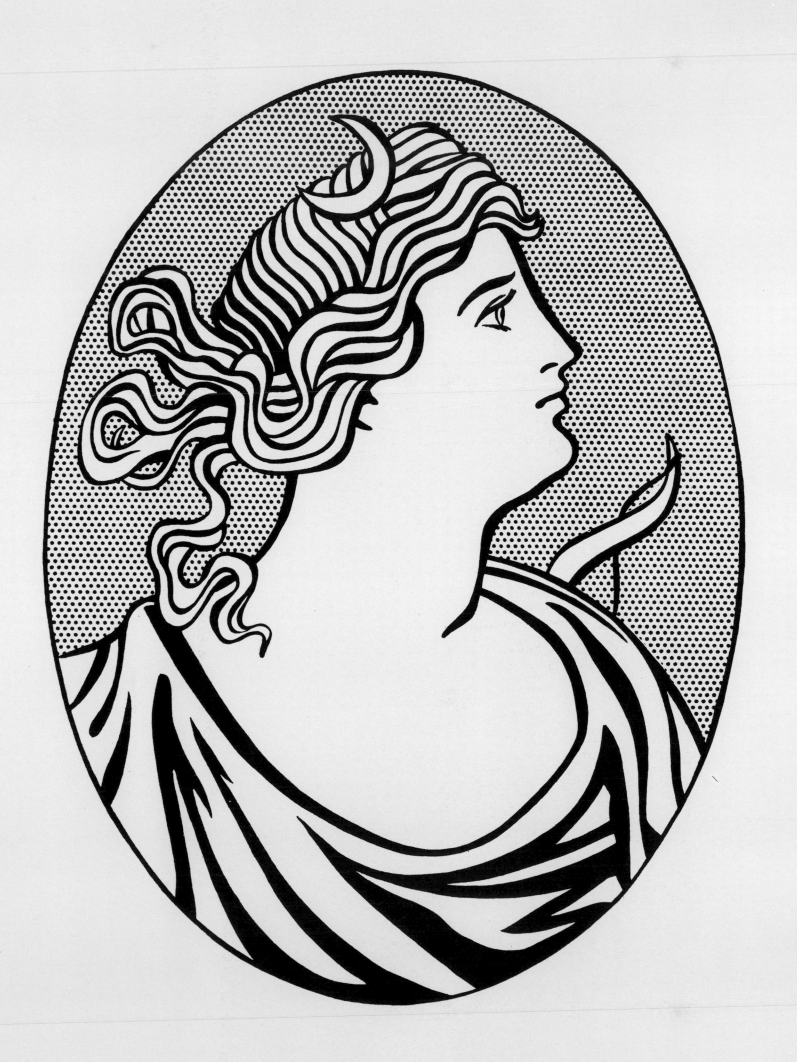

65–3
BRUSHSTROKE *(1965)*

Pencil and touche, 22¼×30 in. sheet
Provenance: Leo Castelli Gallery, New York
Collection Steve Schapiro, New York
Exhibited: Cleveland Museum of Art, 1966
 New School, New York, *American Drawings of the Sixties :
 A Selection,* 1969, No. 85

66–1
BRUSHSTROKES *(1966–68)*

Pencil and touche, 22¼×30 in.
Collection Mr. and Mrs. Leo Castelli, New York
Exhibited: University of Vermont, Burlington, Vermont, 1969
 Guggenheim, 1969, No. 85

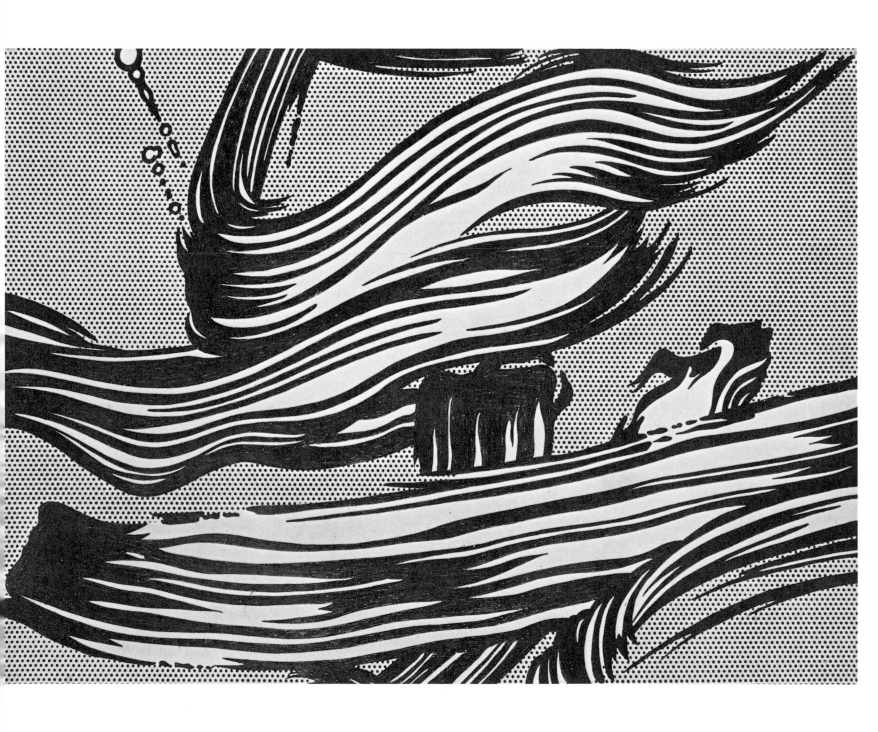

66–2
ALKA SELTZER *(1966)*

Pencil and touche, 30×22 in.
Provenance: Leo Castelli Gallery, New York; Bianchini Gallery, New York
Collection Mr. and Mrs. Richard L. Selle, Chicago
Exhibited: Bianchini Gallery, New York and Contemporary Arts Center, Cincinnati,
 Master Drawings: Pissarro to Lichtenstein, 1966, No. 11, illus.
 Guggenheim, 1969, No. 83

Erratum, page 118:
Caption of drawing 66-2
entitled ''Alka-Seltzer''
should read ''Tablet''

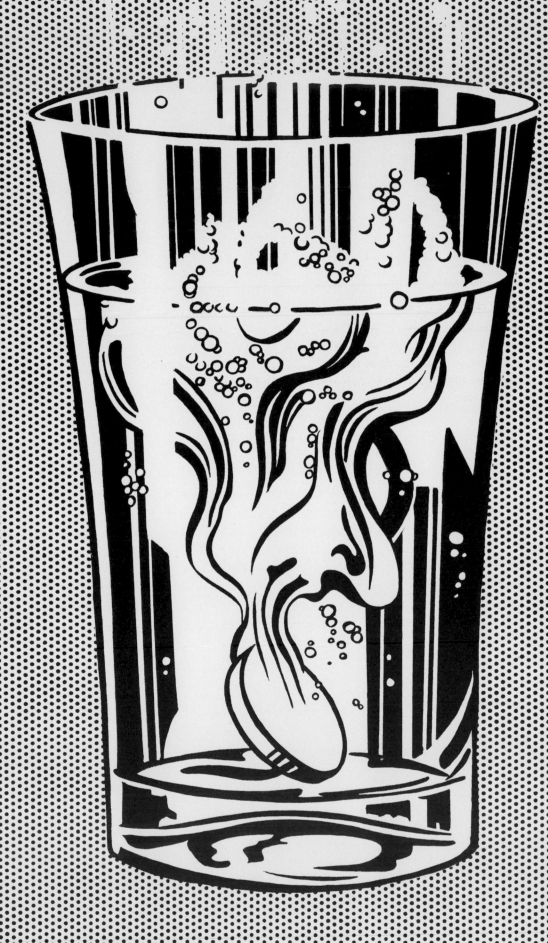

67–1
MODERN PAINTING WITH SMALL BOLT *(1967)*

Pencil and touche, 22½×25 in. sheet
Collection Mr. and Mrs. Leo Castelli, New York
Exhibited: Guggenheim, 1969, No. 84, Bianchini Gallery, New York
 One Hundred Years of Fantastic Drawings. 1967

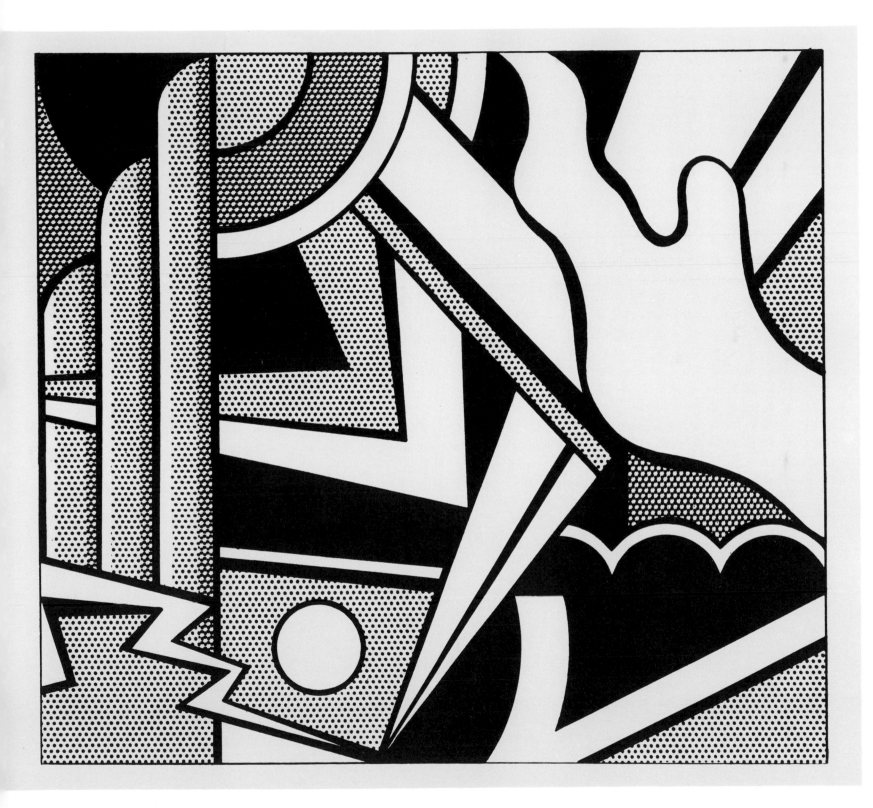

68-1
TOWN AND COUNTRY *(1968)*

Gouache, ink and pasted papers, 32×24 in. sheet
Private collection, New York

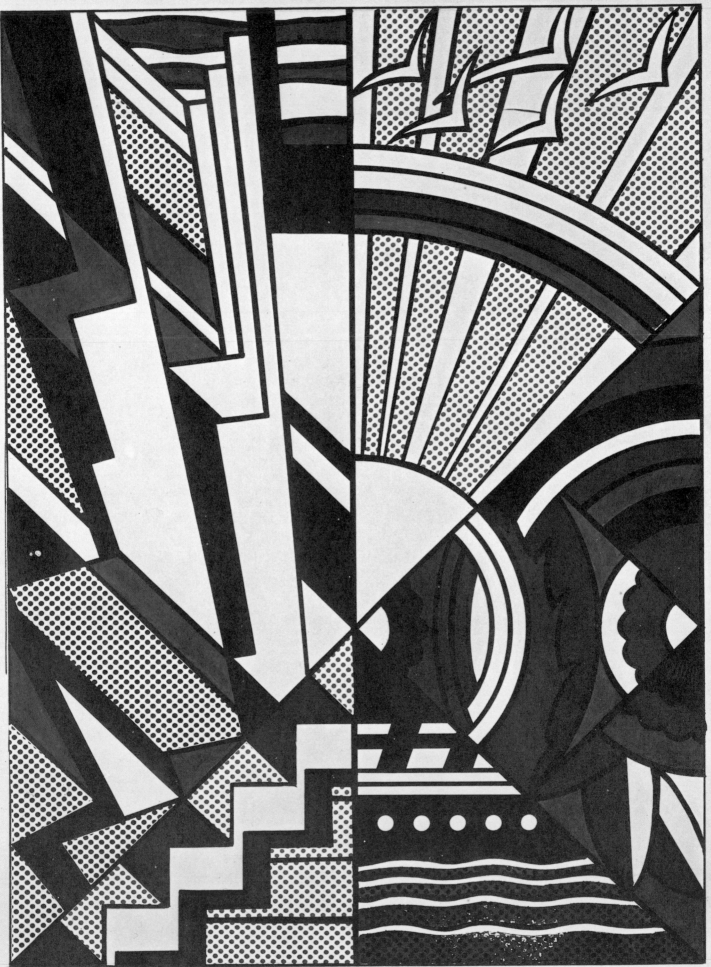

SALUTE TO AIRMAIL (Design for medallic sculpture) *(1968)*

Pencil, 24⅝×20 in. sheet
Private collection, New York

68–3
PREPAREDNESS *1968*

Pencil and colored pencil, 17½×25⅝ in. sheet
Private collection, New York
Exhibited : New School, New York, *American Drawings of the Sixties:*
 A Selection, 1969, No. 85

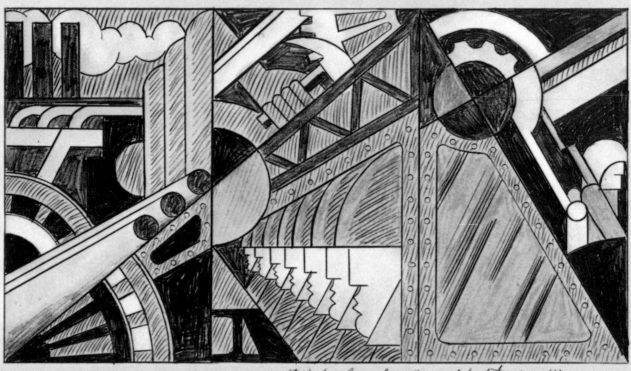

"Study for Preparedness" rf Lichtenstein '68

69–1
Sheet of designs for sculpture *(1969)*

Pencil, 18⅝×39 in. sheet
Private collection, New York

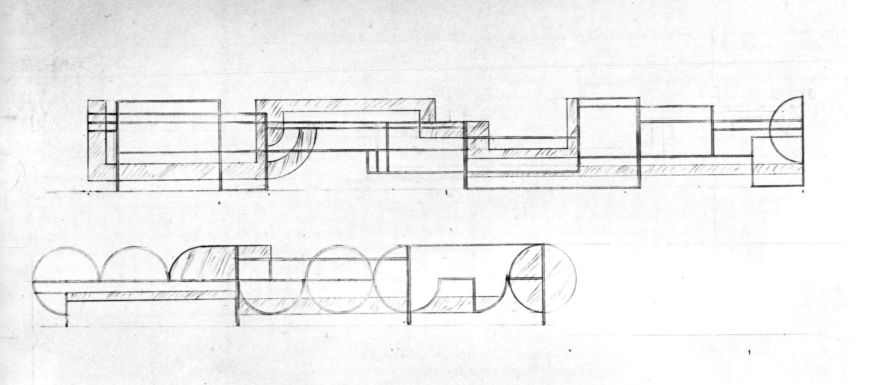

69–2
Design for **THE SOLOMON R. GUGGENHEIM MUSEUM POSTER** *(1969)*

Pencil and Colored pencil, 32×29 in. sheet irregular; 23⅛ in. diameter composition
Private collection, New York

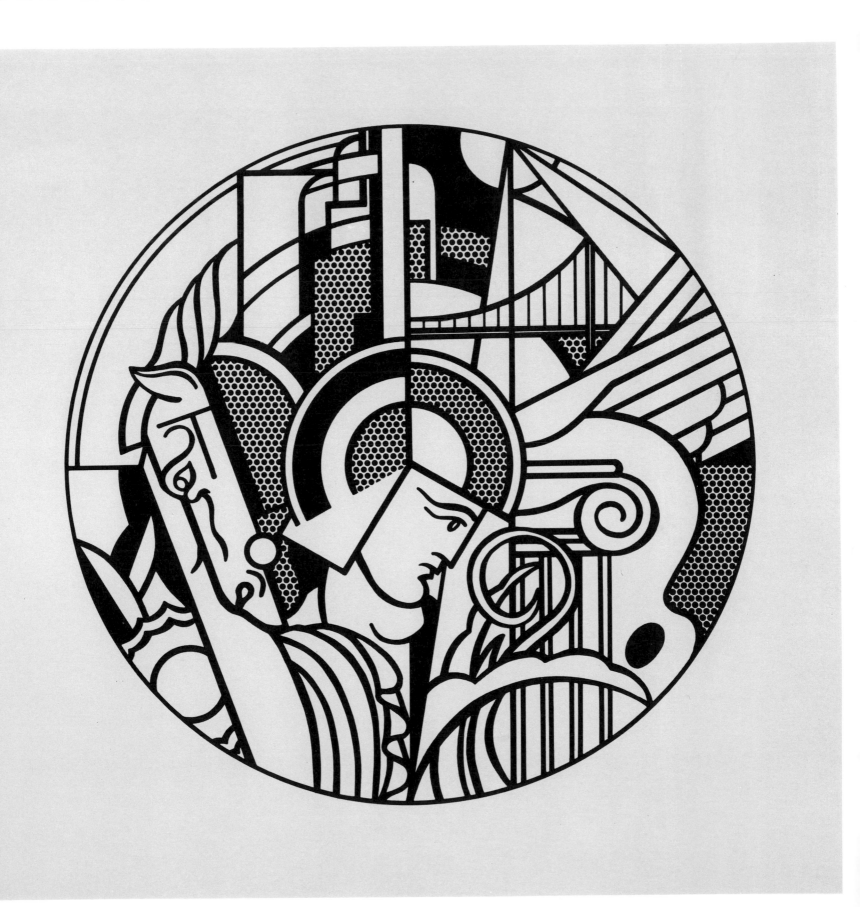

Studies 1961-1969

There are few studies which do not relate to a particular work.
Lichtenstein used lead and colored pencils or occasionally magic
markers as tools employed for the sake of expediency. As the notations
for a painting or a sculpture the sketches are remarkably complete
containing all of the data that the artist required for his finished work.

The early studies for the comic strip paintings were frequently copied and
sometimes partly or wholly traced from a comic book. In some cases the
resulting imagery represents a combination of several sources. The final
study was transferred to the canvas by means of an opaque projector,
a technique that Lichtenstein has continued to use. Lichtenstein's
landscapes are frequently pure invention, composed from secondary
sources or occasionally drawn from photographs of a particular landscape
or sunset that appealed to the artist. For the brushstroke drawings
Lichtenstein applied black Magnicolor on acetate. The Magnicolor produ-
ced a very definite shape that resembled a brushstroke type of line more
successfully than any he could invent or derive from a secondary source.
He made many adjustments by placing one acetate over another until he
arrived at a shape that was satisfactory. This technique allowed him to
retain the look of action and spontaneity that he needed for the paintings
which were intended in part as a comment on Action Painting. For the
Moderne series, he again returned to a specific source, the thirties,
selecting motifs primarily from the decoration of the period. From these
sources he designed motifs that can be defined as thirties yet they are
substantially his own invention. In the studies for his sculpture Lichtenstein
evolved a series of forms derived from the theater lobbies, banisters, and
automobile grills of the thirties. The final study, full-size, was then sent to
the factory to become a blueprint for the fabrication of a piece.

61–13
Flowers (1961)

Pencil, 6×6 in. sheet
Private collection, New York

136

63–11
Study for **BASEBALL MANAGER** *(1963)*

Pencil, 6×4⅜ in. sheet
Private collection, New York

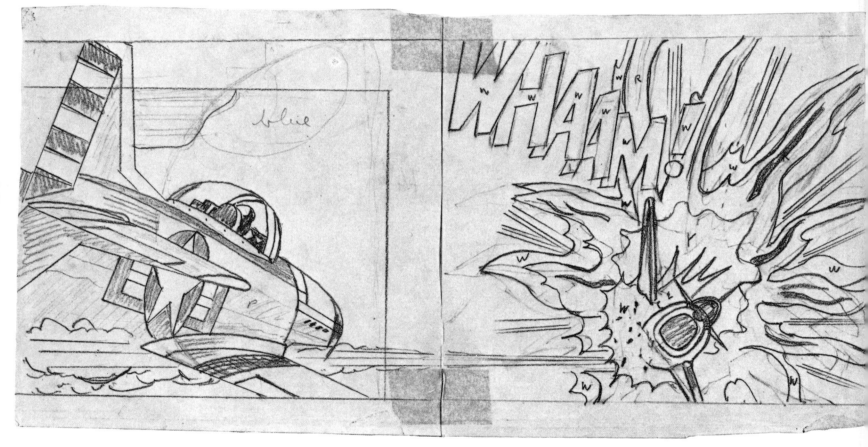

63–12
Study for **WHAAM** *(1963)*

Pencil, 6×6 in. left sheet; 6×6 in. right sheet
Collection the Tate Gallery, London

63–13
Study for **VAROOM** *(1963)*

Pencil, 5⅛×5⅜ in. sheet
Private collection, New York

63–14
Study for **BALL OF TWINE** *(1963)*

Pencil, 15×18⅝ in. sheet irregular
Collection Lettie Lou Eisenhauer, New York

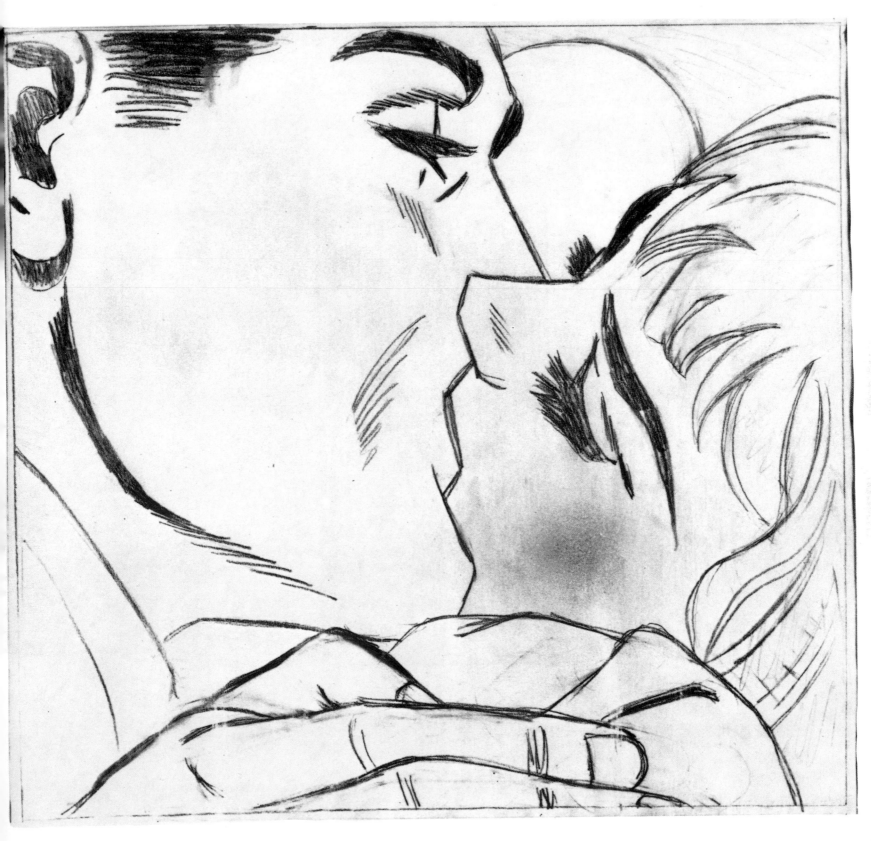

63–15
Study for **KISS II** *(1963)*

Pencil, 18½ × 23½ in. sheet irregular
Collection Ellen H. Johnson, Oberlin, Ohio

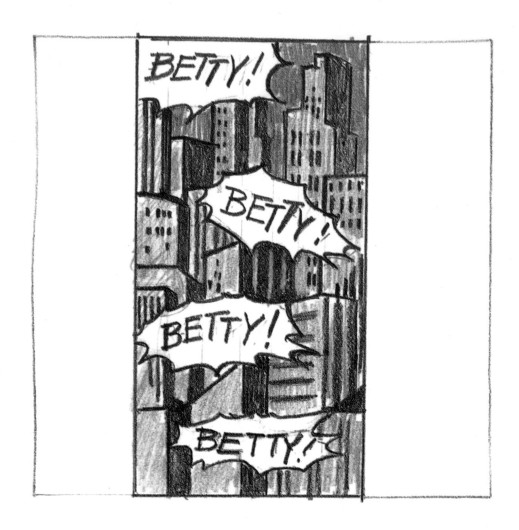

63–16
Betty! Betty! *(c. 1963–1964)*

Pencil and colored pencil, 5¾×5⅝ in. sheet
Private collection, New York

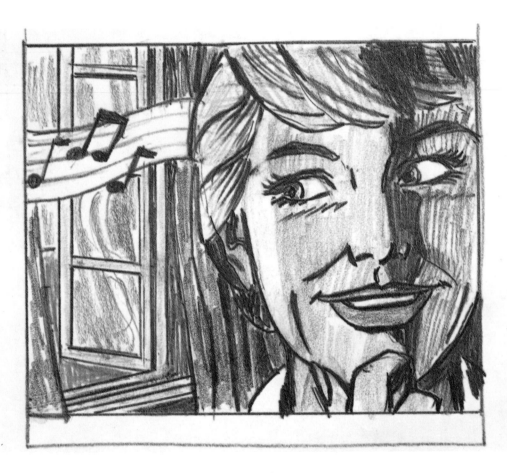

63–17
Study for **THE SOUND OF MUSIC** *(c. 1963–1964)*

Pencil and colored pencil, 4½×5¾ in. sheet
Private collection, New York

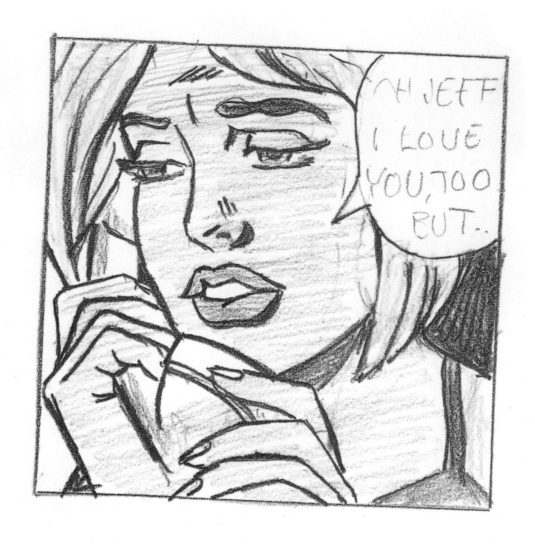

64—9
Study for **OH JEFF I LOVE YOU TOO, BUT . . .** *(1964)*

Pencil and colored pencil, 5¾×5¾ in. sheet
Private collection, New York

64—10
Study for **GOOD MORNING DARLING** *(1964)*

Pencil and colored pencil, 5⅞×5⅞ in. sheet
Collection Professor Hanford Yang, New York
Exhibited: *Selections from the Collection of Hanford Yang,* 1968
 The Aldrich Museum of Contemporary Art, Ridgefield, Connecticut

64–11
Study for **SLEEPING GIRL** *(1964)*

Pencil and colored pencil, 5¾ × 5¾ in. sheet
Collection Jack Klein, New York

64–12
Study for enamel **CRYING GIRL** *(1964)*

Pencil, colored pencil and gouache, 5½ × 5¾ in. sheet
Collection Professor Hanford Yang, New York
Exhibited: *Selections from the Collection of Hanford Yang,* 1968
 The Aldrich Museum of Contemporary Art, Ridgefield, Connecticut

64–13
Study for enamel **CRYING GIRL** (1964)

Pencil and colored pencil, 5×5 in.
Collection Mr. and Mrs. Burton Tremaine, Meriden, Connecticut

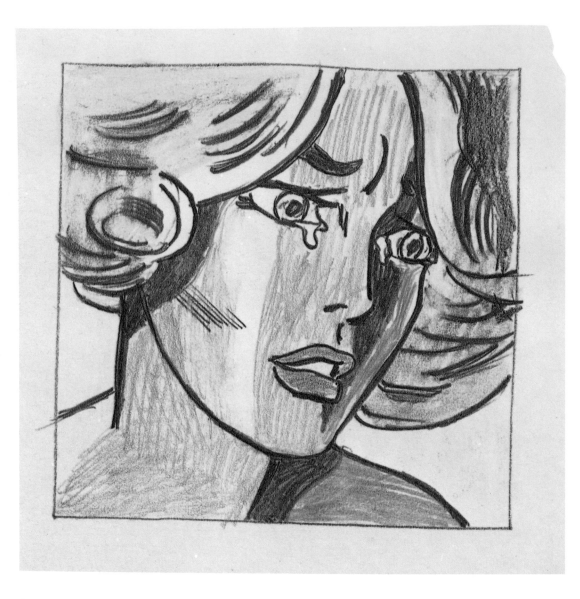

64–14
Study for **FRIGHTENED GIRL** (1964)

Pencil and colored pencil, 5¾×5¾ in. sheet
Private collection, New York

64–15
Study for man in **TENSION** (1964)

Pencil, 5½×5¾ in. sheet
Private collection, New York

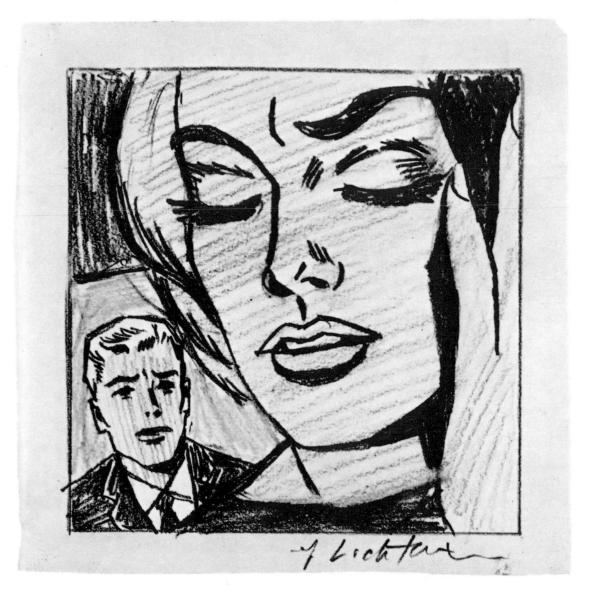

64–16
Study for **TENSION** *(1964)*

Pencil and colored pencil, 5¾ × 5¾ in. sheet
Collection Professor Hanford Yang, New York
Exhibited: *Selections from the Collection of Hanford Yang,* 1968
 The Aldrich Museum of Contemporary Art, Ridgefield, Connecticut

64–17
Preliminary study for enamel **GIRL IN MIRROR** *(1964)*

Pencil and colored pencil, 5½ × 5½ in. sight
Collection Stanley Landsman, New York

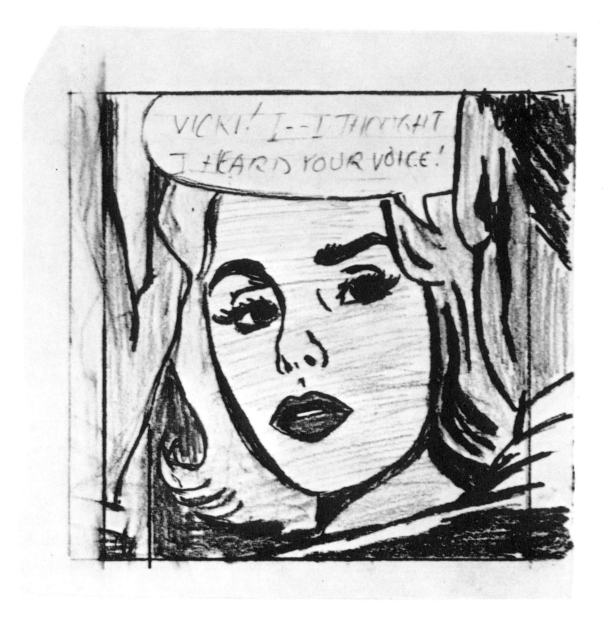

64–18
Study for **VICKI! I — I THOUGHT I HEARD YOUR VOICE!** *(1964)*

Pencil and colored pencil, 5¾×5¾ in. sheet
Collection Leo Steinberg, New York
Exhibited: *Art in Process,* 1965 Finch College, New York

64–19
Study for silkscreen **CRAK!** *(1964)*

Pencil, 5¾×6 in.
Collection Françoise Essellier, Paris

64–20
Study for **ECCENTRIC SCIENTIST** *(1964)*

Pencil and colored pencil, 5½×5½ in. sight
Collection Stanley Landsman, New York

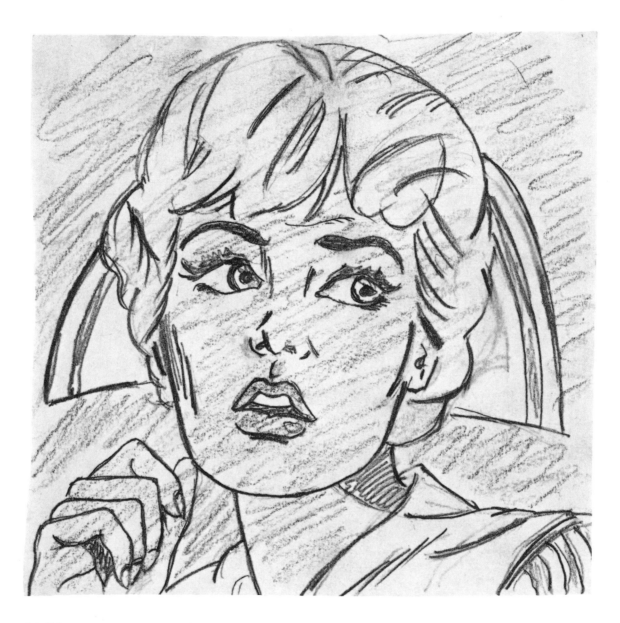

64–21
Study for **NURSE** *(1964)*

Pencil and colored pencil, 5⅞×5⅞ in. sheet
Private collection, New York

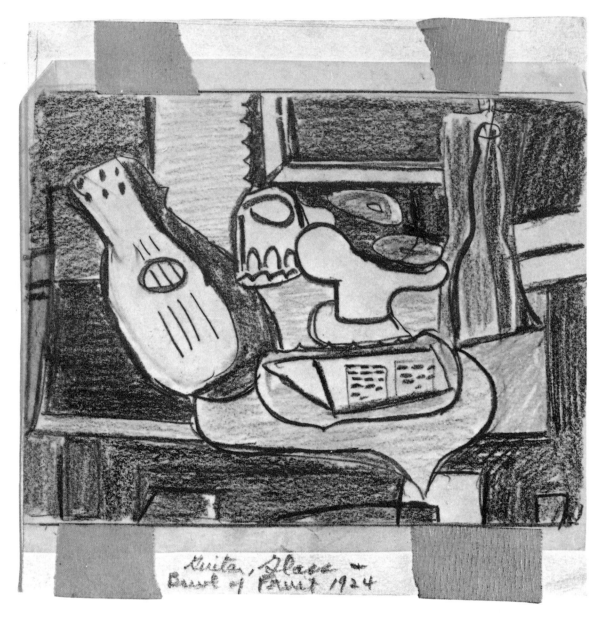

64–22
Study for **STILL LIFE** *(1964)*
 (After Picasso's *Guitar, Glass and Bowl of Fruit,* 1924.)

Pencil and colored pencil, 5⅛ × 5⅞ in. sheet
Private collection, New York

64–23
Non-objective sketch (1964)

Pencil and colored pencil, 6×5⅞ in. sheet
Private collection, New York

64–24
Finger Print (c. 1964)

Pencil, 5¾×5 in.
Collection Charles Cowles, New York

64–25
Girl and Landscape (c. 1964)

Pencil and colored pencil, 5¾×5¾ in. sheet
Private collection, New York

64–26
Landscape sketch (c. 1964)

Pencil, ink and colored pencil, 7¼×7¼ in. sheet irregular
Private collection, New York

64–27
Landscape sketch (c. 1964)

Pencil and colored pencil, 5½×5½ in. sheet
Private collection, New York

64–28
Landscape sketch (c. 1964)

Pencil and colored pencil, 6⅝×4¾ in. sheet irregular
Private collection, New York

64–29
Landscape sketch *(c. 1964)*

Pencil and colored pencil, 5¾ × 5¾ in. sheet
Private collection, New York

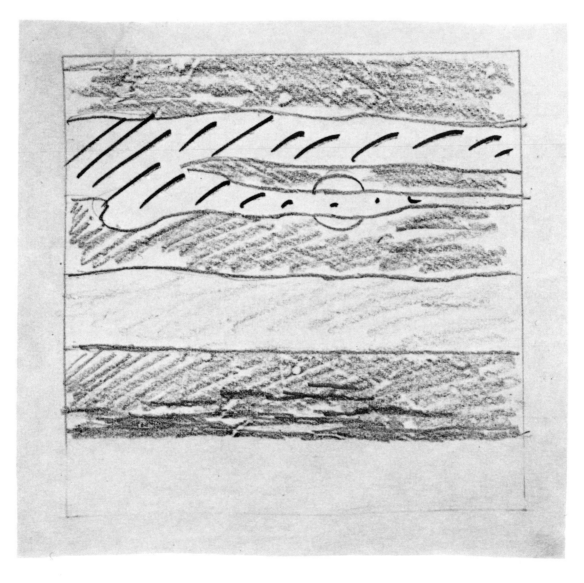

64–30
Landscape sketch *(c. 1964)*

Pencil, ink and colored pencil, 5½×5¾ in. sheet
Private collection, New York

64–31
Landscape sketch *(c. 1964)*

Pencil, 4¾×5½ in.
Collection David Whitney, New York

64–32
Yellow Cloud *(c. 1964)*

Pencil, colored pencil and ink, 5½×5¾ in. sheet
Collection Professor Hanford Yang, New York
Exhibited: *Selections from the Collection of Hanford Yang,* 1968
 The Aldrich Museum of Contemporary Art, Ridgefield, Connecticut

64–33
Blue Cloud *(c. 1964)*

Pencil and colored pencil, 5×6⅞ in. sheet irregular
Collection Professor Hanford Yang, New York
Exhibited: *Selections from the Collection of Hanford Yang,* 1968
 The Aldrich Museum of Contemporary Art, Ridgefield, Connecticut

64–34
Landscape Red Sunset *(c. 1964)*

Pencil and colored pencil, 5½×5¾ in. sheet irregular
Collection Professor Hanford Yang, New York
Exhibited: *Selections from the Collection of Hanford Yang,* 1968
 The Aldrich Museum of Contemporary Art, Ridgefield, Connecticut

64–35
Landscape Yellow Sunset *(c. 1964)*

Pencil and colored pencil, 5⅞×6⅞ in. sheet
Collection Professor Hanford Yang, New York
Exhibited: *Selections from the Collection of Hanford Yang,* 1968
 The Aldrich Museum of Contemporary Art, Ridgefield, Connecticut

64–36
Landscape sketch *(1964)*

Pencil and colored pencil, 4¾×5¾ in. sheet
Private collection, New York

64–37
Sheet of sketches with landscape and hot dog *(c. 1964)*

Pencil and colored pencil, 9¾×5⅝ in. sheet
Private collection, New York

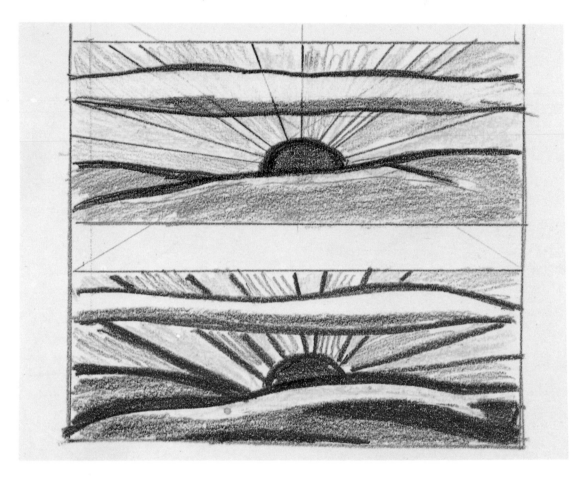

64–38
Landscape with sun (c. 1964)

Pencil, 6½×10⅛ in. sheet irregular
Private collection, New York

64–39
Sheet with two landscapes with sun (c. 1964)

Pencil and colored pencil, 4½×5¾ in. sheet
Private collection, New York

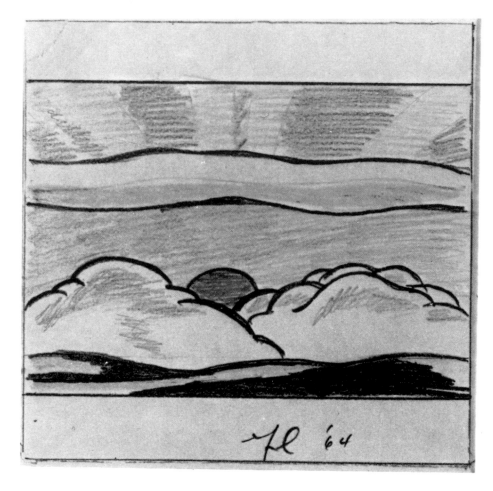

64–40
Landscape with setting sun (1964)

Colored pencil, 4⅝ × 4⅝ in.
Collection Mr. and Mrs. Burton Tremaine, Meriden, Connecticut

64–41
Landscape with sun (c. 1964)

Pencil and colored pencil, 4¼ × 5¾ in. sheet
Collection Lettie Lou Eisenhauer, New York

154

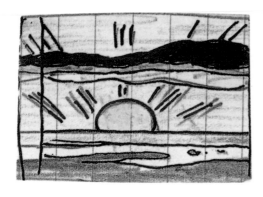

64–42
Preliminary study for **SETTING SUN AND SEA** *(1964)*

Pencil, ink and colored pencil, 1¾×2½ in. sheet
Private collection, New York

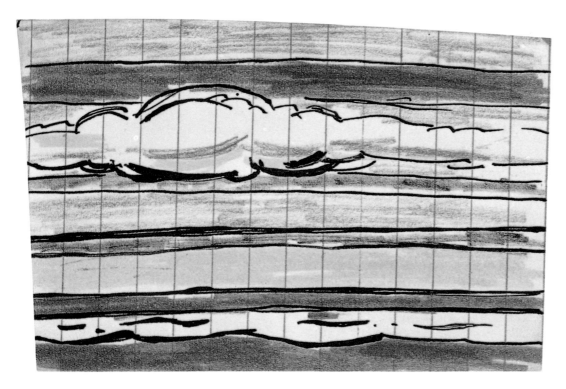

64–43
Seascape with clouds *(c. 1964)*

Ink and colored pencil, 3½×5½ in. sheet
Private collection, New York

64–44
Cloud study *(c. 1964)*

Pencil, 4⅛×9¾ in. sheet
Private collection, New York

64–45
Landscape with cloud *(c. 1964)*

Pencil and colored pencil, 2¾×4⅛ in. sheet
Private collection, New York

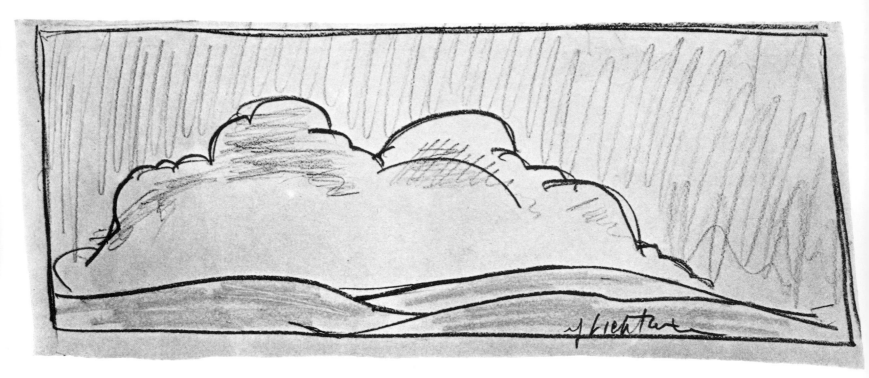

64–46
Landscape with cloud *(1964)*

Pencil, 4½×11 in.
Collection Charles Cowles, New York

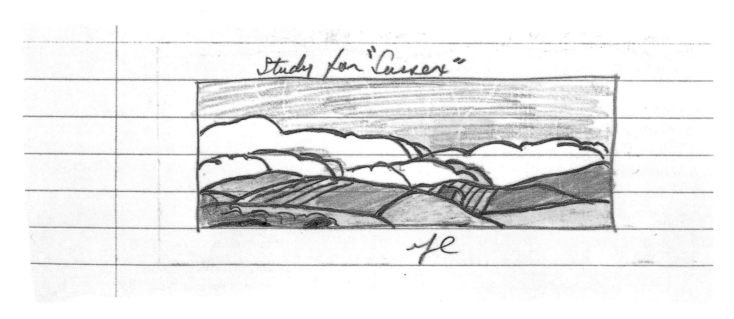

64–47
Preliminary study for **SUSSEX** *(1964)*

Pencil and colored pencil, 2⅞×7¼ in. sheet
Collection David Whitney, New York

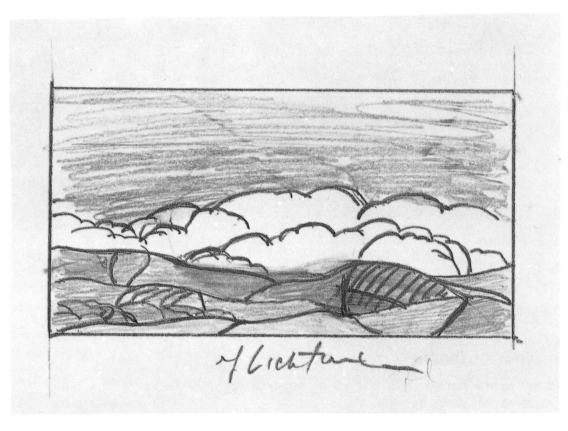

64–48
Study for **SUSSEX** *(1964)*

Pencil and colored pencil, 4¼×5¾ in. sheet
Collection Mr. and Mrs. W. B. McHenry, New York

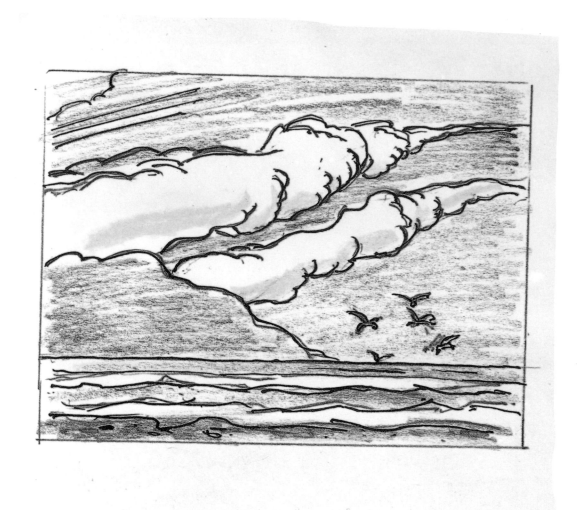

64–49
Study for **GULLSCAPE** *(1964)*

Pencil, ink and colored pencil, 5½×5¾ in. sheet
Collection Jack Klein, New York

64–50
Study for **GULLSCAPE** *(1964)*

Pencil and colored pencil, 7¼×8¾ in. sheet
Collection Professor Hanford Yang, New York
Exhibited: *Selections from the Collection of Hanford Yang,* 1968
 The Aldrich Museum of Contemporary Art, Ridgefield, Connecticut

64–51
Study for **TEMPLE I** *(1964)*

Pencil and colored pencil, 21×15⅜ in. sheet
Collection John W. Weber, New York

64–52
Study for **TEMPLE OF APOLLO** *(1964-1965)*

Crayon and pencil, 5⅞×5¾ in.
Collection Mr. and Mrs. Leo Castelli, New York
Exhibited: *Contemporary American Drawings,* 1964
 The Solomon R. Guggenheim Museum, New York
 Cleveland Museum of Art, 1966
 Pasadena/Minneapolis, 1967, No. 61
 Stedelijk, 1967, No. 73
 Tate, 1968, No. 72
 Kunsthalle, Bern, 1968, No. 67
 Hannover, 1968, No. 67
 Guggenheim, 1969, No. 81

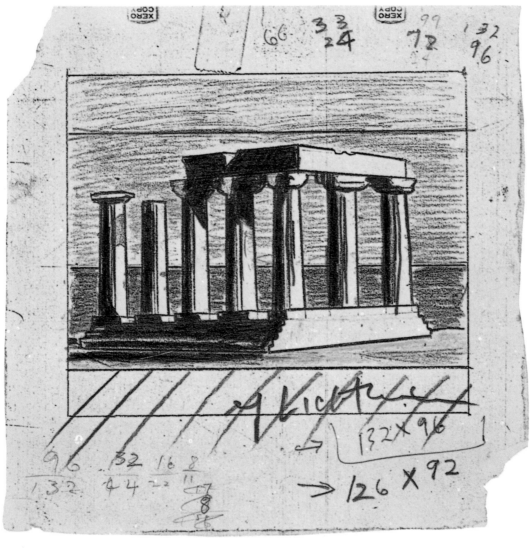

64–53
Study for **TEMPLE OF APOLLO** *(1964–1965)*

Pencil and colored pencil, 5½×5⅜ in. sheet
Collection Mr. and Mrs. Paul Waldman, New York

64–54
Landscape with sun *(c. 1964–1965)*

Pencil and ink, 5×8 in. sheet
Private collection, New York

64–55
Landscape sketch *(c. 1964)*

Pencil and ink, 4⅞×9¾ in. sheet irregular
Private collection, New York

64–56
Landscape with sun *(1964)*

Pencil and ink, 3¼×5¼ in.
Provenance: Marshall Bean
Collection Gordon Locksley, Minneapolis

65–4
Seascape *(1965)*

Colored pencil, 5½×6¾ in.
Collection Galerie Heiner Friedrich, Munich

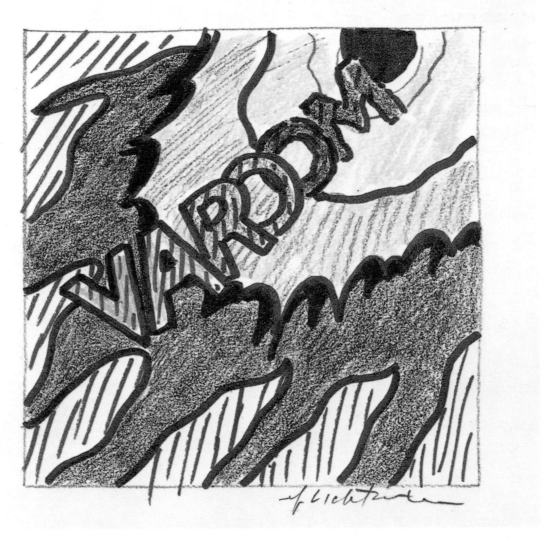

65–5
Study for **VAROOM** *(1965)*

Pencil, colored pencil and ink, 5¾×6 in. sheet
Collection Lettie Lou Eisenhauer, New York

65–6
Study for **EXPLOSION** *(1965)*

Pencil, colored pencil and ink, 9×6 in. sheet
Private collection, New York

65–7
Preliminary study for **DESK EXPLOSION** *(1965)*

Pencil, 10⅝×8¼ in. sheet
Private collection, New York

65–8
Study for **DESK EXPLOSION** *(1965)*

Pencil and ink, 10⅝×8¼ in. sheet
Private collection, New York

65–9
Study for **DESK EXPLOSION** *(1965)*

Pencil and ink, 10½×8¼ in.
Private collection, New York

65–10
Study for **DESK EXPLOSION** *(1965)*

Pencil and ink, 10½×8¼ in. sheet
Private collection, New York

65–11
Study for **DESK EXPLOSION** *(1965)*

Pencil and ink, 10⅝×8¼ in. sheet
Private collection, New York

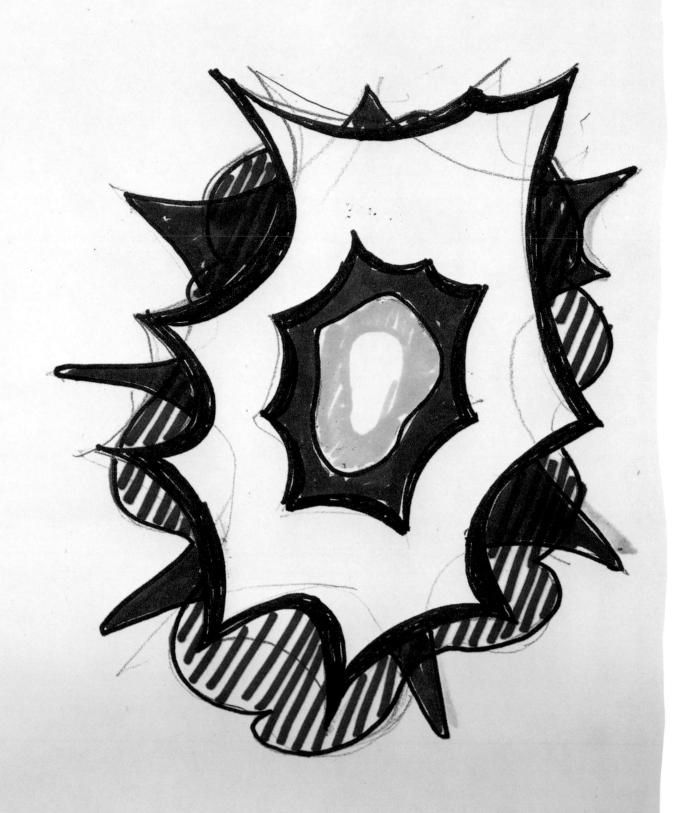

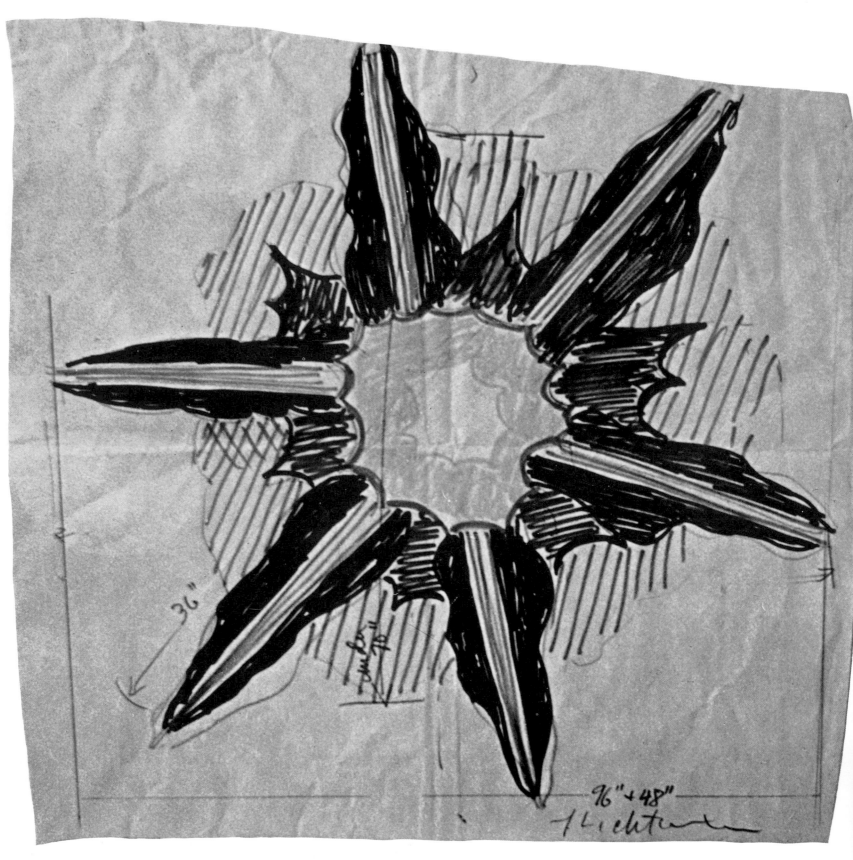

65–12
Burst sketch (c. 1965)

Colored pencil, 11½ × 11½ in.
Collection Jack Klein, New York

164

65–13
Explosion sketch (c. 1965)

Pencil, 5¼×4⅝ in. sheet
Private collection, New York

65–15
Explosion sketch (c. 1965)

Pencil, colored pencil and ink, 9¾×6¾ in. sheet
Private collection, New York

65–14
Explosion sketch (c. 1965)

Pencil, colored pencil and ink, 10⅝×8⅛ in. sheet
Private collection, New York

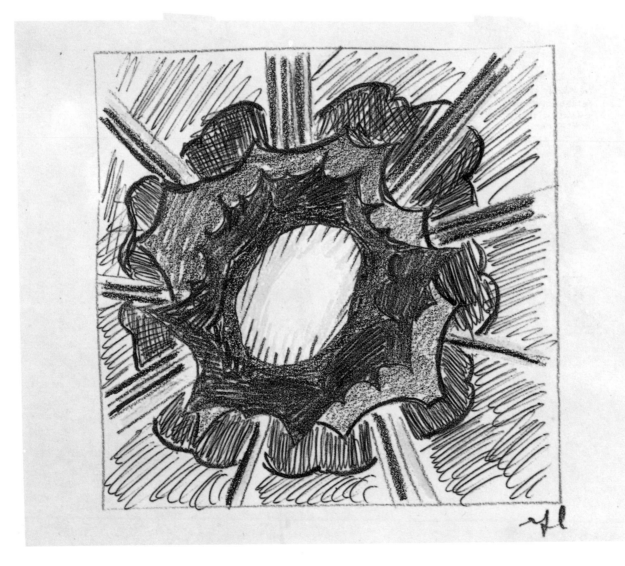

65–16
Explosion sketch (c. 1965)

Pencil, colored pencil and ink, 5½×6½ in. sheet
Collection Mr. and Mrs. Horace H. Solomon, New York

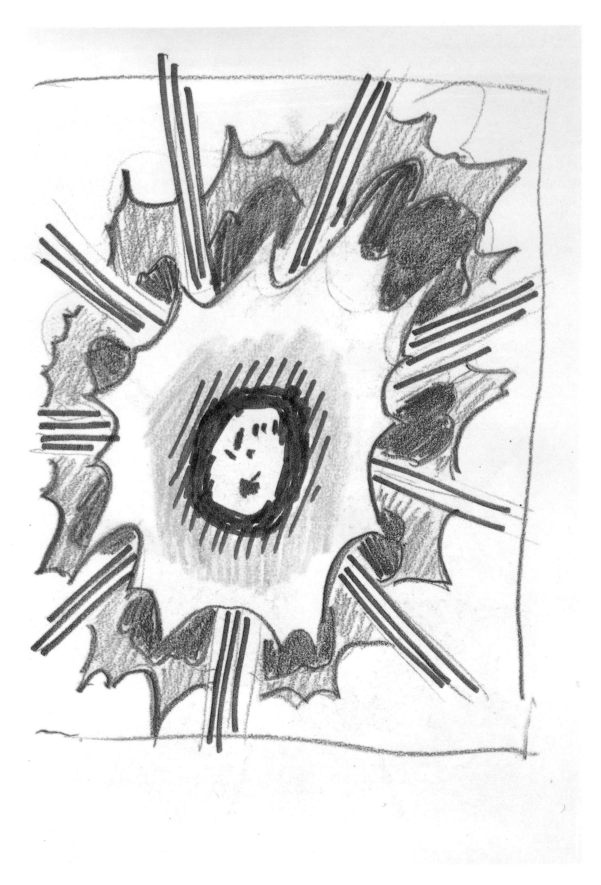

65–17
Explosion sketch *(c. 1965)*

Pencil, ink and colored pencil, 9×6 in. sheet
Private collection, New York

65–18
Study for **GRRR!** *(1965)*

Pencil, 5¾×4½ in. sheet
Private collection, New York

65–19
Girl *(1965)*

Pencil and colored pencil, 5⅝×5¾ in. sheet
Collection Otto Hahn, Paris

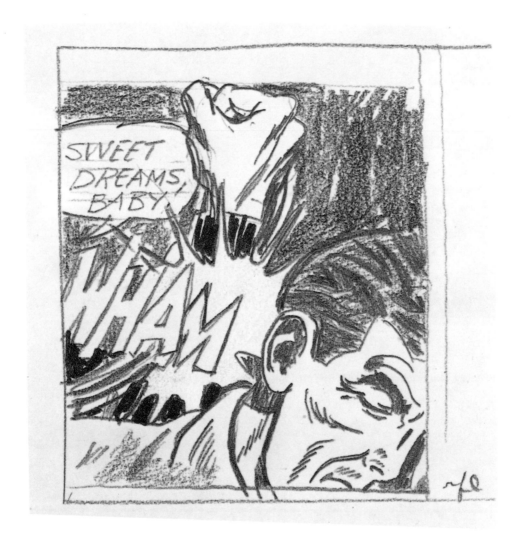

65–20
Study for silkscreen **SWEET DREAMS, BABY** *(1964–1965)*

Pencil and colored pencil, 5¼×4⅞ in.
Collection Mr. and Mrs. Horace H. Solomon, New York

65–21
THE MELODY HAUNTS MY REVERIE *(1965)*

Colored pencil, 6×5½ in.
Collection Galerie Heiner Friedrich, Munich

65–22
I'LL THINK ABOUT IT *(c. 1965)*
(Original drawing for *10 from Rutgers* catalogue 1965)

Ink, 7¾×6¾ in.
Collection Mr. and Mrs Jack W. Glenn, Kansas City, Missouri

65–23
FINGER POINTING *(c. 1965)*

Pencil, 7¼×5⅛ in. sheet
Private collection, New York

65–24
BRUSHSTROKES *(1965)*

Ink, 8¼×10⅝ in. sheet
Private collection, New York

65–25
Study for **DIANA** *(1965)*

Pencil, 4¾×4¾ in.
Collection Mr. and Mrs Jack W. Glenn, Kansas City, Missouri
Exhibited: Kansas State University, Manhattan, Kansas, 1967

65–26
Landscape *(1965)*

Pencil and colored pencil, 3⅛×3½ in.
Collection Françoise Essellier

65–27
Sheet of two sketches of landscape with column and landscape with columns *(1965)*

Pencil and colored pencil, 10⅝×7½ in. sheet
Private collection, New York

65–28
Sheet of two sketches of landscape with columns and columns *(1965)*

Pencil and colored pencil, 10⅝×8¼ in. sheet
Private collection, New York

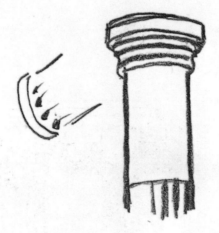

65–29
Landscape with columns *(1965)*

Pencil and colored pencil, 10⅝×8¼ in. sheet
Private collection, New York

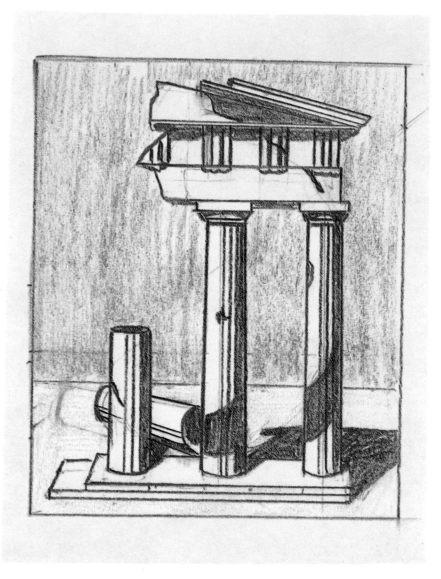

65–30
Study for **TEMPLE II** *(1965)*

Pencil and colored pencil, 5¾×4½ in. sheet
Private collection, New York

66–3
Seascape *(1966)*

Colored pencil, 4½×4½ in.
Collection Karl Ströher, Darmstadt
Exhibited: Neue Pinakothek, Munich, 1968;
 Neue Nationalgalerie, Berlin, 1969;
 Kunsthalle, Düsseldorf, 1969;
 Kunsthalle, Bern, 1969

66–4
Seascape *(1966)*

Colored pencil, 4½×4½ in.
Collection Karl Ströher, Darmstadt
Exhibited: Neue Pinakothek, Munich, 1968;
 Neue Nationalgalerie, Berlin, 1969;
 Kunsthalle, Düsseldorf, 1969;
 Kunsthalle, Bern, 1969

66–5
Preliminary study for **MODERN PAINTING I** *(1966)*

Pencil and ink, 5×4½ in. sheet
Private collection, New York

171

66–6
Study for **PARIS REVIEW POSTER** *(1966)*

Pencil and ink, 13⅞×11½ in. sheet irregular
Private collection, New York

66–8
Study for **INDUSTRY AND CULTURE** *(1966)*

Pencil, 5⅜×3½ in. sheet
Private collection, New York

66–7
Study for **LINCOLN CENTER POSTER** *(1966)*

Ink and pencil, 15×10¼ in. sheet irregular
Private collection, New York

66–9
Study for **INDUSTRY AND CULTURE** *(1966)*

Pencil, 22¼×17 in. sheet
Private collection, New York

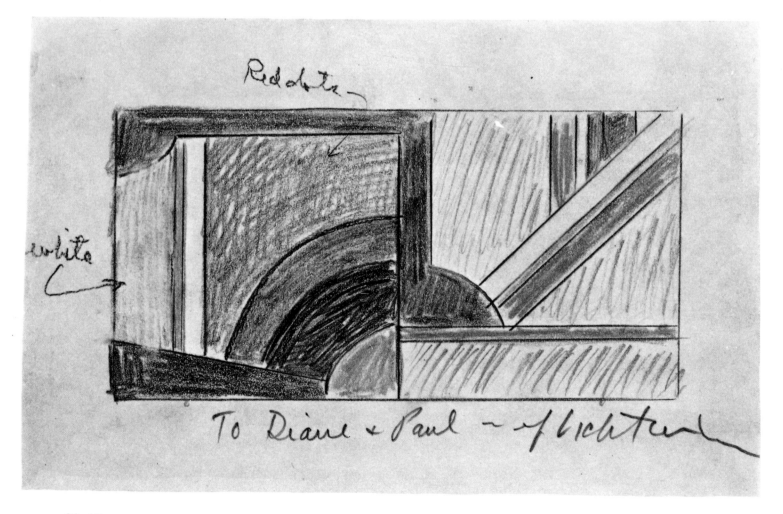

66–10
Study for **MODERN PAINTING WITH DIVISION** *(1966)*

Pencil and colored pencil, 5×7¾ in. sheet
Collection Mr. and Mrs. Paul Waldman, New York

172

66–11
Study for **MODERN PAINTING WITH DIVISION** *(1966)*

Pencil, 4⅞×8 in. sheet
Private collection, New York

66–12
Study for **MODERN PAINTING DIPTYCH** *(1966)*

Pencil and colored pencil, 4⅞×8 in. sheet
Private collection, New York ˇ

66–13
Study for **MODERN PAINTING DIPTYCH** *(1966)*

Pencil, 5×8 in. sheet irregular
Private collection, New York

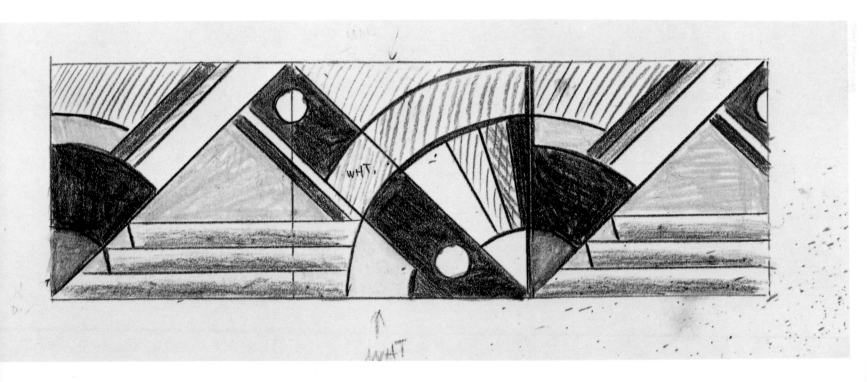

67–2
Study for Mural for *Expo* *(1967)*

Pencil and colored pencil, 4½×10¾ in. sheet
Private collection, New York

67–3
Study for Mural for *Expo* (1967)

Pencil, 5⅜×11 in. sheet
Private collection, New York

67–4
Study for **MODERN PAINTING TRIPTYCH** *(1967)*

Pencil and colored pencil, 5⅛×7⅛ in. sheet
Private collection, New York

67–5
Study for **MODERN PAINTING TRIPTYCH** *(1967)*

Pencil and colored pencil, 5¼×8¼ in. sheet
Private collection, New York

67–6
Study for **MODERN PAINTING TRIPTYCH** *(1967)*

Pencil and colored pencil, 4½×10¾ in.
Collection Dr. Martin Greifinger, New York

67–7
Study for **MODERN PAINTING TRIPTYCH II** *(1967)*

Pencil, 5¼×10½ in. sheet
Private collection, New York

67–8
Study for **MODERN PAINTING IN PORCELAIN** *(1967)*

Pencil and colored pencil, 4×5 in. sheet
Private collection, New York

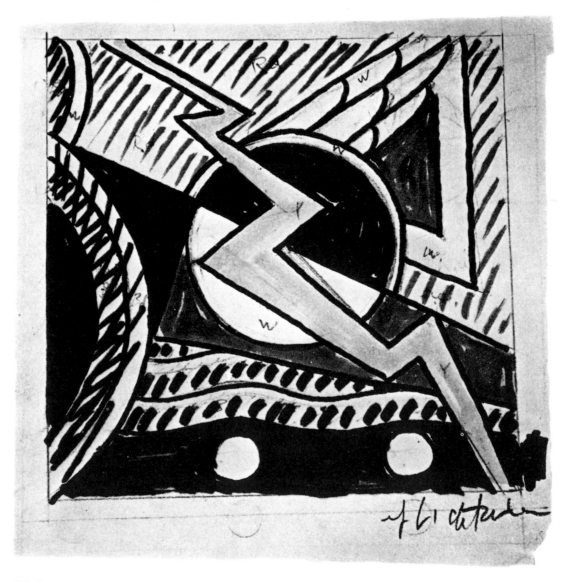

67–9
Study for **MODERN PAINTING WITH BOLT** *(1967)*

Pencil, 5¾×5⅝ in.
Collection Charles Cowles, New York

67–10
Preliminary study for **MODERN PAINTING WITH SMALL BOLT** *(1967)*

Pencil, 5¾×7½ in. sheet
Private collection, New York

67–11
Study for **MODERN PAINTING WITH SMALL BOLT** *(1967)*

Pencil and colored pencil, 5×5½ in.
Collection Mr. and Mrs. Jack W. Glenn, Kansas City, Missouri

67–12
Preliminary study for **MODERN PAINTING WITH ARC II** *(1967)*

Pencil and colored pencil, 6×6 in. sheet
Private collection, New York

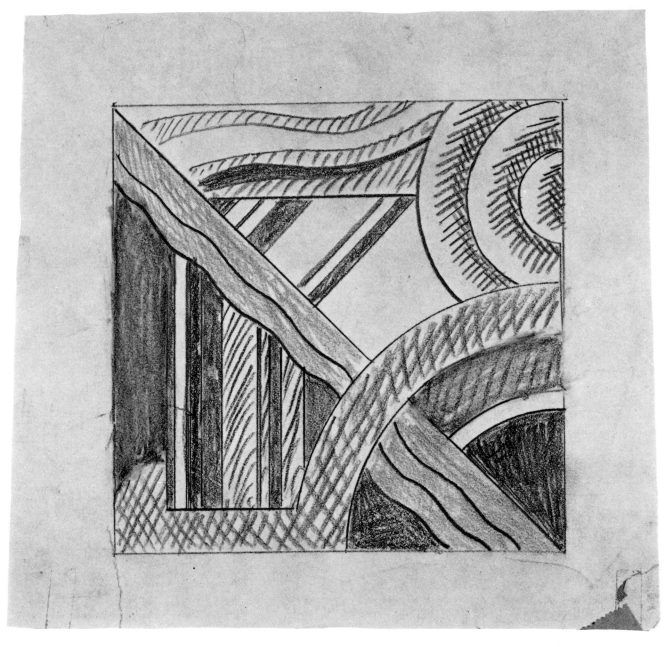

67–13
Study for **MODERN PAINTING WITH TARGET** *(1967)*

Pencil and colored pencil, 6½×6¾ in. sheet
Private collection, New York

67–14
Study for **MODERN PAINTING WITH TARGET** *(1967)*

Pencil, 6½×6½ in. sheet
Private collection, New York

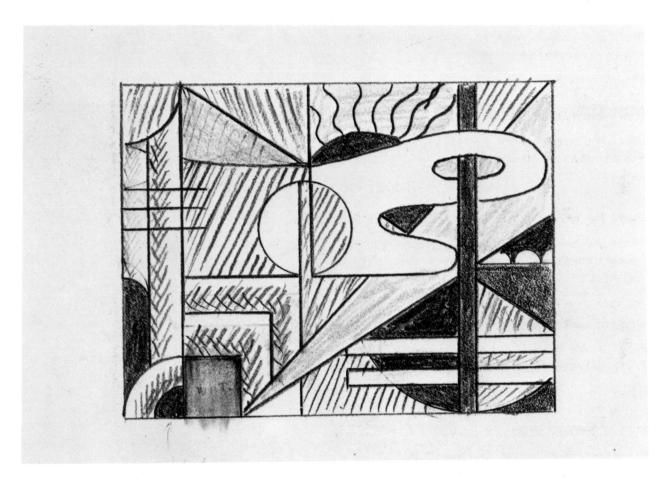

67–15
Study for **MODERN PAINTING WITH BLACK SUN** *(1967)*

Pencil and colored pencil, 4½×6½ in. sheet
Private collection, New York

67–16
Study for **MODERN PAINTING WITH RED COLUMN** *(1967)*

Pencil and colored pencil, 3⅝×3½ in. sheet
Private collection, New York

67–17
Modern painting sketch *(c. 1967)*

Pencil and colored pencil, 6×6 in. sheet
Private collection, New York

67–18
Study for **MODERN PAINTING WITH BLACK SEMI-CIRCLE** *(1967)*

Pencil and colored pencil, 5×3⅞ in. sheet irregular
Private collection, New York

67–19
Study for **RED AND YELLOW MODERN PAINTING** *(1967)*

Pencil and colored pencil, 6¾×6½ in. diagonal sheet
Private collection, New York

67–20
Study for **RED, YELLOW AND BLUE MODERN PAINTING** *(1967)*

Pencil and colored pencil, 4⅞×5¼ in. sheet
Private collection, New York

67–21
Study for **YELLOW AND BLUE MODERN PAINTING** *(1967)*

Pencil and colored pencil, 4⅞×4⅛ in. sheet
Private collection, New York

67–22
Modern painting sketch *(c. 1967)*

Pencil, 4×4½ in. sheet
Private collection, New York

67–23
Modern painting sketch *(c. 1967)*

Pencil and colored pencil, 4⅝×5 in. sheet
Private collection, New York

67–24
Modern painting sketch *(c. 1967)*

Pencil and colored pencil, 3×3¾ in. sheet
Private collection, New York

67–25
Modern painting sketch *(c. 1967)*

Pencil and colored pencil, 4×4⅛ in. sheet
Private collection, New York

67–26
Modern painting sketch *(c. 1967)*

Pencil and colored pencil, 3½×4½ in. sheet
Private collection, New York

67–27
Modern painting with moon sketch *(c. 1967)*

Pencil and colored pencil, 3¾×3 in. sheet
Private collection, New York

67–28
Modern painting with moon sketch *(c. 1967)*

Pencil and colored pencil, 4½×3⅞ in. sheet
Private collection, New York

67–29
Modern painting with moon sketch *(c. 1967)*

Pencil and colored pencil, 6½×5⅝ in. sheet
Private collection, New York

67–30
Preliminary study for **MODERN PAINTING WITH WEDGE** *1967*

Pencil and colored pencil, 4⅞×6¾ in. sheet
Collection Mr. and Mrs. W. B. McHenry, New York

67–31
Study for **MODERN PAINTING** *(1967)*

Pencil and colored pencil, 4¼×4½ in. sheet
Private collection, New York

67–32
Modern painting sketch *(c. 1967)*

Pencil and colored pencil, 3¼×5 in. sheet
Private collection, New York

67–33
Study for **MODERN PAINTING WITH YELLOW ARROW** *(1967)*

Pencil and colored pencil, 2¾×4½ in. sheet
Private collection, New York

67–34
Study for **BLUE AND GREEN MODERN PAINTING** *(1967)*

Pencil and colored pencil, 4¾×4½ in. sheet
Private collection, New York

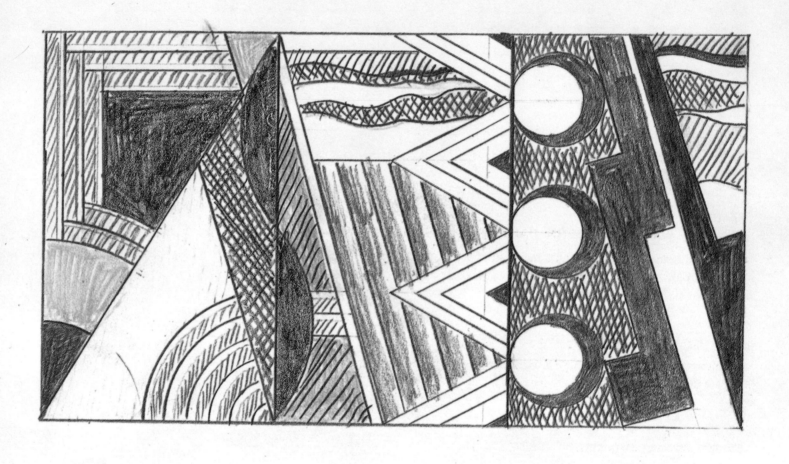

67–35
Study for **MODERN PAINTING WITH CLEF** *(1967)*

Pencil and colored pencil, 6⅝×10¼ in. sheet
Private collection, New York

67–36
Preliminary study for **MODERN PAINTING WITH CLEF** *(1967)*

Pencil and colored pencil, 6⅝×10¼ in. sheet
Private collection, New York

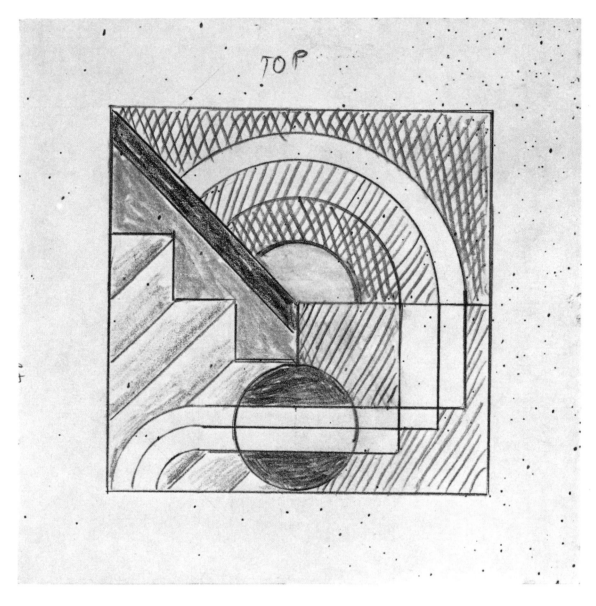

67–37
Study for **MODERN PAINTING WITH RED SLANT** (1967)

Pencil and colored pencil, 6×5⅞ in. sheet
Private collection, New York

67–38
Modern painting sketch (c. 1967)

Ink, 3×5 in. sheet
Private collection, New York

67–39
Modern painting sketch (c. 1967)

Pencil and colored pencil, 6×6½ in. sheet
Private collection, New York

67–40
Study for **MODERN PAINTING WITH ZIGZAG** (1967)

Ink, 3×5 in. sheet
Private collection, New York

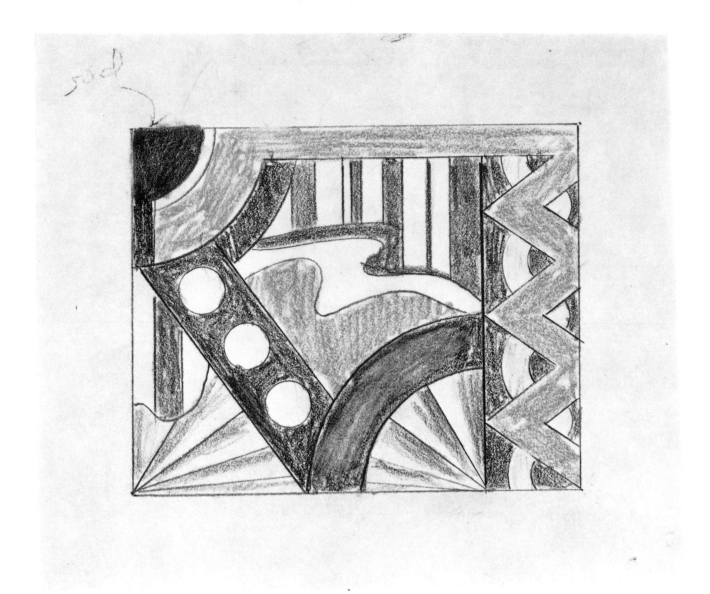

67–41
Study for **MODERN PAINTING WITH ZIGZAG** *(1967)*

Pencil and colored pencil, 5⅞ × 6¾ in. sheet
Private collection, New York

67–42
Study for **MODERN PAINTING WITH ZIGZAG** *(1967)*

Pencil, 5¾ × 6½ in. sheet
Private collection, New York

67–43
Study for **LITTLE AVIATION** *(1967)*

Pencil and colored pencil, 23¼ × 15¼ in. sheet
Private collection, New York

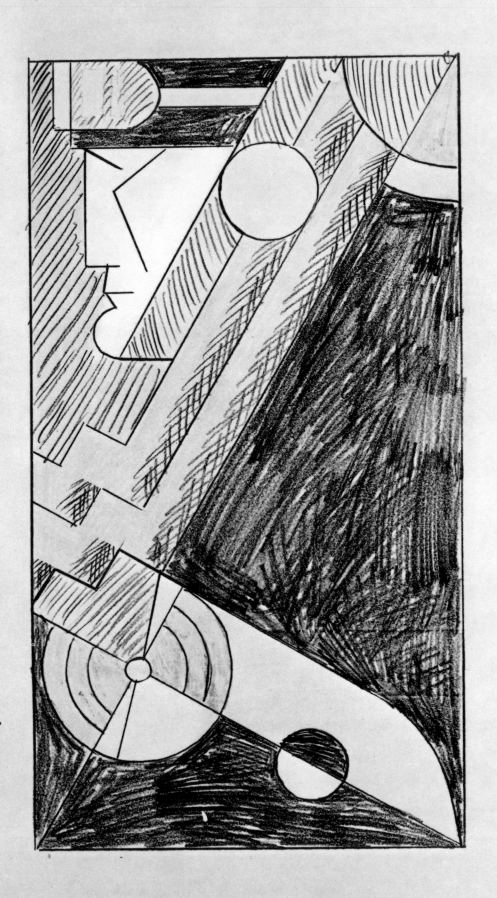

67–44
Study for **LITTLE AVIATION** *(1967)*

Pencil, 22×15 in. sheet
Private collection, New York

67–46
Study for **AVIATION** *(1967)*

Pencil, 22×26¼ in. sheet
Private collection, New York

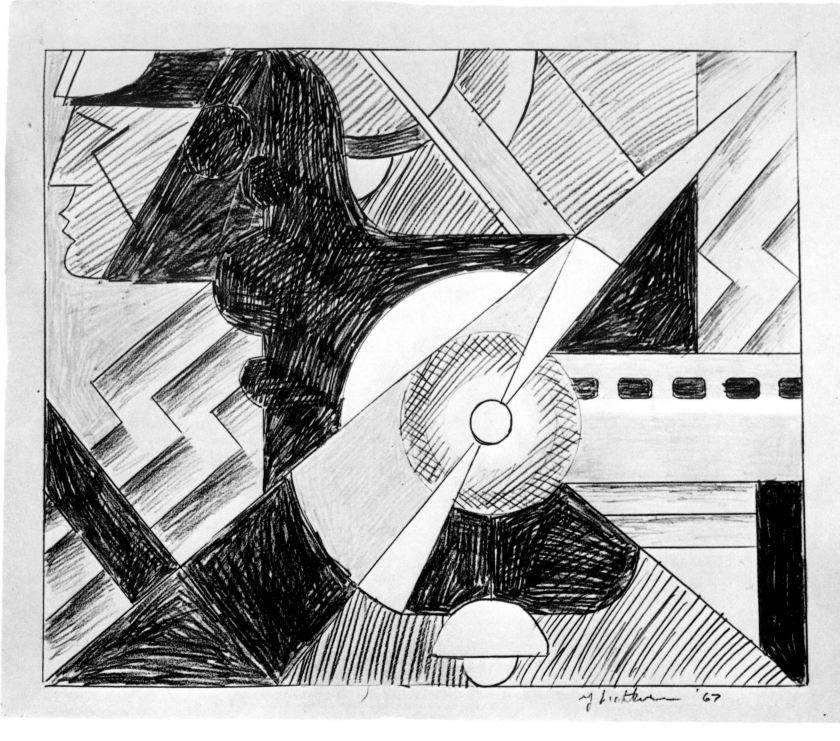

67–45
Study for **AVIATION** *(1967)*

Pencil and colored pencil, 22⅞×27⅛ in. sheet
Private collection, New York

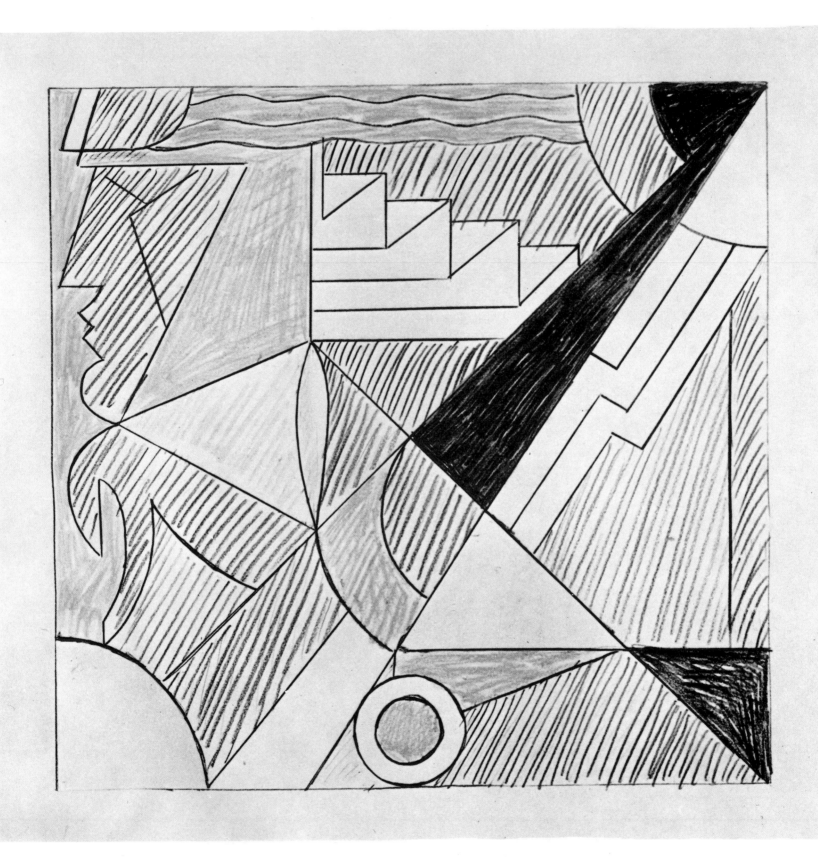

67–47
Study for *Studio International* Cover *(1967)*

Pencil, colored pencil and pasted paper, 22½ × 22⅜ in. sheet
Private collection, New York

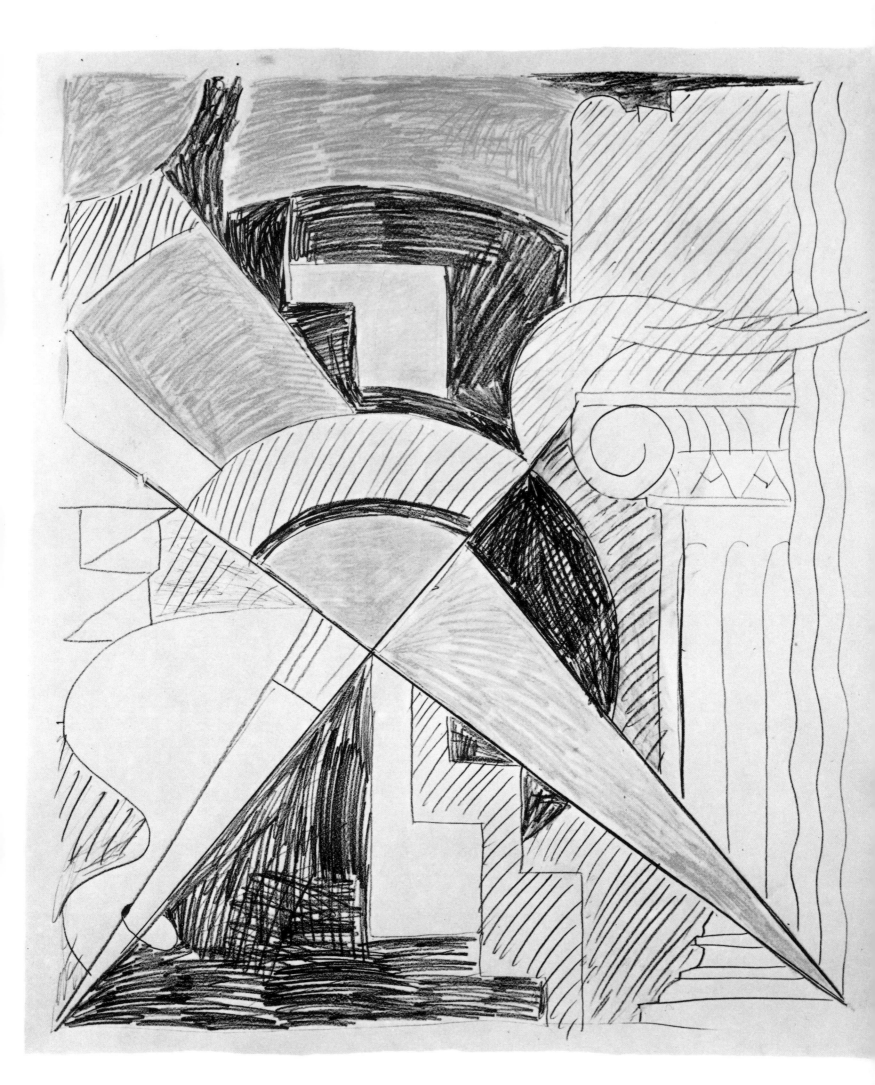

67–48
Study for *Studio International* Cover (1967)

Pencil, 22×30 in. sheet
Private collection, New York

67–49
Preliminary study for **STEDELIJK MUSEUM POSTER** (1967)

Pencil and colored pencil, 22¾×26¾ in. sheet
Private collection, New York

67–50
Preliminary study for **STEDELIJK MUSEUM POSTER** (1967)

Pencil, 22⅛×26⅜ in. sheet
Pivate collection, New York

67–51
Study for **STEDELIJK MUSEUM POSTER** (1967)

Pencil, colored pencil and pasted paper, 32¼×26¼ in. sheet
Private collection, New York

67–52
Study for **STEDELIJK MUSEUM POSTER** (1967)

Pencil, 32⅛×26⅞ in. sheet
Private collection, New York

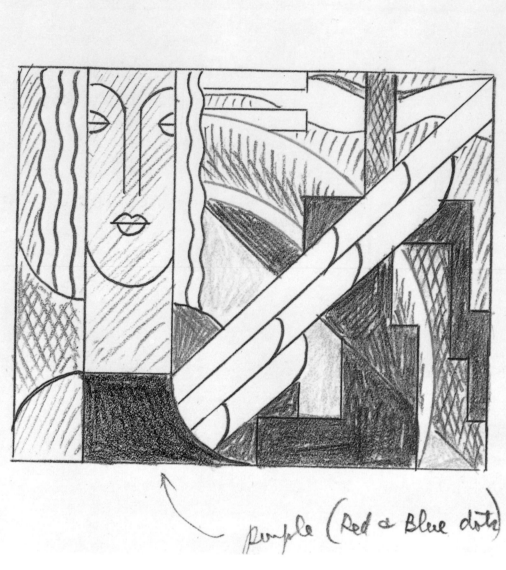

purple (Red & Blue dots)

67–53
Study for **MODERN PAINTING WITH CLASSIC HEAD** *(1967)*

Pencil and colored pencil, 6×7 in. sheet
Private collection, New York

67–54
Study for **MODERN PAINTING WITH CLASSIC HEAD** *(1967)*

Pencil, 6×6⅞ in. sheet
Private collection, New York

67–55
Study for **MODERN ART POSTER** *(1967)*

Ink and pasted papers, 14½×18⅛ in. sheet
Private collection, New York

67–56
Study for **MODERN PAINTING WITH IONIC COLUMN** *(1967)*

Pencil, colored pencil and pasted papers, 25⅜ × 33⅜ in. sheet
Private collection, New York

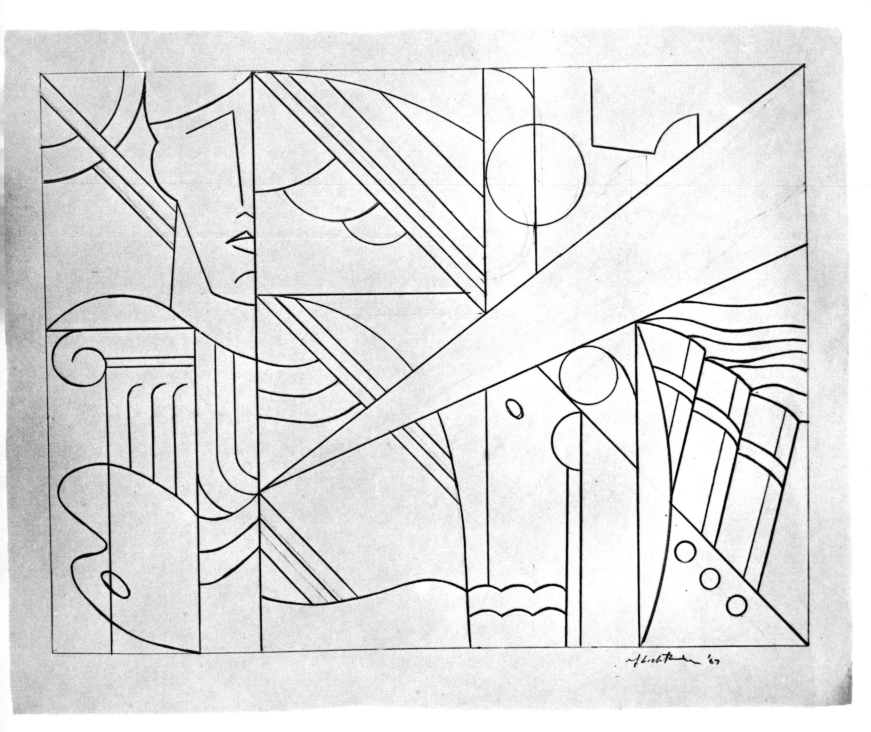

67–57
Study for **MODERN PAINTING WITH IONIC COLUMN** *(1967)*

Pencil, 27½ × 34⅝ in. sheet
Private collection, New York

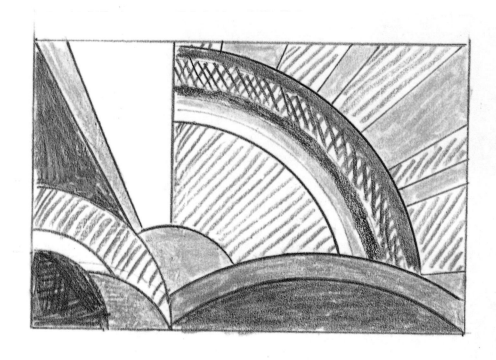

67–58
Study for **MODERN PAINTING WITH SUN RAYS** *(1967)*

Pencil and colored pencil, 4⅜×6½ in. sheet
Private collection, New York

67–59
Study for **MODERN PAINTING WITH SUN RAYS** *(1967)*

Pencil and colored pencil, 2½×4 in.
Collection Mr. and Mrs. Horace H. Solomon, New York

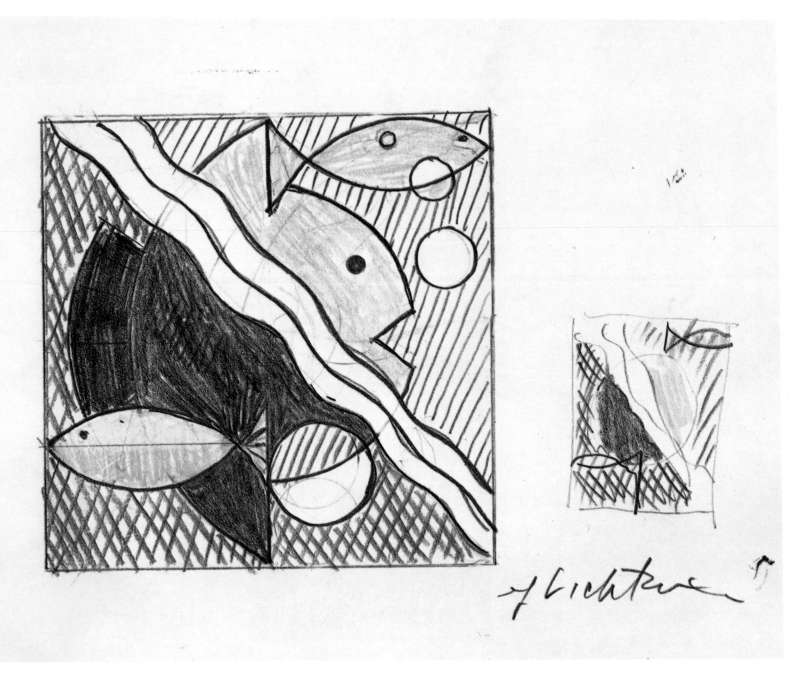

67–60
Preliminary study for **MODERN PAINTING WITH FISHES** *(1967)*

Pencil and colored pencil, 6⅝×8¾ in. sheet
Private collection, New York

67–61
Preliminary study for **MODERN PAINTING WITH FISHES** *(1967)*

Pencil and colored pencil, 7½×6¾ in. sheet
Private collection, New York

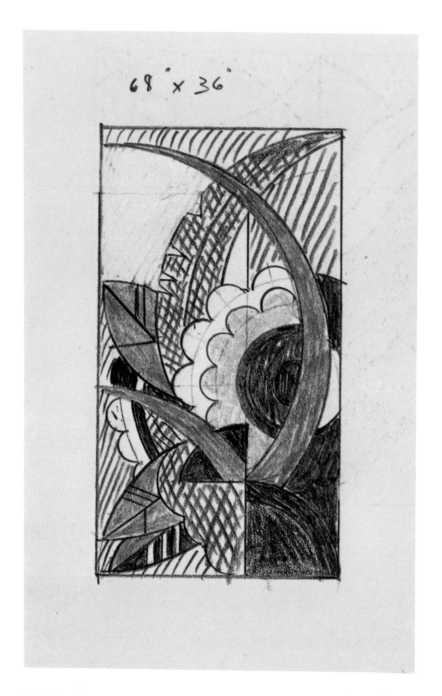

67–62

Preliminary study for **MODERN PAINTING WITH FLORAL FORMS** *(1967)*

Pencil and colored pencil, 6⅝ × 4⅛ in. sheet
Private collection, New York

67–63
Study for **ASPEN WINTER FESTIVAL POSTER** *(1967)*

Pencil and colored pencil, 7 × 4½ in.
Collection Mr. and Mrs. Horace H. Solomon, New York

67–64
Study for **PAPER PLATE** *(c. 1967)*

Pencil, colored pencil and pasted paper, 12 × 12 in. sheet
Private collection, New York

67–65
Modern painting sketch *(1967)*

Colored pencil, 3 × 9 in.
Collection L. M. Asher Family, Los Angeles

67–66
Sketch

Pencil and colored pencil, 4½ × 7 in.
Collection Sterling Halloway

67–67
Sketch *(c. 1967)*

Colored pencil
Collection William N. Copley, New York

68–4
Study for a painting related to **YELLOW ABSTRACTION** *(c. 1968)*

Pencil and ink, 6 × 11½ in. sheet
Private collection, New York

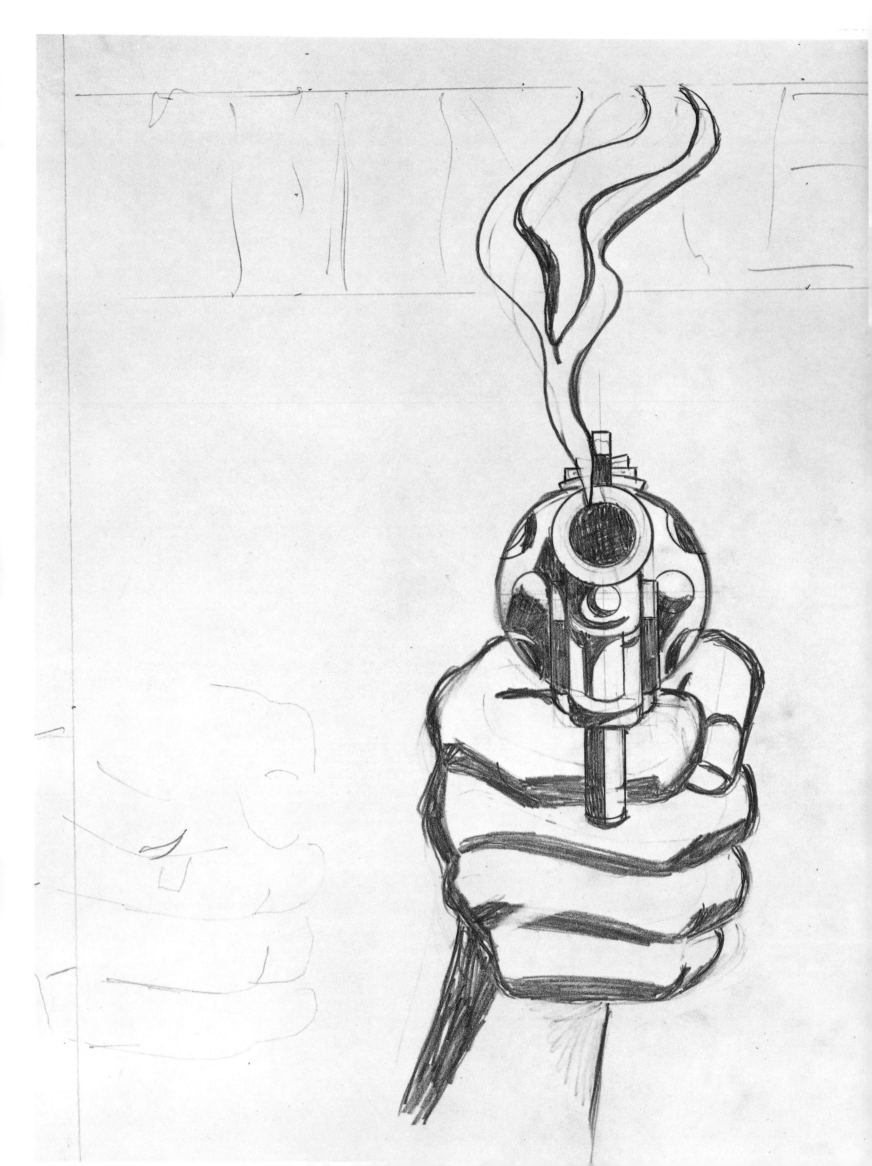

68–5
Study for *Time Magazine* Cover (1968)

Pencil, 16⅜×12⅛ in. sheet
Private collection, New York

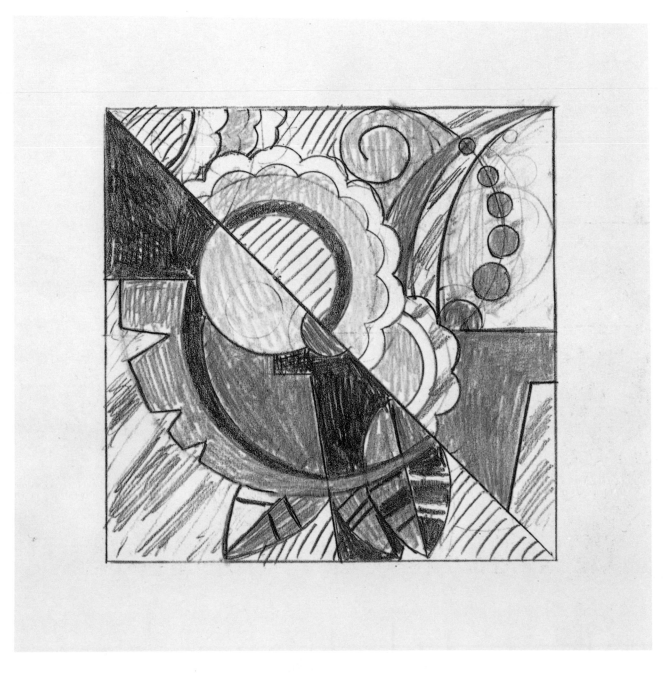

68–6
Study for silkscreen **MODERN PLAQUE WITH FLORAL PATTERN** (1968)

Pencil and colored pencil, 6½×6¾ in. sheet
Private collection, New York

68–7
Sheet of studies for **LEDA AND THE SWAN** enamels *(1968)*

Pencil, 19×35¼ in. sheet
Private collection, New York

68–8
Study for **LEDA AND THE SWAN** enamels, left panel *(1968)*

Pencil and colored pencil, 8×22⅝ in. sheet
Collection Patricia Hills, New York

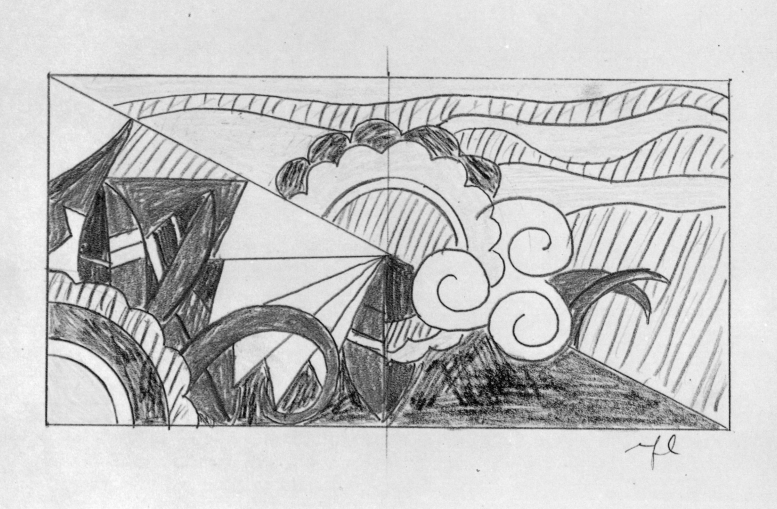

68–9
Study for **LEDA AND THE SWAN** enamels, center panel *(1968)*

Pencil and colored pencil, 7¼×11¾ in. sheet
Private collection, New York

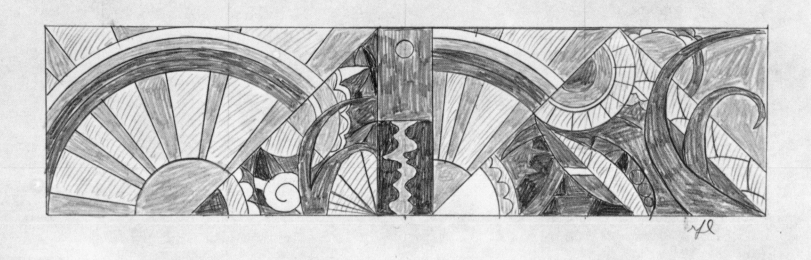

68–10
Study for **LEDA AND THE SWAN** enamels, right panel *(1968)*

Pencil and colored pencil, 9¼×23 in. sheet
Private collection, New York

68–11
Study for silkscreen **SALUTE TO AVIATION** *(1968)*

Pencil and colored pencil, 8×3¾ in. sheet
Private collection, New York

68–12
Study for silkscreen **SALUTE TO AVIATION** *(1968)*

Pencil, 39½×25 in. sheet
Private collection, New York

68–13
Preliminary study for **PREPAREDNESS** *(1968)*

Pencil, 8½×11 in. sheet
Private collection, New York

68–14
Study for Enamel Pin *(1968)*

Pencil and colored pencil, 6×4⅝ in.
Collection the artist

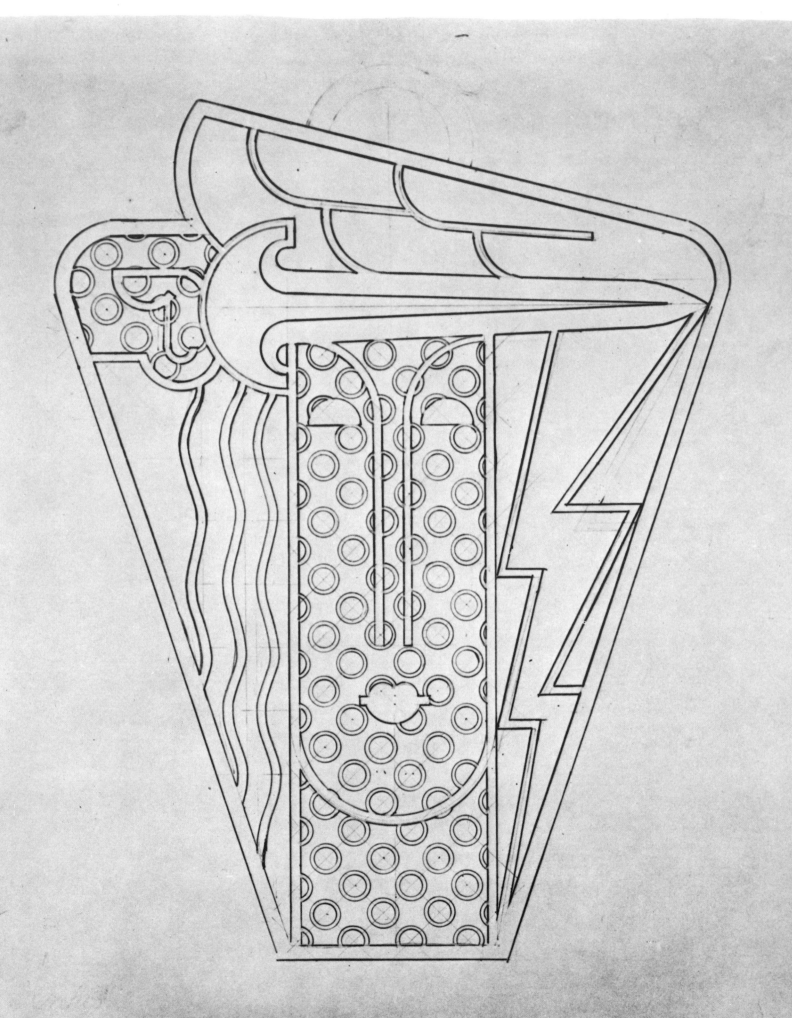

68–15
Study for Enamel Pin (1968)

Pencil, 24⅜×20 in. sheet
Private collection, New York

68–16
Study for **TOWN AND COUNTRY** (1968)

Pencil, 18⅝×15 in. sheet
Private collection, New York

68–17
Study for **MODERN PAINTING WITH NINE PANELS** (1968)

Pencil and colored pencil, 8½×11 in. sheet
Private collection, New York

199

68–18
Study for wallpaper design *(1968)*

Pencil and colored pencil, 6¾ × 8½ in. sheet
Private collection, New York

68–19
Study for wrapping paper *(1968)*

Pencil and colored pencil, 7½ × 8⅛ in.
Private collection, New York

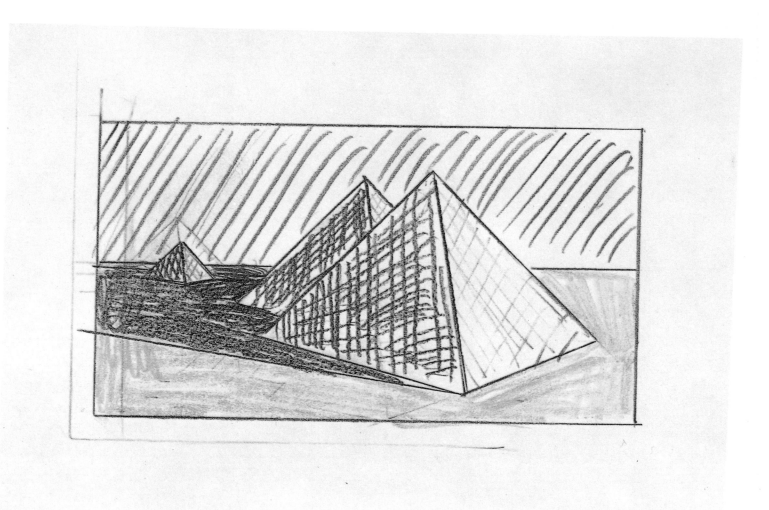

68–20
Study for **PYRAMIDS** *(1968)*

Pencil and colored pencil, 5 × 7⅝ in. sheet
Private collection, New York

68–21
Pyramids sketch *(1968)*

Pencil, 20 × 25½ in. sheet
Private collection, New York

68–22
Pyramids sketch *(1968)*

Pencil, 20 × 25½ in. sheet
Private collection, New York

68–23
Pyramids sketch *(1968)*

Pencil, 20×25½ in. sheet
Private collection, New York

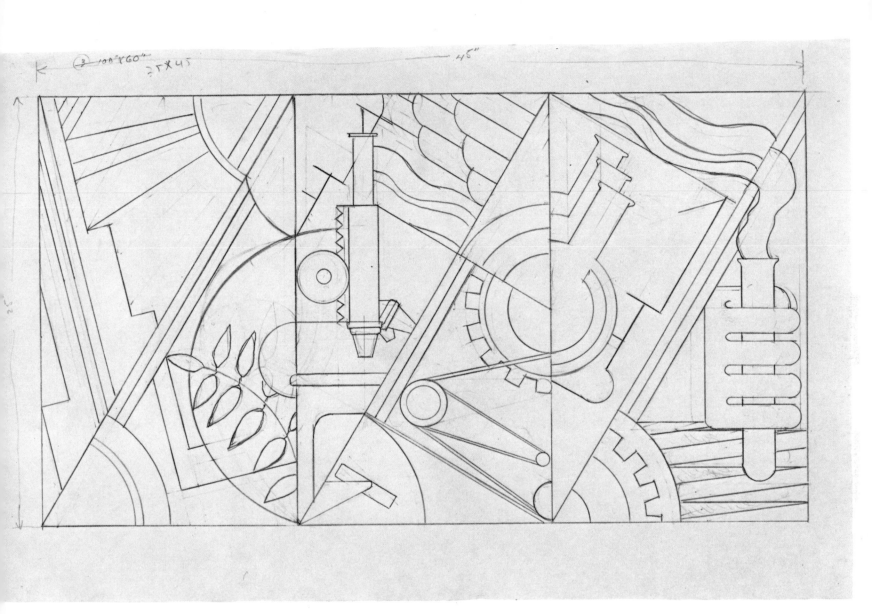

68–24
Study for **PEACE THROUGH CHEMISTRY** *(1968)*

Pencil, 13×20 in. sheet
Private collection, New York

68–25
Sculpture design sketch *(1968–1969)*

Pencil, 12⅝×20 in. sheet
Private collection, New York

68–26
Sculpture design sketch *(1968–1969)*

Pencil, 12¾×20⅛ in. sheet
Private collection, New York

69–3
Sculpture design sketch *(1969)*

Pencil, 9×28½ in. sheet
Private collection, New York

69–4
Sculpture design sketch *(1969)*

Pencil, 5¼×12½ in. sheet
Private collection, New York

69–5
Study for **MODERN RAILING** *(1969)*

Pencil, 13×39 in. sheet
Private collection, New York

69–6
Modern sculpture sketch *(1969)*

Pencil, 16½×25 in. sheet
Collection the Rhode Island School of Design

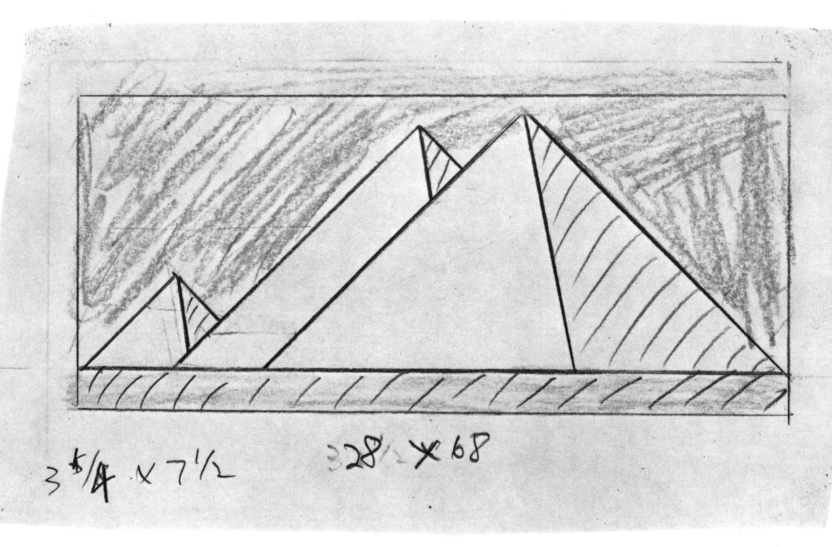

69–7
Study for **PYRAMIDS III** *(1969)*

Pencil and colored pencil, 5⅝×9 in. sheet
Private collection, New York

69–8
Pyramids sketch *(1969)*

Pencil and colored pencil, 5¼×6¾ in. sheet
Private collection, New York

69–9
Pyramids sketch *(1969)*

Pencil and colored pencil, 3⅜×4⅜ in. sheet
Private collection, New York

69–10
Pyramids sketch *(1969)*

Pencil and colored pencil, 14⅞×18¾ in. sheet irregular
Private collection, New York

69–11
Pyramids sketch *(1969)*

Pencil and colored pencil, 16¼×10¼ in. sheet
Private collection, New York

69–12
Pyramids sketch *(1969)*

Pencil and colored pencil, 17½×24⅛ in. sheet
Private collection, New York

69–13
Pyramids sketch *(1969)*

Pencil and colored pencil, 14½×10¾ in. sheet irregular
Private collection, New York

69–14
Pyramids sketch *(1969)*

Pencil, 20×25 in. sheet
Private collection, New York

69–15
Pyramids sketch *(1969)*

Pencil and colored pencil, 19¾×20¼ in. sheet
Private collection, New York

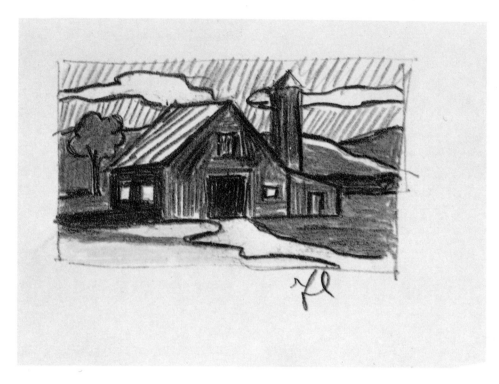

69–16
Study for **RED BARN I** *(1969)*

Pencil and colored pencil, 3⅝×5 in. sheet
Collection Mr. and Mrs. Paul Waldman, New York

69–17
Study for **RED BARN II** *(1969)*

Pencil and colored pencil, 3⅞×5⅞ in. sheet
Collection Otto Hahn, Paris

69–18
Study for **RED BARN II** *(1969)*

Collection Jack Klein, New York

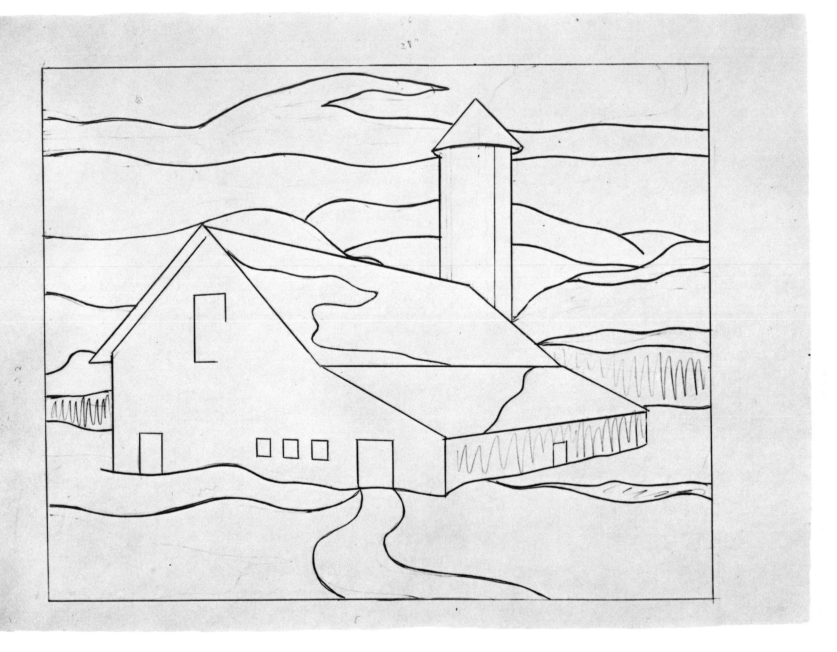

69—19
Study for **RED BARN II** *(1969)*

Pencil, 25⅝×35⅞ in. sheet
Private collection, New York

69—20
Voomp! *(1969)*

Pencil, 20×25½ in. sight
Collection Mr. and Mrs. Horace H. Solomon, New York

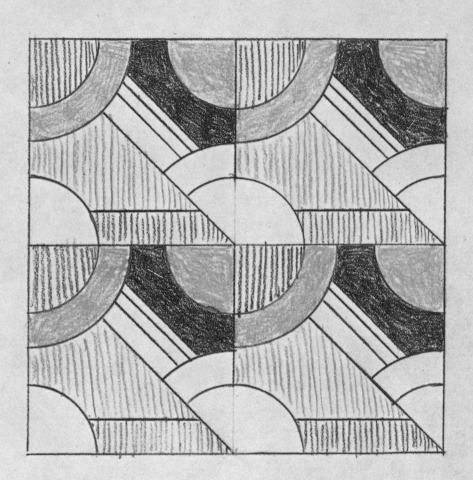

69–21
Modern painting sketch *(1969)*

Pencil and colored pencil, 15¼×12⅝ in. sheet
Private collection, New York

69–22
Modern painting sketch *(1969)*

Pencil and colored pencil, 12½×10 in. sheet
Private collection, New York

69–23
Modern painting sketch *(1969)*

Pencil and colored pencil, 19¾×12½ in. sheet
Private collection, New York

69–24
Modern painting sketch *(1969)*

Pencil and colored pencil, 5¼×4¾ in. sheet
Private collection, New York

69–25
Study for **MODULAR PAINTING WITH FOUR PANELS** *(1969)*

Pencil, 6½×6⅜ in. sheet
Private collection, New York

69–26
Study for **MODULAR PAINTING WITH FOUR PANELS** *(1969)*

Pencil and colored pencil, 10×13 in. sheet
Private collection, New York

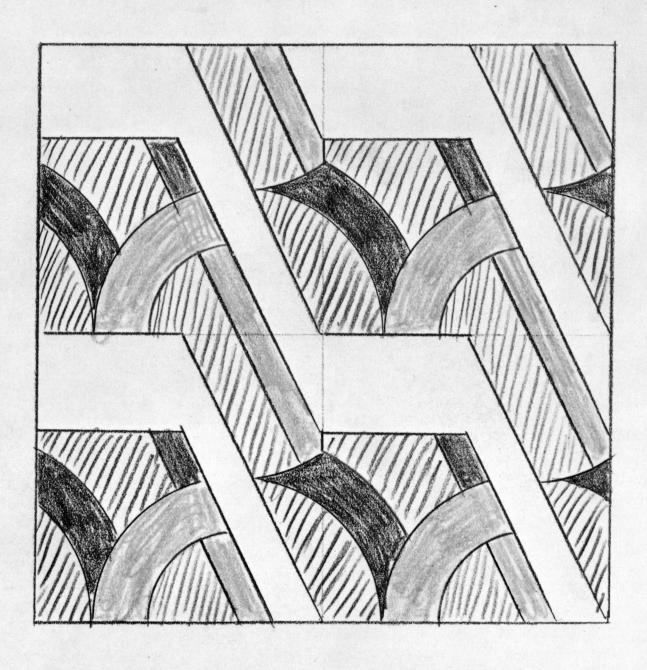

69–27
Study for **MODULAR PAINTING WITH FOUR PANELS** *(1969)*

Pencil and colored pencil, 8⅝ × 8¾ in. sheet
Private collection, New York

208

69–28
Study for **MODULAR PAINTING WITH FOUR PANELS** *(1969)*

Pencil and colored pencil, 8¼×9¼ in. sheet irregular
Private collection, New York

69–29
Study for **MODULAR PAINTING WITH FOUR PANELS** *(1969)*

Pencil and colored pencil, 8¼×8¼ in. sheet
Private collection, New York

69–30
Study for **MODULAR PAINTING WITH FOUR PANELS** *(1969)*

Pencil, 10⅛×12⅞ in. sheet
Private collection, New York

69–31
Study for **MODULAR PAINTING WITH FOUR PANELS** *(1969)*

Pencil and colored pencil, 8½×10¾ in. sheet irregular
Private collection, New York

69–32
Study for **MODULAR PAINTING WITH FOUR PANELS II** *(1969)*

Pencil and colored pencil, 7⅞×8⅜ in. sheet
Private collection, New York

69–33
Study for **MODERN PRINT I** *(1969)*

Pencil and colored pencil, 6½×12¾ in. sheet
Private collection, New York

69–34
Sheet of sketches inscribed *L'Esprit Nouveau* *(1969)*

Pencil, 12×9 in. sheet
Private collection, New York

69–35
Sheet of sketches including dove *(1969)*

Pencil, 12½×9¾ in. sheet
Private collection, New York

69–36
Sheet of sketches for **THE SOLOMON R. GUGGENHEIM
 MUSEUM POSTER** *(1969)*

Pencil and colored pencil, 6½×5¼ in. sheet
Private collection, New York

69–37
Study for **THE SOLOMON R. GUGGENHEIM MUSEUM POSTER** *(1969)*

Pencil, 29½×29¾ in. sheet
Private collection, New York

69–38
Design for **THE SOLOMON R. GUGGENHEIM MUSEUM POSTER** *(1969)*

Ink and pasted papers, 34⅝×29¾ in. sheet
Private collection, New York

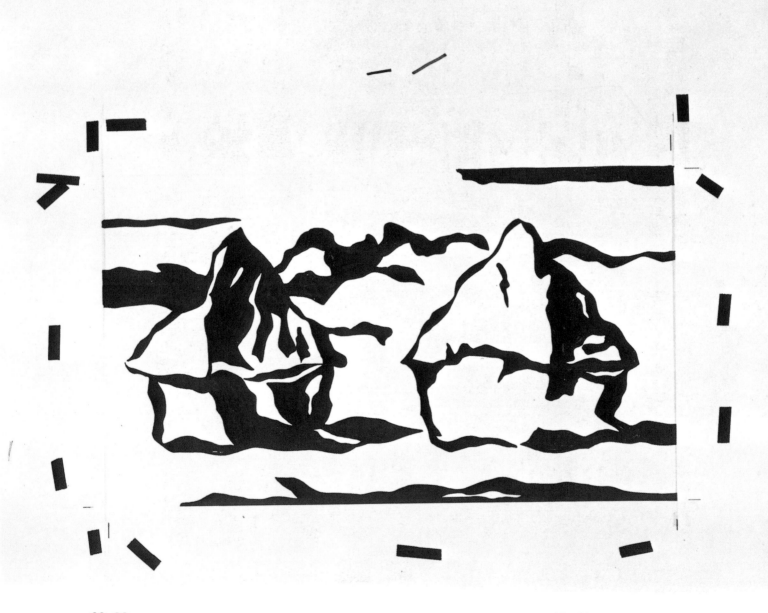

69–39
Design for **HAYSTACKS** *(1969)*
(A series of lithographs)

Ink, 13½×23⅜ in.
Private collection, New York

69–40
Design for **CATHEDRAL** *(1969)*
(A series of lithographs)

Ink, 28×42 in.
Private collection, New York

210

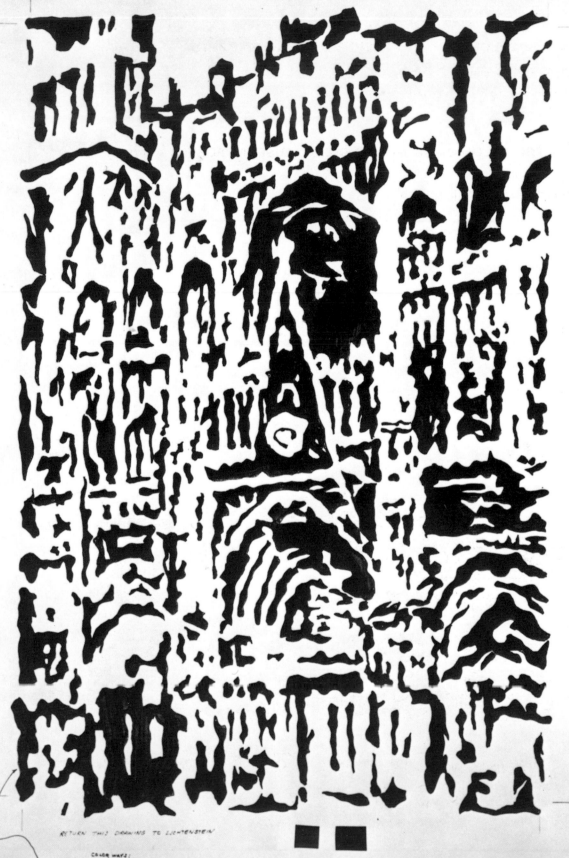

RETURN THIS DRAWING TO LICHTENSTEIN

COLOR WAYS:

← THESE FIVE MAY MAKE
THE MOST INTERESTING GROUP

BLUE DESIGNS THE DRAWN
ON THE 2 DOT PATTERNS

Catalogue of Prints 1962-1969

In the offset lithographs and silkscreens of the early 1960's Lichtenstein used conventional printing techniques. He began to experiment with new materials, particularly plastics, in 1964 and produced the first plastic silkscreen Sandwich and Soda (#7) part of the portfolio Ten Works/Ten Painters. Lichtenstein then realized that Rowlux, a type of plastic with a refractory surface resembling a moiré pattern, could be used to suggest the illusion of a landscape. In Ten Landscapes (#26A-J), he created a variety of optical effects by alternating a Rowlux sea or sky with photographic reproductions of sand, sea or sky, dot-filled horizon or shorelines, and refractory aluminized plastic moons. In Fish and Sky (#25) Lichtenstein employed still another type of plastic for a trompe-l'œil effect in which the specially ridged plastic image of fish, the black and white photograph of a cloud-filled sky, and the flat dot pattern of the shoreline form a complex interplay at once flat and suggestive of deep space.

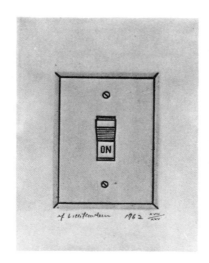

1
ON *(1962)*

Etching
9⅜×7½ in. sheet; 5¾×4½ in. plate
Edition of 100; signed *rf Lichtenstein,* dated and
 numbered below plate
From *The International Avant-Garde,* Vol. 5,
 of the *International Anthology of
 Contemporary Engraving,* edited by Tristan
 Sauvage
Published by Galeria Schwarz, Milan, Italy
Printed by Georges Leblanc, Paris

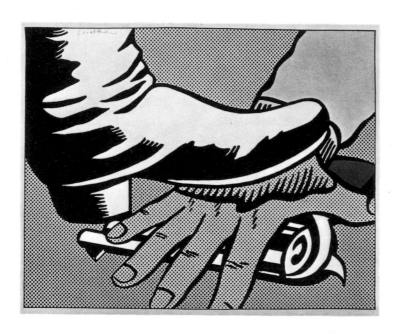

2
FOOT AND HAND *(1962)*

Offset lithograph in red, yellow and black
17¼×21½ in. sheet; 16¾×21 in. composition
Unnumbered edition; signed upper left
 rf Lichtenstein
Published by Leo Castelli Gallery, New York

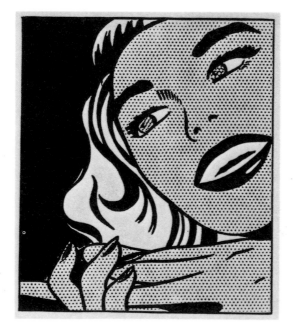

3A
GIRL *(1963)*

Lithograph in blue, red and yellow
16⅛×11½ in. sheet; 12¾×10⅝ in. composition
Edition of 100
From *One-Cent Life,* poems by Walasse Ting
Published by Kornfeld and Klipstein, Bern,
 Switzerland

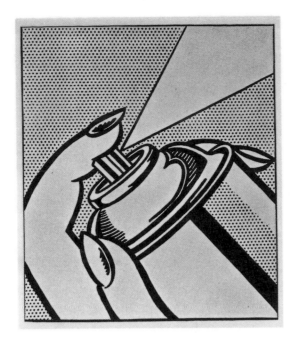

3B
SPRAY CAN *(1963)*

Lithograph in blue
16⅛×11½ in. sheet; 12¾×10⅝ in. composition
Edition of 100; signed lower right *rf Lichtenstein*
From *One-Cent Life,* poems by Walasse Ting
Published by Kornfeld and Klipstein, Bern,
 Switzerland

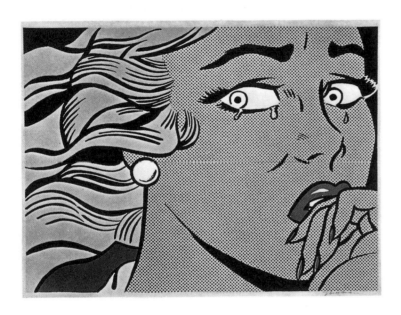

4
CRYING GIRL *(1963)*

Offset lithograph in red, yellow and black
18×24 in. sheet; 17¼×23¼ in. composition
Unnumbered edition; signed lower right
 rf Lichtenstein
Published by Leo Castelli Gallery, New York

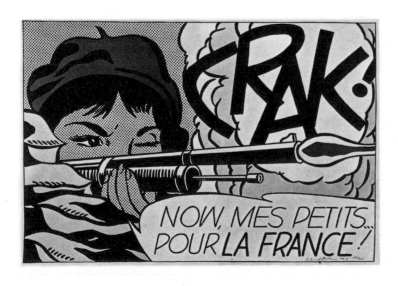

5
CRAK! *(1964)*

Offset lithograph in red, yellow and black
19¼×27¾ in. sheet; 18⅝×27 in. composition
Edition of 300; signed lower right *rf Lichtenstein,*
 dated and numbered
Published by Leo Castelli Gallery, New York

217

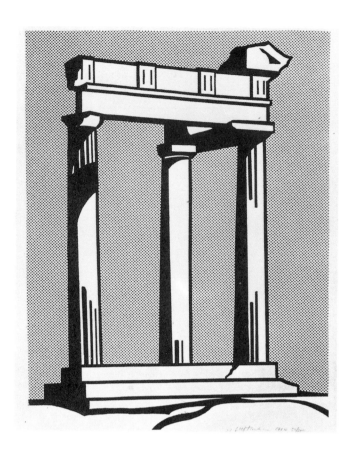

6
TEMPLE *(1964)*

Offset lithograph in blue and black
23¾ × 17¾ in. sheet; 23⅛ × 17⅛ in. composition
Edition of 300; signed lower right *rf Lichtenstein,*
 dated and numbered
Published by Leo Castelli Gallery, New York

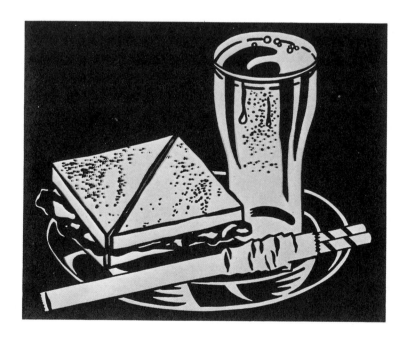

7
SANDWICH AND SODA *(1964)*

Silkscreen in blue and red on white plastic
20 × 24 in. sheet; 19 × 23 in. composition
Edition of 500; signed lower right *rf Lichtenstein,*
 unnumbered
From the portfolio *Ten Works / Ten Painters*
Published by Wadsworth Atheneum, Hartford,
 Connecticut
Printed by Ives-Sillman, New Haven, Connecticut

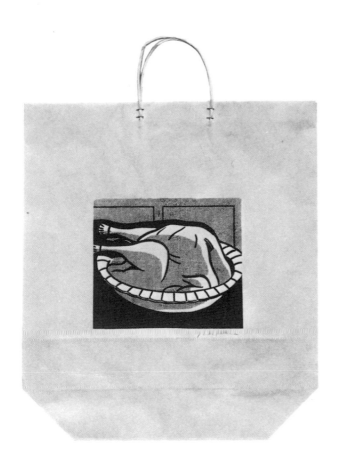

8
TURKEY SHOPPING BAG *(1964)*

Silkscreen in yellow and black and also in yellow
 and red
23¼×17 in. bag (including handle);
 7½×8⅝ in. composition
Edition of 200; signed below composition right
 rf Lichtenstein, unnumbered
Published by Bianchini Gallery, New York
Printed by Ben Birillo, New York

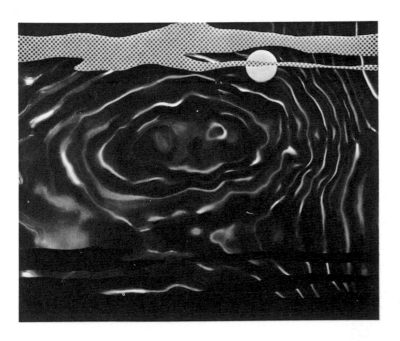

9
MOONSCAPE *(1965)*

Silkscreen in blue, red and white on metallic
 Rowlux
20×24 in. sheet and composition
Edition of 200 plus 20 reserved for Philip
 Morris Inc.; signed and dated on reverse
From *11 Pop Artists* portfolio, Vol. I
Published by Original Editions, New York

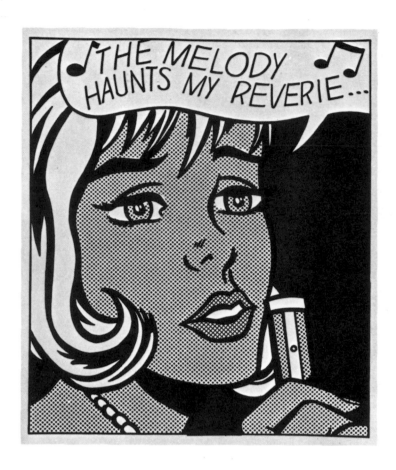

10
THE MELODY HAUNTS MY REVERIE
(1965)

Silkscreen in red, blue, yellow and black
30×24 in. sheet; 27×22⅞ in. composition
Edition of 200 plus 20 reserved for Philip
 Morris Inc.; numbered lower left and signed
 lower right *rf Lichtenstein*
From *11 Pop Artists* portfolio, Vol. II
Published by Original Editions, New York

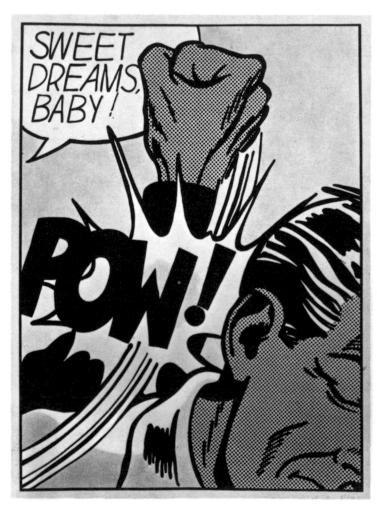

11
SWEET DREAMS, BABY! *(1965)*

Silkscreen in red, yellow and black
37⅝×27½ in. sheet; 35⅝×25½ in. composition
Edition of 200 plus 20 reserved for Philip
 Morris Inc.; signed lower right *rf Lichtenstein*
From *11 Pop Artists* portfolio, Vol. III
Published by Original Editions, New York

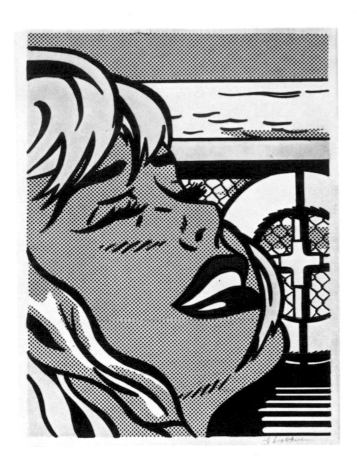

12
SHIPBOARD GIRL *(1965)*

Offset lithograph in red, blue, yellow and black
27⅛ × 20¼ in. sheet; 26 × 19¼ in. composition
Unnumbered edition; signed lower right
 rf Lichtenstein
Published by Leo Castelli Gallery, New York

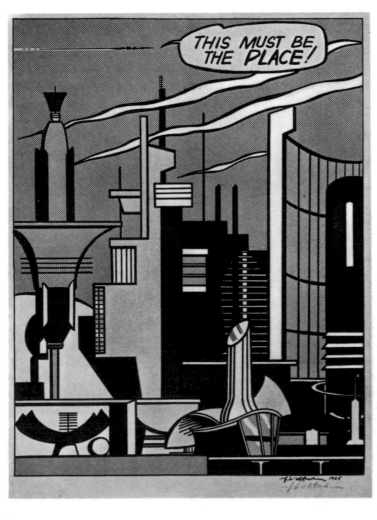

13
THIS MUST BE THE PLACE *(1965)*

Offset lithograph in red, yellow and black
24¾ × 17¾ in. sheet; 21⅜ × 16 in. composition
Unnumbered edition; signed and dated on plate
 lower right *rf Lichtenstein,* signed in pencil
 below printed signature
Published by the American Cartoonists Society

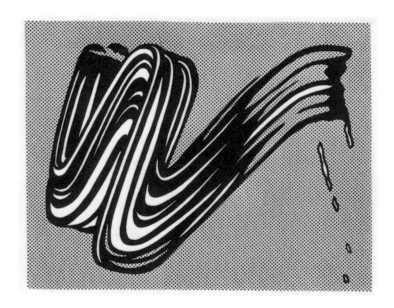

14
BRUSHSTROKE *(1965)*

Silkscreen in yellow, blue and black
23 × 29 in. sheet; 22¼ × 28⅜ in. composition
Edition of 280; signed lower right *rf Lichtenstein,*
 numbered
Published by Leo Castelli Gallery, New York

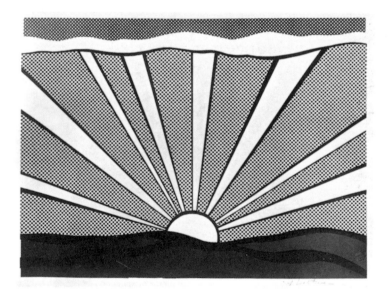

15
SUNRISE *(1965)*

Offset lithograph in red, blue and yellow
18⅜ × 24⅜ in. sheet; 17¼ × 23¼ in. composition
Unnumbered edition: signed lower right
 rf Lichtenstein
Published by Leo Castelli Gallery, New York

16
SEASCAPE *(1965)*

Silkscreen in blue and white on clear Rowlux
17 × 21⅞ in. sheet and composition
Edition of 200
From *New York Ten* portfolio
Published by Tanglewood Press Inc., New York

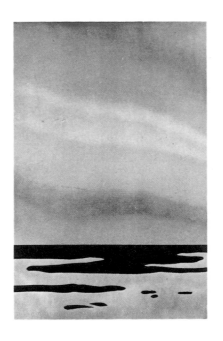

17
NEW SEASCAPE *(1966)*

Silkscreen in black on optical plastic
12×8 in. sheet and composition
Edition of 70; signed verso
Published by Leo Castelli Gallery, New York

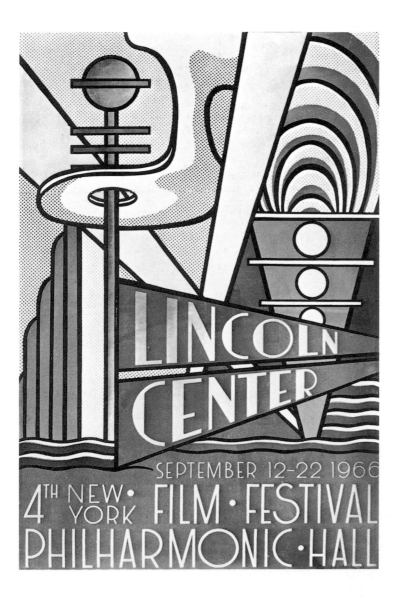

18
LINCOLN CENTER POSTER *(1966)*

Silkscreen in red. blue, yellow and black on silver
 paper
45½×29½ in. sheet
Edition of 100; signed *rf Lichtenstein,* dated and
 numbered
Published by List Art Posters, New York

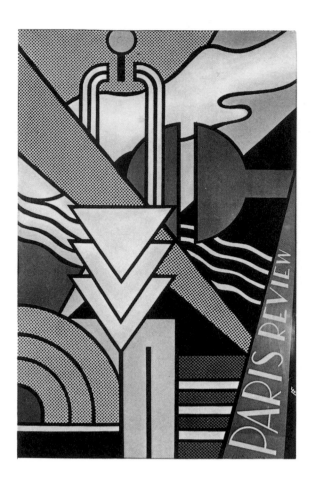

19
PARIS REVIEW POSTER *(1966)*

Silkscreen in red, yellow, blue and black
40×26 in. sheet and composition
Edition of 150; signed lower right *rf Lichtenstein,*
 numbered
Published by *Paris Review*
Printed by Chiron Press, New York

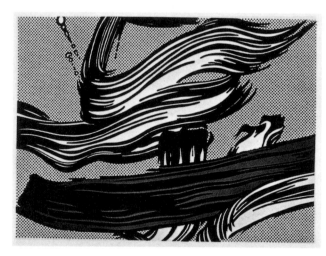

20
BRUSHSTROKES *(1967)*

Silkscreen in red, yellow, blue and black
23×31 in. sheet; 22×30 in. composition
Edition of 300; signed lower right *rf Lichtenstein*
Published by Pasadena Art Museum, California

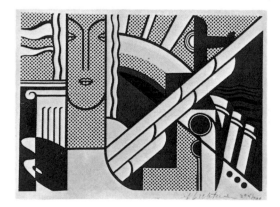

21
MODERN ART POSTER *(1967)*

Silkscreen in red, yellow and blue
9×12 in. sheet; 8×11 in. composition
Edition of 300; signed lower right *rf Lichtenstein,*
 numbered
Published by Leo Castelli Gallery, New York

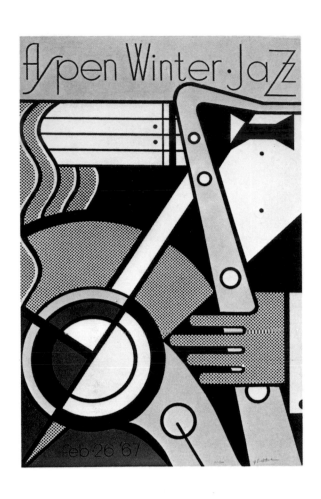

22

ASPEN WINTER JAZZ *(1967)*

Silkscreen in red, yellow and black
40×26 in. sheet and composition
Edition of 300; signed lower right *rf Lichtenstein,*
 numbered
Published by Leo Castelli Gallery, New York for the
 Aspen Winter Jazz Festival, commissioned by
 John Powers
Printed by Chiron Press, New York

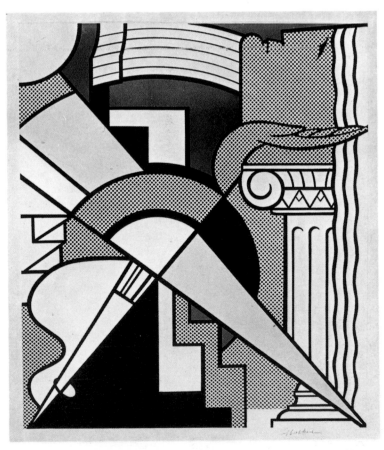

23

STEDELIJK MUSEUM POSTER *(1967)*

Offset lithograph in red, yellow and black
31¼×25 in. sheet; 30×25 in. composition
Unnumbered edition; signed lower right
 rf Lichtenstein
Published by the Stedelijk Museum, Amsterdam

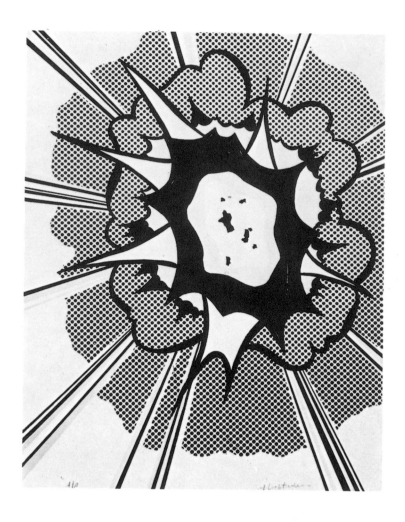

24
EXPLOSION *(1967)*

Lithograph in red, yellow and blue
22×17 in. sheet and composition
Edition of 100; signed lower right *rf Lichtenstein,*
 numbered lower left
From *Portfolio 9*
Published and printed by Irwin Hollander,
 New York

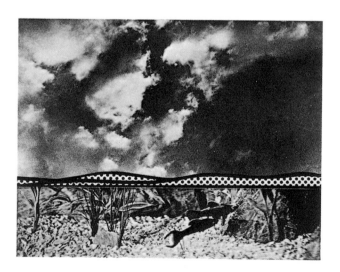

25
FISH AND SKY *(1967)*

Silkscreen in black and white and photomontage
 on laminated plastic
11×14 in. sheet and composition
Edition of 200
From *Ten from Leo Castelli* portfolio
Published by Tanglewood Press Inc., New York

26

TEN LANDCAPES *(1967)*

The following ten landscapes were published by Original Editions, New York, 1967,
 in collaboration with the Leo Castelli Gallery, New York, in an edition of 100.
Each work is laminated to composition board and mounted (16⅝×21⅝ in.)
Each is signed *rf Lichtenstein* and dated on reverse.

26A
LANDSCAPE 1

Silkscreen in red, yellow, blue and black
11×18 in. sheet and composition

26B
LANDSCAPE 2

Silkscreen in white on gray and white Rowlux
11⅞×18 in. sheet and composition

26C
LANDSCAPE 3

Silkscreen in yellow and black and color photo-
 graphic reproduction
12×16⅝ in. sheet and composition

26D
LANDSCAPE 4

Silkscreen in black
11⅛×18 in. sheet and composition

26E
LANDSCAPE 5

Silkscreen in yellow and black on blue and pink
 Rowlux
14⅞×17⅞ in. sheet and composition

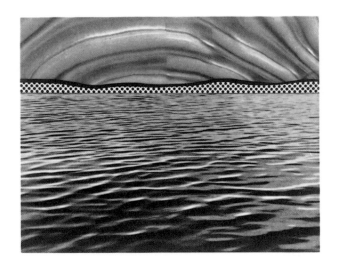

26F
LANDSCAPE 6

Blue Rowlux, silkscreen in black and color
 photographic reproduction
13⅛×16¼ in. sheet and composition

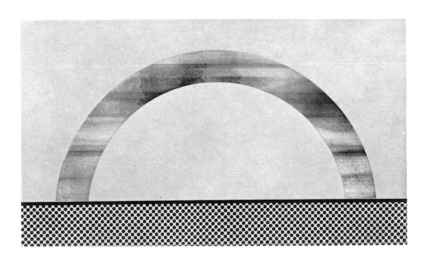

26G
LANDSCAPE 7

Silkscreen in yellow and black and plastic
10¾×18¼ in. sheet and composition

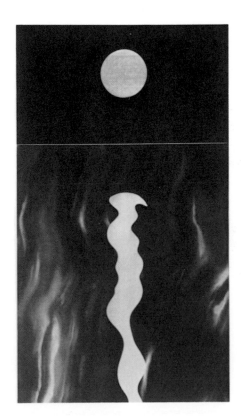

26H
LANDSCAPE 8

Gray and white Rowlux and black plastic
19⅝×11¼ in. sheet and composition

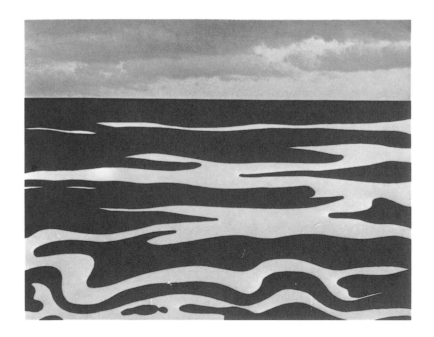

LANDSCAPE 9

Color photographic reproduction and silkscreen in black
12¾×16¼ in. sheet and composition

26J

LANDSCAPE 10

Gray Rowlux, silkscreen in black and color photo-
graphic reproduction
15½×16⅝ in. sheet and composition

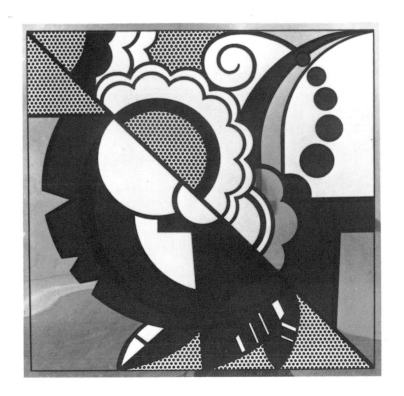

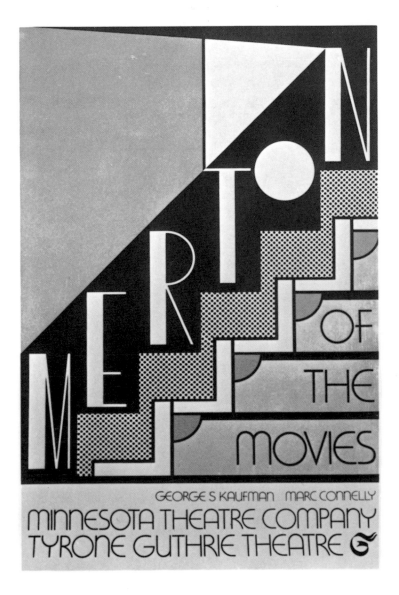

27
STILL LIFE *(1968)*

Silkscreen on aluminum in white, green, yellow
 and black
36×36 in. sheet; 34×34 in. composition
Edition of 50 plus 10 reserved for the
 Metropolitan Museum Education Department
From *The Metropolitan Scene*
Published by Tanglewood Press Inc., New York

28
MERTON OF THE MOVIES *(1968)*

Silkscreen in silver, red, yellow and black
30×20 in. sheet; 25⅝×20 in. composition
Edition of 450; signed below composition
 lower right *rf Lichtenstein,* numbered
List Art Poster published by H.K.L. Ltd., New York

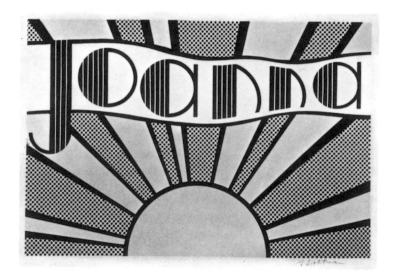

29

JOANNA *(1968)*

Offset lithograph in blue and yellow
20¾×27⅝ in. sheet; 15⅜×22¾ in. composition
Unnumbered edition; signed lower right
 rf Lichtenstein
Published by Twentieth Century Fox for
 the movie *Joanna,* not released for sale

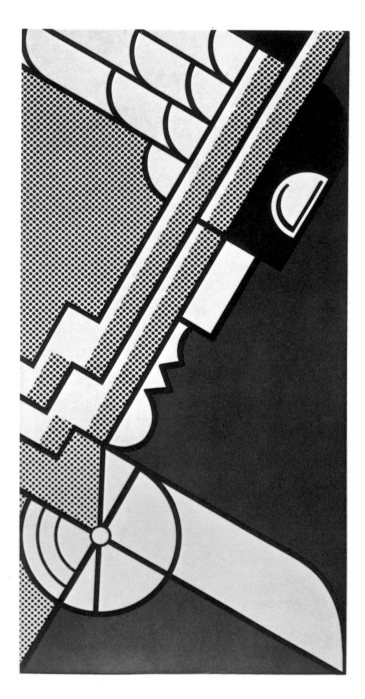

30

SALUTE TO AVIATION *(1968)*

Silkscreen in yellow, blue and black
45⅛×24¾ in. sheet; 43×21½ in. composition
Edition of 135; signed lower right *rf Lichtenstein,*
 numbered lower left and dated.
Published by Richard Feigen Graphics, New York
Silkscreened by Ives-Sillman, New Haven,
 Connecticut

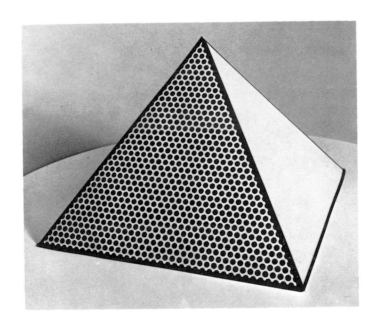

31
PYRAMID *(1968)*

Silkscreen on paper, mounted on composition
 board, folded in shape of pyramid
14×20×20 in.
Edition of 300; signed and numbered on reverse
Published by Leo Castelli Gallery, New York

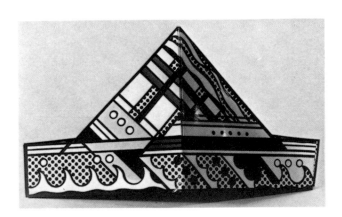

32
HAT *(1968)*

Silkscreen on vinyl-coated paper, folded in
 shape of paper hat
7¼×14 in.
Edition of 2500
Published by *The Letter Edged in Black Press,*
 Vol. I, No. 4, July-August 1968

33
HAYSTACKS in seven different color combinations *(1969)*

Lithographs each 20½×30½ in. sheet; 13⅜×23½ in. comp.
Each in edition of 100, numbered LL and signed LR *rf Lichtenstein*
Published and printed by Gemini G.E.L., Los Angeles
Copyright Gemini G.E.L. 1969

33–A
HAYSTACKS 1 in yellow

33–B
HAYSTACKS 2 in red and black

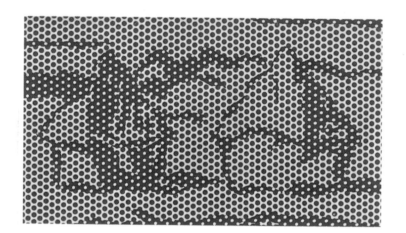

33–C
HAYSTACKS 3 in blue and black

33–D
HAYSTACKS 4 in red and blue

234

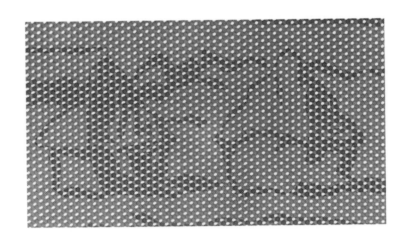

33–E
HAYSTACKS 5 in red and blue

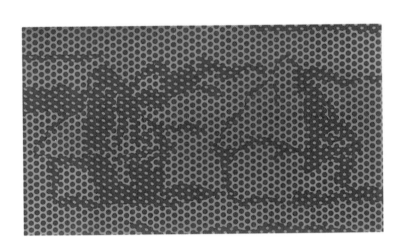

33–F
HAYSTACKS 6 in red and black

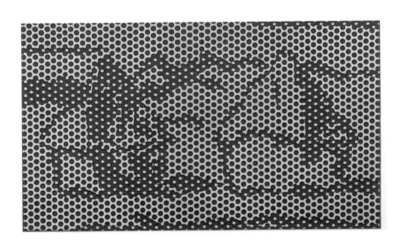

33–G
HAYSTACKS 7 in black and white embossed

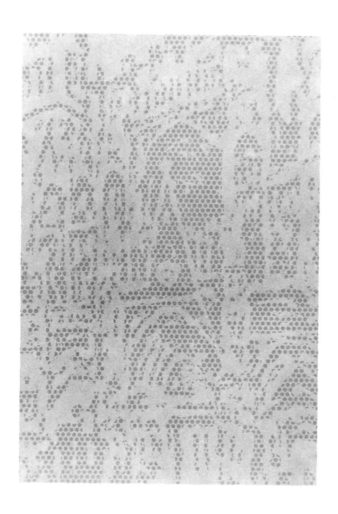

34

ROUEN CATHEDRAL in six different color combinations *(1969)*

Lithographs
Each 48¼×32¼ in. sheet; 41¾×27 in. composition
Each in edition of 75, numbered LL and signed LR
rf Lichtenstein
Published and printed by Gemini G.E.L., Los Angeles
Copyright Gemini G.E.L. 1969

34–A
ROUEN CATHEDRAL 1 in yellow

34–B
ROUEN CATHEDRAL 2 in red and blue

34–D
ROUEN CATHEDRAL 4 in red and blue

237

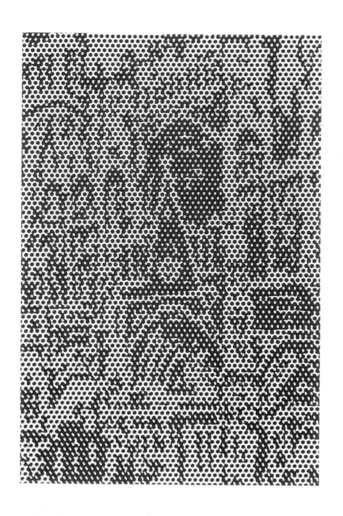

34–F
ROUEN CATHEDRAL 6 in black and blue

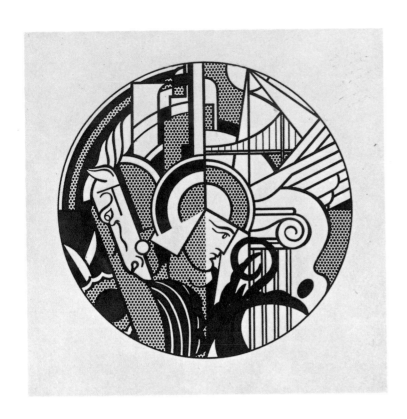

35
**THE SOLOMON R. GUGGENHEIM
MUSEUM POSTER** *(1969)*

Lithograph in red, green, yellow and black
28¾ × 28¾ in. sheet
Edition of 250 signed and numbered;
Published by Leo Castelli Gallery
 and Poster Originals Ltd., New York

36
REPEATED DESIGN *(1969)*

Lithograph in black and yellow
16¾ × 40¾ in. sheet; 12 × 35⅞ in. composition
Edition of 100; signed and numbered
Published by Roy Lichtenstein
Printed by Mourlot, New York

37
REAL ESTATE *(1969)*

Lithograph in blue
19½×39 in. sheet; 13½×32 in. composition
Edition of 100 signed
Published by Publications IRL, Lausanne, Switzerland
Printed by Mourlot, New York

Biography

Born in New York City, October 27, 1923.
Served in the U.S. Army in Europe, February 1943 to
 January 1946.
Education: Ohio State University, Columbus, Ohio.
 B.F.A., 1946, M.F.A., 1949.
Taught at Ohio State University, 1946-1951.
Worked on various free-lance design jobs in Cleveland
 while painting, 1951-1957.
Taught at New York State College of Education,
 Oswego, New York, 1957-1960.
Taught at Douglass College, Rutgers University,
 New Brunswick, New Jersey, 1960-1963.

One-man exhibitions

Carlebach Gallery, New York, 1951
John Heller Gallery, New York, 1952, 1953, 1954, 1957.
Leo Castelli Gallery, New York, 1962.
Ferus Gallery, Los Angeles, 1963.
Galerie Ileana Sonnabend, Paris, 1963.
Leo Castelli Gallery, New York, 1963.
Il Punto, Turin, 1963.
Leo Castelli Gallery, New York, 1964.
Ferus Gallery, Los Angeles, 1964.
Galerie Ileana Sonnabend, Paris, 1965.
Leo Castelli Gallery, New York, 1965.
The Cleveland Museum of Art, Cleveland, Ohio, 1966.
The Pasadena Art Museum, Pasadena, California, 1967.
The Walker Art Center, Minneapolis, Minnesota, 1967.
Leo Castelli Gallery, New York, 1967.
Contemporary Arts Center, Cincinnati, Ohio, 1967.
Stedelijk Museum, Amsterdam, 1967.
Tate Gallery, London, 1968.
Kunsthalle, Bern, 1968.
Kestner-Gesellschaft, Hannover, 1968.
Irving Blum Gallery, Los Angeles, 1968.
Irving Blum Gallery, Los Angeles, 1969.
The Solomon R. Guggenheim Museum, New York, 1969.

Group exhibitions

1962

*American Painting and Sculpture from Connecticut.
 Collections,* The Wadsworth Atheneum, Hartford,
 Connecticut.
*Art of Two Ages: The Hudson River School and Roy
 Lichtenstein,* Mi Chou Gallery, New York.
*An International Selection of Contemporary Painting
 and Sculpture,* The Dayton Art Institute, Dayton,
 Ohio.
New Paintings of Common Objects, The Pasadena Art
 Museum, Pasadena, California.

Art-1963: A New Vocabulary, YM/YWHA, Philadelphia, Pennsylvania.

The New Realists, The Sidney Janis Gallery, New York.

My Country 'Tis of Thee, Dwan Gallery, Los Angeles.

The Figure and Object from 1917 to the New Vulgarians, Galerie Saqqarah, Gstaad, Switzerland.

1961, The Dallas Museum for Contemporary Arts, Dallas, Texas.

Drawings, Leo Castelli Gallery, New York.

1963

66th American Annual, The Art Institute of Chicago, Chicago, Illinois.

Six Painters and the Object, The Solomon R. Guggenheim Museum, New York, and Traveling Exhibition: 1963-1964.

The Popular Image Exhibition, The Washington Gallery of Modern Art, Washington, D.C.

Drawings, Leo Castelli Gallery, New York.

Popular Art, Nelson Gallery-Atkins Museum, Kansas City, Missouri.

Pop Goes the Easel, Contemporary Arts Museum, Houston, Texas.

1er Salon International de Galeries Pilotes, Musée Cantonal des Beaux-Arts, Lausanne, Switzerland.

The Popular Image, Institute of Contemporary Arts, London.

The Art of Things, Jerrold Morris International Gallery, Toronto, Canada.

Mixed Media and Pop Art, Albright-Knox Art Gallery, Buffalo, New York.

The Park Synagogue Art Festival, Cleveland, Ohio.

The South County State Bank, St. Louis, Missouri.

Drawing Show, Washington Gallery of Modern Art, Washington, D.C.

New Directors in American Painting, Rose Art Museum, Brandeis University, Waltham, Mass.

Signs of Our Times, Des Moines Art Center, Iowa.

Pop Art USA, Oakland Art Museum, Oakland.

Pop, etc, Vienna Museum des 20. Jahrhunderts, Vienna.

Drawings, Leo Castelli Gallery, New York.

Dealer's Choice, Dwan Gallery, Los Angeles.

1964

Black, White, and Grey, Wadsworth Atheneum, Hartford, Connecticut.

Amerikansk Pop Konst, Moderna Museet, Stockholm.

Pop Art, Louisiana Museum, Humlebæk, Denmark.

Pop Kunst, Stedelijk Museum, Amsterdam, Holland.

New Realism, Municipal Museum, The Hague, Holland.

The Atmosphere of '64, ICA, Philadelphia, Pa.

Recent American Drawings, Rose Art Museum, Brandeis University, Waltham, Mass.

Painting and Sculpture of a Decade, Gulbenkian Foundation, Tate Gallery, London.

Circarama Building, New York State Pavilion for the World's Fair.

Salon de Mai, Paris, France.

100 American Drawings, Byron Gallery, New York.

American Drawings, Solomon R. Guggenheim Museum, New York.

New School of New York, Morris International Gallery, Toronto, Canada.

3 Generations, Sidney Janis Gallery, New York.

A Look at Realism in Art, Rochester Memorial Art Museum, Rochester.

Yankee Doodles, Bianchini Gallery, New York.

The Wright Collection, Portland Art Museum, Portland, Oregon.

Pop, etc. Museum des 20. Jahrhunderts, Vienna.

1965

New American Realism, Worcester Art Museum, Worcester, Mass.

Corcoran Bienniale, Corcoran Gallery of Art, Washington, D.C.

Arena of Love, Dwan Gallery, Los Angeles, Calif.

Pop Art, Nouveau Réalisme, etc..., Palais des Beaux-Arts, Brussels, Belgium.

Sports Festival, New York University, Loeb Center, New York.

Pop Art from USA, Hamburger Kunstkabinett, Hamburg.

Pop and Op, Janis Gallery, New York.

Master Drawings — Degas to Lichtenstein, Fort Worth Art Center, Fort Worth, Texas.

Annual Exhibition of Contemporary American Painting, Whitney Museum of American Art, New York.

U.S.A. Nouvelle Peinture, American Embassy, Paris.

The Other Tradition, Institute of Contemporary Art, University of Pennsylvania, Philadelphia, Pa.

Ten from Rutgers, Bianchini Gallery, New York.

Drawings And, University of Texas, Austin, Texas.

Neue Realisten und Pop Art, Akademie der Kunst, Berlin.

Pop Art and the American Tradition, Milwaukee Art Center, Milwaukee.

Word and Image, The Solomon R. Guggenheim Museum, New York.

Art in Process: The Visual Development of a Painting, Finch College Museum of Art, New York.

Recent Landscapes by Nine Americans, Palazzo Collicula, Spoleto.

1966

Master Drawings — Pissarro to Lichtenstein, Bianchini Gallery, New York and Contemporary Arts Center, Cincinnati, Ohio.

Recent Still Life — Painting and Sculpture, Rhode Island School of Design, Providence, Rhode Island.

Contemporary American Painting, Norfolk Museum, Norfolk, Virginia.

Six Artists From New York, San Francisco Museum of
Art, San Francisco, California.
Esposizione Biennale Internazionale d'Arte, Venice.
Seven Decades of Modern Art, Cordier Ekstrom Gallery,
New York.
Group Exhibition, Galleria Gian Enzo Sperone, Milan.
Harry N. Abrams Family Collection, The Jewish Museum,
New York.
Flint Invitational, Flint Institute of Arts, Flint, Michigan.
Recent American Painting, Museum of Modern Art
Circulating Exhibition, Japan, India.
Contemporary American Still-Life, Museum of Modern
Art, New York and Canada.
Art in the Mirror, Museum of Modern Art, New York
and circulating.
Art in Process: The Visual Development of a Collage,
Finch College Museum of Art, New York.
*Dine, Lichtenstein, Oldenburg, Rosenquist, Warhol,
Wesselmann,* Galleria L'Elefanta, Venice.

1967
Ten Years, Leo Castelli Gallery, New York.
American Painting Now, U.S. Pavilion, Expo '67,
Montreal, Canada and Boston, Institute of
Contemporary Art.
One Hundred Years of Fantastic Drawings, Bianchini
Gallery, New York.
IX São Paulo Bienal, São Paulo, Brazil.
*The 1960's: Painting and Sculpture from the Museum
Collection,* Museum of Modern Art, New York.
*The 1967 Pittsburgh International Exhibition of Con-
temporary Painting and Sculpture,* Carnegie Institute,
Pittsburgh, Pennsylvania.
Kompas III, Stedelijk van Abbemuseum, Eindhoven,
Holland and Frankfort, Frankfurter Kunstverein.
International Exhibition of Contemporary Art, Palazzo
Grassi, Venice.
1967 Annual Exhibition of Contemporary Art, Whitney
Museum of American Art, New York.
Eleven Pop Artists — The New Image, The New
Brunswick Museum, St. John, Canada.
Mixed Masters, University of St. Thomas, Houston.

1968
Image of Man Today, I.C.A., London.
Art Vivant, Maeght Foundation, Saint Paul, France.
Documenta, IV, Kassel, Germany.
Highlights of the Art Season, Larry Aldrich Museum,
Ridgefield, Connecticut.
The Art of the Real: USA 1948-1968, Museum of
Modern Art, New York.
Violence in Recent American Art, Museum of Con-
temporary Art, Chicago, Illinois, 1968.
Annual Exhibition: Sculpture, Whitney Museum of
American Art, New York.

Menschenbilder, Kunsthalle, Darmstadt.
American Tapestries, Charles E. Slatkin Inc., New York.
Untitled, 1968, San Francisco Museum of Art,
San Francisco.

1969
The Dominant Woman, Finch College Museum of Art,
Finch College, New York.
New York 13, Vancouver Art Gallery, Vancouver, Canada,
Regina, The Norman Mackenzie Art Gallery
Montréal, Musée d'Art Contemporain.
New York Painting and Sculpture, The Metropolitan
Museum of Art, New York.
Prints by Five New York Painters, The
Metropolitan Museum of Art, New York.
Pop Art, Hayward Gallery, The Arts Council of Great
Britain, London.
Painting in New York 1944 to 1969, The Pasadena
Art Museum, Pasadena.
American Drawings of the Sixties: A Selection, New
School, New York.
*16th National Print Exhibition: Two Decades of
American Prints: 1947-1968,* Brooklyn Museum
of Art, Brooklyn.
New York: The Second Breakthrough: 1959-1964,
University of California at Irvine, Irvine.
New — dada e pop art newyorkesi, Galleria Civica
D'Arte Moderna, Turin.
Contemporary American Sculpture: Selection 2, The
Whitney Museum of American Art, New York.

Bibliography

Exhibition Catalogues

1962

Dallas, The Dallas Museum for Contemporary Arts, *1961*, April 3-May 13, 1962. Introduction by Douglas Mac Agy.

Los Angeles, Dwan Gallery, *My Country 'Tis of Thee*, November 18-December 15, 1962. Catalogue introduction by Gerald Nordland.

New York, Sidney Janis Gallery, *The New Realists*, October 31 – December 1, 1962. Introduction by John Ashbery. Excerpts from an essay by Pierre Restany. Text by Sidney Janis.

Pasadena, Pasadena Art Museum, *New Paintings of Common Objects*, September 25 – October 19, 1962. Introduction by John Coplans.

1963

Buffalo, Albright-Knox Art Gallery, *Mixed Media and Pop Art*, November 19 – December 15, 1963. Foreword by Gordon M. Smith.

Chicago, The Art Institute, *66th American Annual Exhibition*, January 11 – February 10, 1963. Catalogue foreword by A. James Speyer.

Houston, Contemporary Art Association, *Pop Goes the Easel*, April 1963. Catalogue essay by Douglas Mac Agy.

Kansas City, Nelson Gallery/Atkins Museum, *Popular Art*, April 28 – May 26, 1963. Catalogue essay by Ralph T. Coe.

London, Institute of Contemporary Art, *The Popular Image*, October 24 – November 23, 1963. Essay by Alan R. Solomon.

New York, The Solomon R. Guggenheim Museum, *Six Painters and the Object*, March 14 – June 12, 1963. Preface by Thomas M. Messer. Essay by Lawrence Alloway.

Oakland, Oakland Art Museum, *Pop Art USA*, September 7 – 29, 1963. Essay by John Coplans.

Paris, Galerie Ileana Sonnabend *Roy Lichtenstein*, June 1963. Catalogue with essays by Alain Jouffroy, Ellen H. Johnson, Robert Rosenblum.

Turin, Galleria Il Punto Arte Moderna, *Lichtenstein*, December 23, 1963 – January 23, 1964. Essay by Michael Sonnabend.

Waltham, Massachusetts, Rose Art Museum, Brandeis University, *New Directions in American Painting*, December 1, 1963 – January 6, 1964. Introduction by Sam Hunter.

Washington, D.C., Gallery of Modern Art, *The Popular Image*, April 18 – June 2, 1963. Foreword by Alice M. Denny. Essay by Alan R. Solomon.

1964

Amsterdam, Stedelijk Museum, *American Pop Art*,

June 22 – July 26, 1964. Essay by Alan
R. Solomon.

Berlin, Akademie der Kunst, *Neue Realisten und
Pop Art,* November 20, 1964 – January 3, 1965.
Essay by Werner Hofmann.

The Hague, Gemeente Museum, *Nieuwe Realisten,*
June 24 – August 31, 1964. Texts by Jasia
Reichardt, L. J. F. Wijksenbeek,
W. A. L. Beeren, Pierre Restany.

London, The Tate Gallery, *Painting and Sculpture of
a Decade: 1954-1964,* April 22 – June 28, 1964.
Catalogues notes by Alan Bowness, Lawrence
Gowing, Philip James.

New York, Sidney Janis Gallery, *A Selection of
20th Century Art of Three Generations,*
November 24 – December 26, 1964.

New York, The Solomon R. Guggenheim Museum,
American Drawings, September – October, 1964.
Catalogue preface by Thomas M. Messer,
Introduction by Lawrence Alloway.

Paris, Musée d'Art Moderne de la ville de Paris,
XXᵉ Salon de Mai, May 16 – June 7, 1964.
Catalogue foreword by Gaston Diehl. Essay by
Yvon Tillandier.

Rochester, Memorial Art Gallery, University of
Rochester, *In Focus: A Look at Realism in Art,*
December 28, 1964 – January 31, 1965. Text by
Harris K. Prior.

Stockholm, Moderna Museet, *Amerikansk Pop-Kunst*
February 29 – April 12, 1964. Foreword by
K. G. Hulten. Texts by Alan R. Solomon and
Billy Kluver.

Vienna, Museum des 20. Jahrhunderts, *Pop, etc.,*
September 19 – October 31, 1964. Foreword by
Werner Hofmann. Essays by Werner Hofmann,
Otto A. Graf.

1965

Brussels, Palais des Beaux-Arts, *Pop Art, Nouveau
Réalisme, etc.,* February 5 – March 1, 1965.
Preface by Jean Dypreau. Essay by
Pierre Restany.

Fort Worth, Texas, Fort Worth Art Center,
Master Drawings – Degas to Lichtenstein,
June – July 1963. Preface by
Raymond Entenman.

Milwaukee, Milwaukee Art Center, *Pop Art and the
American Tradition,* April 9 – May 9, 1965
Essay by Tracy Atkinson.

New York, Bianchini Gallery, *Ten from Rutgers,*
December 1965. Introduction by Alan Kaprow.

New York, Sidney Janis Gallery, *Pop and Op,*
December 1 – 31, 1965.

New York, The Solomon R. Guggenheim Museum,
World and Image, December, 1965. Introduction
by Lawrence Alloway.

New York, The Whitney Museum of American Art,
*1965 Annual Exhibition of Contemporary
American Painting,* December 8, 1965 – January 30,
1966.

Paris, Galerie Ileana Sonnabend, *Roy Lichtenstein,* June
1965. Interview by G. R. Swenson.

Washington, D.C., Corcoran Gallery of Art, *The
29th Biennial Exhibition of Contemporary
American Painting,* February 26 – April 18, 1965.
Catalogue essay by Herman Warner Williams, Jr.

Worcester, Massachusetts, Worcester Art Museum,
The New American Realism, February 18 –
April 14, 1965. Preface by Daniel Catton Rich.
Essay by Martin Carey.

1966

Cleveland, Cleveland Museum of Art, *Roy Lichtenstein,*
December 1966. Leaflet essay by Edward
B. Henning.

New York, Bianchini Gallery, *Master Drawings –
Pissaro to Lichtenstein,* January 15 – February 6,
1966 and Contemporary Arts Center, Cincinnati,
Ohio, February 7 – February 26, 1966. Preface by
William Albers Leonard.

New York, The Jewish Museum, *The Harry N. Abrams
Family Collection,* June 29 – September 5, 1966.
Catalogue interview by Sam Hunter.

New York, Museum of Modern Art, International
Council, *Two Decades of American Painting,*
1966-1967. Catalogue essays by Irving Sandler,
Lucy Lippard, G. R. Swenson.

New York, Public Education Association, *Seven
Decades: 1895-1965: Crosscurrents in Modern
Art,* April 26 – May 21, 1966. Catalogue text by
Peter Selz.

Philadelphia, Institute of Contemporary Art, University
of Pennsylvania, *The Other Tradition,* January 27 –
March 7, 1966. Essay by G. R. Swenson.

Providence, Rhode Island School of Design Museum,
Recent Still Life, February 23 – April 4, 1966.
Catalogue essay by Daniel Robbins.

San Francisco, San Francisco Museum of Art, *The
Current Moment in Art: Exhibition: East,*
April 15 – May 22, 1966.

Venice, United States Pavilion, *XXXIII International
Biennial Exhibition of Art,* June 18 – October 16,
1966. Foreword by David W. Scott. Introduction
by Henry Geldzahler. Essay on Lichtenstein by
Robert Rosenblum.

1967

Amsterdam, Stedelijk Museum, *Roy Lichtenstein,*
November 4 – December 17, 1967. Foreword by
E. de Wilde. Essay by W. A. L. Beeren. Interview
conducted by John Coplans.

Boston, Institute of Contemporary Art, *American
 Painting Now*, December 15, 1967 –
 January 10, 1968. Catalogue essay by
 Alan R. Solomon.
Cincinnati, The Contemporary Arts Center, *Roy
 Lichtenstein*, December 1967. Introduction by
 Lawrence Alloway.
Frankfort, Frankfurter Kunstverein, *Kompass New York*,
 December 30, 1967 – February 11, 1968.
 Catalogue text by Jean Leering.
Houston, University of St. Thomas, *Mixed Masters*,
 May – September, 1967. Catalogue introduction
 by Kurt von Meier.
New York, Leo Castelli Gallery, *Ten Years*,
 February 4 – 26, 1967. Catalogue introduction
 by David Whitney. Statements by William
 C. Agee, Lawrence Alloway, John Cage.
New York, Museum of Modern Art, *The 1960s:
 Painting and Sculpture from the Museum
 Collections*, June 28 – September 24, 1967.
 Brochure introduction by Dorothy Miller.
New York, The Whitney Museum of American Art,
 The 1967 Annual Exhibition of American Painting,
 December 13, 1967 – February 4, 1968.
Pasadena, Pasadena Art Museum, *Roy Lichtenstein*,
 April 18 – May 28, 1967. In collaboration with:
 Minneapolis, Walker Art Center, June 23 – July 30,
 1967. Introduction and interview by John Coplans.
 Extensive bibliography by Jane Gale.
Pittsburgh, Carnegie Institute, *The 1967 Pittsburgh
 International Exhibition of Contemporary
 Painting and Sculpture*, October 27, 1967 –
 January 7, 1968. Catalogue foreword by Gustav
 von Groschwitz.
St. John Canada, The New Brunswick Museum,
 Eleven Pop Artists — The New Image,
 January 6 – 27, 1967. Essay by Max Kozloff.
São Paulo, Museum of Modern Art, *IX Biennial*,
 September 22, 1967 – January 8, 1968.
 Bilingual catalogue text by William Seitz.
 Excerpts on Lichtenstein from an essay by
 John Coplans.
Venice, Palazzo Grassi, *Mostra Internazionale d'Arte
 Contemporanea*, July – October, 1967. Catalogue
 essay by Paolo Marinotti.

1968
Bern, Kunsthalle, *Roy Lichtenstein*, February 23 -
 March 31, 1968.
 Essays by Jean-Christophe Amman,
 W. A. L. Beeren. Interviews by Alan R. Solomon,
 Raphael Sorin, John Coplans.
Brooklyn, Brooklyn Museum of Art, *16th National
 Print Exhibition: Two Decades of American
 Prints: 1947-1968*. October 29, 1968 –

January 26, 1969. Catalogue introduction by
 Una E. Johnson.
Chicago, Museum of Contemporary Art, *Violence in
 Recent American Art*, November 8, 1968 –
 January 12, 1969. Catalogue introduction by
 Jan van der Marck. Essay by Robert Glauber.
Darmstadt, Kunsthalle, *Menschenbilder*, September 17 –
 November 17, 1968. Catalogue essays by
 Arnold Gehlen, Werner Haftmann, Wieland
 Schmied, Rolf Gunter-Dienst.
Hanover, Kestner-Gesellschaft, *Roy Lichtenstein*,
 April 11 – May 12, 1968. Essay by Wieland Schmied.
 Interviews by G. R. Swenson, David Pascal,
 Alan R. Solomon, Raphael Sorin, John Coplans.
Kassel, Galerie an der Schönen Aussicht, Museum
 Fridericianum, Orangerie im Auepark,
 Documenta 4, June 27 – October 6, 1968.
 Catalogue essays by Max Imdahl, Jean Leering,
 Günther Gercken, Werner Spies.
London, Tate Gallery, *Roy Lichtenstein*, January 6 –
 February 4, 1968. Foreword by Norman Reid.
New York, Finch College Museum of Art, *The
 Dominant Woman*, December 13, 1968 –
 January 26, 1969. Catalogue foreword by
 Elayne H. Varian. Text by Walter Gutman.
New York, Charles E. Slatkin, Inc. *American
 Tapestries*, October 22 – November 23, 1968.
 Catalogue introduction by Mildred Constantine.
 Notes by Irma Jaffe.
New York, The Whitney Museum of American Art,
 *The 1968 Annual Exhibition of American
 Sculpture*, December 17, 1968 – February 9, 1969.
Ridgefield, The Aldrich Museum of Contemporary
 Art, *Highlights of the 1967-1968 Art Season*,
 June 16 – September 15, 1968. Catalogue
 preface by Larry Aldrich.
St. Paul de Vence, France, Foundation Maeght,
 L'Art Vivant: 1965-1968, April 13 - June 30, 1968.
 Catalogue introduction by François Wehrlin.
San Francisco, San Francisco Museum of Art,
 Untitled, 1968, November 9 – December 19, 1968.
 Catalogue foreword by Gerald Nordland.
 Introduction by Wesley Chamberlin.

1969
Irvine, University of California at Irvine, *New York:
 The Second Breakthrough: 1959-1964*,
 March 15 – April 27, 1969. Catalogue essay by
 Alan R. Solomon.
New York, New School, *American Drawings of the
 Sixties: A Selection*, November 11, 1969 - January
 10, 1970, Introduction by Paul Mocsanyi.
New York, The Solomon R. Guggenheim Museum,
 Roy Lichtenstein, September 18 – November 9,
 1969. Introduction by Diane Waldman.
London, The Hayward Gallery, the Arts Council of

Great Britain, *Pop Art,* July 9 – September 3, 1969.
Introduction by John Russell and Suzi Gablik.

New York, The Metropolitan Museum of Art, *New York Painting and Sculpture, 1940-1970,* October 18, 1969 – February 1, 1970. Introduction by Henry Geldzahler.

New York, The Metropolitan Museum of Art, *Prints by Five New York Painters,* October 18 – December 8, 1969.

New York, The Whitney Museum of American Art, *Contemporary American Sculpture: Selection 2,* April 15 – May 5, 1969. Catalogue foreword by John Baur.

Pasadena. California, The Pasadena Art Museum, *Painting in New York 1944 to 1969,* November 24, 1969 – January 1, 1970. Introduction by Alan R. Solomon.

Turin, Galleria Civica D'Arte Moderna, *New-dada e pop art newyorkese,* April 2 – May 4, 1969. Introduction by Luigi Mallé.

Vancouver, Vancouver Art Gallery, *New York/13,* January 21 – April 27, 1969. Catalogue essay by Alan R. Solomon.

Books and Articles

1962

Coplans, John, "The New Paintings of Common Objects," *Artforum,* vol. 1, no. 6, November 1962, pp. 26-29. (Reprinted from exhibition catalogue, *The New Paintings of Common Objects,* Pasadena Art Museum, September 25 - October 19, 1962.)

"Everything Clear Now?" *Newsweek,* vol. 59, February 2, 1962, p. 96.

Kozloff, Max, "Pop Culture," Metaphysical Disgust and the New Vulgarians," *Art International,* vol. 6, no. 2, March 1962, pp. 34-36.

"The Slice of Cake School," *Time,* vol. 79, May 11, 1962, p. 52.

"Something New Is Cooking," *Life,* vol. 52, no. 24, June 15, 1962, pp. 115-120.

Swenson, G. R., "The New American Sign Painters," *Art News,* vol. 61, no. 5, September 1962, pp. 44-47, 60-62.

1963

Alloway, Lawrence, "Notes on Five New York Painters," *Gallery Notes,* Albright-Knox Art Gallery, vol. 26, no. 2, Autumn 1963, pp. 13-20.

Coplans, John, "Pop Art, USA," *Artforum,* vol. 2, no. 4, October 1963, pp. 27-30. (Reprinted from exhibition catalogue, *Pop Art, USA,* Oakland Art Museum, September 7-29, 1963.)

—, "An Interview with Roy Lichtenstein," *Artforum,* vol. 2, no. 4, October 1963, p. 31.

Fried, Michael, *Art International,* vol. 7, no. 9, December 1963, p. 66.

Karp, Ivan C., "Anti-Sensibility Painting," *Artforum,* vol. 2, no. 3, September 1963, pp. 26-27.

Kozloff, Max, *The Nation,* vol. 197, no. 14, November 2, 1963, pp. 284-289.

Loran, Erie, "Cézanne and Lichtenstein: Problems of 'Transformation'," *Artforum,* vol. 2, no. 3, September 1963, pp. 34-35.

—, "Pop Artists or Copy Cats?" *Art News,* vol. 62, no. 5, September 1963, pp. 48-49, 61.

"Pop Art — Cult of the Commonplace," *Time,* vol. 81, May 3, 1963, pp. 69-72.

"Pops or Robbers. The Big Question," *Newsweek,* vol. 62, September 16, 1963, p. 90.

Rose, Barbara, "Dada Then and Now," *Art International,* vol. 7, no. 1, January 1963, pp. 23-28.

Rosenblum, Robert, "Roy Lichtenstein and the Realist Revolt," *Metro,* no. 8, April 1963, pp. 38-44.

Selz, Peter, "A Symposium on Pop Art," *Arts,* vol. 37, no. 7, April 1963, pp. 36-45. A symposium held at The Museum of Modern Art, New York, December 1963. Moderator: Peter Selz. Participants: Henry Geldzahler, Hilton Kramer, Dore Ashton, Leo Steinberg, Stanley Kunitz.

Swenson, G. R., "What Is Pop Art?" *Art News,* vol. 62, no. 7, November 1963, pp. 24-25, 62-63. Interview with Roy Lichtenstein.

1964

Canaday, John, "Pop Art Sells On and On — Why?" *The New York Times,* Sunday Magazine Section, May 31, 1964, pp. 7, 48-53.

Danieli, Fidel A., "Roy Lichtenstein: Ferus Gallery," *Artforum,* vol. 3, no. 4, January 1964, p. 12.

"Discredited Merchandise," *Newsweek,* vol. 64, November 9, 1964, pp. 94-96.

Johnson, Philip, "Young Artists at the Fair and at Lincoln Center," *Art in America,* vol. 52, no. 4, August 1964, pp. 112-127.

Jouffroy, Alain, "Une Révision Moderne du Sacre," *XXe Siècle,* no. 24, December 1964, pp. 89-98.

Kozloff, Max, "Art and the New York Avant Garde," *Partisan Review,* vol. 31, no. 4, Fall 1964, pp. 535-554.

—, *The Nation,* vol. 199, November 30, 1964,

Picard, Lil, *Das Kunstwerk,* vol. 18, no. 6, December 1964, p. 26.

Rose, Barbara, *Art International,* vol. 8, no. 10, December 1964, p. 66.

Rosenberg, Harold, *The Anxious Object: Art Today and Its Audience,* New York, 1964.

Rosenblum, Robert, "Pop Art and Non-Pop Art," *Art and Literature,* no. 5, Summer 1964, pp. 80-93.

Seiberling, Dorothy, "Is He The Worst Artist in the U.S.?" *Life,* vol. 56, no. 5, January 31, 1964, pp. 79-83.

Solomon, Alan R., "The New American Art," *Art International,* vol. 8, no. 2, March 1964, pp. 50-55. (Reprinted from exhibition catalogue, *Amerikansk Pop Kunst,* Stockholm, Moderna Museet, February 29 – April 12, 1964.)

1965

Amaya, Mario, *Pop Art...and After,* New York, 1965.

Backer, Jurgen, *Happenings, Fluxus, Pop Art,* Hamburg, 1965.

Dienst, Rolf-Gunter, *Pop-Art,* Wiesbaden, 1965.

Hahn, Otto, "Lettre de Paris," *Art International,* vol. 9, no. 6, September 1965, p. 72.

Marmer, Nancy, "Los Angeles Letter," *Art International,* vol. 9, no. 1, February 1965, pp. 31-32.

Rose, Barbara, "Pop in Perspective," *Encounter,* vol. 25, no. 2, August 1965, pp. 59-63.

Rublowsky, John, *Pop Art,* New York, 1965. Introduction by Samuel Adams Green. Photography by Ken Hyman.

Sandler, Irving, "The New Cool-Art," *Art in America,* vol. 53, no. 1, February 1965, pp. 96-101.

Tillim, Sidney, "Towards a Literary Revival?" *Arts,* vol. 39, no. 9, May – June 1965, pp. 30-33.

1966

Bannard, Darby, "Present-Day Art and Ready Made Styles," *Artforum,* vol. 5, no. 4, December 1966, pp. 30-35.

Boatto, Alberto and Giordano Falzoni, eds., *Lichtenstein,* Rome, 1966. A book published in magazine format and also known as *Fantazaria,* vol. 1, no. 2, July – August 1966. Texts by Alberto Boatto, Maurizio Calvesi, Ellen Johnson, Max Kozloff, Filberto Menna, Alan R. Solomon, Robert Rosenblum.

Antoine, Jean, "Métamorphoses: L'école de New York," *Quadrum 18,* March 1966, pp. 161-162. Statement of Roy Lichtenstein transcribed from a film soundtrack.

Battcock, Gregory, ed., *The New Art: A Critical Anthology,* New York, 1966.

Fry, Edward, "Roy Lichtenstein's Recent Landscapes," *Art and Literature,* no. 8, Spring 1966, pp. 111-119.

Geldzahler, Henry, "Frankenthaler, Kelly, Lichtenstein, Olitski: A Preview of the American Selection at the 1966 Venice Biennale," *Artforum,* vol. 4, no. 10, June 1966, pp. 32-38. (Revised version of catalogue essay appearing in *XXXIII International Biennial Exhibition of Art,* American Pavilion, Venice, June 18 – October 16, 1966.)

Glaser, Bruce, "Lichtenstein, Oldenburg, Warhol: A Discussion," *Artforum,* vol. 4, no. 6, February 1966, pp. 20-24. (Edited transcript of a discussion moderated by Bruce Glaser on radio station WBAI, June 1964.)

Hahn, Otto, "Roy Lichtenstein," *Art International,* vol. 10, no. 6, Summer 1966, pp. 66-69. (Translation from the French by Arnold Rosin, amended by James Fitzsimmons.)

Hunter, Sam, "Art Since 1945," *New Art Around the World,* New York, 1966.

Irwind, David, "Pop Art and Surrealism," *Studio International,* vol. 171, no. 877, May 1966, pp. 187-191.

Johnson, Ellen H., "The Image Duplicators— Lichtenstein, Rauschenberg, and Warhol," *Canadian Art,* vol. 23, no. 1, January 1966, pp. 12-19.

—, "Lichtenstein, The Printed Image at Venice," *Art and Artists,* vol. 1, no. 3, June 1966, pp. 12-15.

Lippard, Lucy, "New York Letter," *Art International,* vol. 10, no. 1, January 1966, p. 93.

—, ed. *Pop Art,* New York, 1966. Texts by Lucy Lippard, Lawrence Alloway, Nancy Marmer, Nicolas Calas.

Pascal, David, "An Interview with Roy Lichtenstein", *Giff-Wiff,* no. 20, May 1966, pp. 6-15.

Pelligrini, Aldo, *New Tendencies in Art,* New York, 1966. Translated by Robin Carson.

Solomon, Alan R., "American Art Between Two Biennales," *Metro,* no. 11, 1966, pp. 24-35.

— ,"Conversation with Lichtenstein," *Fantazaria,* vol 1, no. 2, July – August 1966, pp. 6-13 (Italian), 36-42 (English summary), 66-73 (French summary). Transcribed television interview with Roy Lichtenstein.

1967

Alloway, Lawrence, "Roy Lichtenstein's Period Style," *Arts,* vol. 42, no. 1, September-October 1967, pp. 24-29. Adapted in *Studio International,* vol. 175, no. 896, January 1968, pp. 25-31.

Coplans, John, "Talking with Roy Lichtenstein," *Artforum,* vol. 5, no. 9, May 1967, pp. 34-39. (Reprinted from exhibition catalogue, *Roy Lichtenstein,* Pasadena Art Museum, April 18 – May 28, 1967.)

Dali, Salvador, "How an Elvis Presley Becomes a Roy Lichtenstein," *Arts,* vol. 41, no. 6, April 1967, pp. 26-31. Translated by Albert Field.

Kozloff, Max, "Modern Art and the Virtues of Decadence," *Studio International,* vol. 174, no. 894. November 1967, pp. 189-199.

Meier, Kurt von, *Art International,* vol. 11, no. 8, October 1967, pp. 59-60.

Melville, Robert, "Battlepieces and Girls," *The Architectural Review,* vol. 141, no. 842, April 1967, pp. 289-291.

"Painting: Kidding Everybody," *Time,* vol. 89, June 23, 1967, pp. 72-73.

Restany, Pierre, "Le Pop-Art: Un Nouvel Humanisme Américain," *Aujourd hui USA,* nos. 55-56, January 1967, pp. 121-122. English summary included.

Roberts, Colette, "Interview de Roy Lichtenstein," *Aujourd hui USA,* nos. 55-56, January 1967, pp. 123-127 (English summary included).

Rose, Barbara, *American Art Since 1900,* New York, 1967.

Rose, Barbara and Irving Sandler, "Sensibility of the Sixties," *Art in America,* vol. 55, no. 1, January – February 1967, p. 45. Roy Lichtenstein's answer to a questionnaire.

Solomon, Alan R., *New York: The New Art Scene,* New York, 1967. Photography by Ugo Mulas.

Waldman, Diane, "Remarkable Commonplace," *Art News,* vol. 66, no. 6, October 1967, pp. 28-31, 65-67.

1968

Alloway, Lawrence, *The Venice Biennale 1895-1968: From Salon to Goldfish Bowl,* Greenwich, 1968.

Arnason, H. H., *History of Modern Art: Painting, Sculpture, Architecture,* New York, 1968.

Baro, Gene, "Roy Lichtenstein: Technique as Style," *Art International,* vol. 12, no. 9, November 1968, pp. 35-38.

Boime, Albert, "Roy Lichtenstein and the Comic Strip," *Art Journal,* vol. 28, no. 2, Winter 1968-69, pp. 155-159.

Calas, Nicolas, *Art in the Age of Risk and other Essays,* New York, 1968.

"Le classicisme du hot dog," *La Quinzaine Littéraire,* no. 42, January 1968, pp. 16-17. Interview by Raphael Sorin.

Hamilton, Richard, "Roy Lichtenstein," *Studio International,* vol. 175, no. 896, January 1968. pp. 20-24.

Johnson, Ellen H., "The Lichtenstein Paradox," *Art and Artists,* vol. 2, no. 10, January 1968, pp. 12-15.

Livingston, Jane, "Los Angeles", *Artforum,* vol. 6, no. 10, Summer 1968, pp. 60-61.

Rose, Barbara, ed. *Readings In American Art Since 1900. A Documentary Survey,* New York, 1968.

Tillim, Sidney, "Lichtenstein's Sculptures," *Artforum,* vol. 6, no. 5, January 1968, pp. 22-24.

1969

Calas, Nicolas, "Roy Lichtenstein: Insight through Irony, The Guggenheim Retrospective," *Arts,* vol. 44, no. 1, September – October 1969, pp. 29-33.

Fry, Edward F., "Inside the Trojan Horse," *Art News,* vol. 68, no. 6, October, 1969, pp. 36-39, p. 60.

Kozloff, Max, *Renderings: Critical Essays on a Century of Modern Art,* New York, 1969.

— ,"Lichtenstein at the Guggenheim", *Artforum,* vol. 8, no. 3, November 1969, pp. 41-45.

Russell, John, "Pop Reappraised," *Art in America,* vol. 57, no. 4, July – August 1969.

Russell, John and Gablik, Suzi, *Pop Art Redefined,* London, 1969.

This book was designed by Marcus Ratliff, New York.
The text is set in monotype Univers.

The photographs used were provided by:
Rudolph Burckhardt, New York; Leo Castelli Gallery, New York; Edward Cornachio, Los Angeles;
Jonas Dovydenas, Chicago; Gemini G.E.L., Los Angeles; Pierre Golendorf, Paris;
The Solomon R. Guggenheim Museum, New York; Malcolm Lubliner, Los Angeles;
Ann Münchow, Aachen, Germany; Eric Pollitzer, New York;
Rollyn Puterbaugh, Dayton, Ohio; Nathan Rabin, New York;
Shunk-Kender, New York; Ileana Sonnabend, Paris; Frank J. Thomas, Los Angeles;
The Victoria and Albert Museum, London; John Webb, London.